Critical acclaim for
Janet LaPierre's
PORT SILVA MYSTER

Unquiet Grave

"*A razor-sharp debut novel... Great atmosphere, quirkily believable characters, and a satisfying romance.*"
—*BOOKLIST*

Children's Games

"*The smooth presentation of believable characters, the coastal atmosphere, and the ever-increasing pressure to discover the murderer, along with the underplayed love affair, are well crafted, so that the resolution is as shocking as the crimes. A winner!*"
—*MURDER AD LIB*

The Cruel Mother

"*There are wheels-within-wheels in the cunning plot, along with a wide spectrum of offbeat characters and shifting locales to keep things moving. A gripping story.*"
—*KIRKUS REVIEWS* ★

Grandmother's House

"*LaPierre's deftly woven mystery explores environmental issues, homelessness, drugs, and family violence. The vividly portrayed characters are well-drawn and believable, as is the rocky, windswept coastal town itself.*"
—*SAN FRANCISCO CHRONICLE*

Old Enemies

"*Set in one of the country's most remote and beautiful spots...it's a moving, involving tale of disappearance and loss and growth.... You'll come away from it wiser than you went in.*"
—*THE PLOT THICKENS*

A Meg Halloran and

Baby

Vince Gutierrez

Mine

Mystery

by

Janet LaPierre

A Perseverance Press Book
John Daniel & Company
Santa Barbara, Calif.
1999

*This novel is a work of fiction. Any resemblance to real situations
or to actual people, living or dead, is completely coincidental.*

A Perseverance Press Book
Published by John Daniel & Company
A division of Daniel & Daniel, Publishers, Inc.
Post Office Box 21922
Santa Barbara, CA 93121
www.danielpublishing.com/perseverance

Book design: Eric Larson
Cover design: Frank Bucy/No Waves Press
Cover photo: Morgan Daniel

LIBRARY OF CONGRESS CATALOGING-IN-PUBLICATION DATA
LaPierre, Janet.
 Baby mine : a Meg Halloran and Vince Gutierrez mystery / by Janet
LaPierre
 p. cm.
 "A Perseverence Press book."
 ISBN 1-880284-32-4 (alk. paper)
 I. Title.
 PS3562.A624B3 1999
 813'.54—dc21 99-12940
 CIP

This book is dedicated to
the California north coast

and to
Meg, Katy, and Vince,
my good companions there

AUTHOR'S NOTE

Port Silva, California, is a fictitious town. Stretch the Mendocino coast some twenty miles longer, scoop up Mendocino village and Fort Bragg, toss in a bit of Santa Cruz. Set this concoction on a dramatic headland over a small harbor and add a university. Established 1885. Elevation 100 feet. Population 24,020, a mix of old families, urban escapers, students, academics, and tourists in season.

Baby
Mine

Chapter 1

"STOP THAT! Leave him alone!"

The bending figures came upright and around in startled, jerky fashion, like a row of marionettes controlled by different hands. All of them—five, six, impossible to be sure in the fog-dimmed glow of the lone street lamp—froze for an instant, just long enough for Meg Halloran to see dark blanks where faces should be, and to acknowledge that once again her mouth had outrun her brain.

Ski masks: she kept her lips pressed tight, but the words "Oh shit!" glowed in her mind like words on a screen. As the yellow cone of light—a flashlight beam—left the prone, writhing figure on the ground and swung to pin her in place, she raised a hand to shield her eyes and remembered too late Vince's tales of vandalism, robbery, and increasingly brutal assaults committed in recent months by a gang of youths.

Assault. Not rape, not killing. Yet, she thought, gulping breath through her mouth against the panic fluttering in her throat. You could be the first, dummy.

"Leave me alone!" Her words came out in a croak as three of them moved toward her, spread out in the street in a stalking line and the one in the center keeping the flash on her. She stepped slowly, carefully backwards, the blood-urge to turn and run checked by her absolute conviction that they'd be after her in a flash, to leap and bring her down like wolves on a deer. Her straining ears caught no sound from behind her, no engine or footstep offering possibility of help.

She tried her voice again. "Leave me alone." And then, shrilly, "Chief Gutierrez is meeting me...."

"Hey! There he goes, the bastard!"

The victim had managed to scramble to his feet while his tormentors were distracted, and now shot away into the dark in a flurry of skeletal, near-naked limbs. Two of the attackers set off in half-hearted pursuit, muttering curses; the others, shifting shape from line to arrow, aimed themselves at Meg.

"Don't!" She half turned and flung her hands up defensively as the leader, very tall, swung the long flashlight and caught her just above the bridge of her nose. Outraged by pain and the sudden taste of her own blood, she found breath for a full-throated shriek and grabbed at him, got her hands on the barrel of the flashlight, and twisted it around for the briefest glimpse of wide pale eyes framed by the mask's dark fabric, strands of light-colored hair trailing over the knit collar of the zipped-up jacket.

"Hey, dipshit, come on!" one of the others called in a hoarse whisper.

He wrestled the flashlight from her now-slippery grasp, said, "Oh, fuck!" in a near-sob, and struck at her again, a backhanded, swinging blow that slammed his forearm across her collarbone and sent her flying. By the time she had rolled over and levered herself up to hands and knees, all of them had disappeared into the dark, the thuds of their running feet faint and then gone.

Okay. She straightened to sit on her heels, tipped her head back, and pressed the sleeve of her wool jacket against her nose. Drew several deep breaths through her mouth, felt like she'd be breathing that way for a while yet.

Okay. First thing, up from knees to feet and get out of the middle of the street. Then, good citizen, call the police. Or Vince. Or both. She remembered a telephone booth beside the Port Silva Library's front door.

Good memory, dead vandalized telephone, what a surprise. Meg leaned her forehead against the etched glass pane of the locked library door, peering in for light and finding none. Public service indeed, and it would serve them right to find bloody smears on their nice door tomorrow. And where were the police when you needed them? Downtown, a long long walk away.

No walk, do not walk, that's what got you into this mess. She pulled herself firmly upright, turned and scanned the parking lot for her car. Not there, somebody took it. She blinked back tears, sniffed,

and then choked and spat blood and made a disgusting noise that sounded like a whimper. Blinked again. No Toyota Camry, just a small, strange…

Oh. Vince's Porsche, her transport tonight because the Toy was in the shop. She could drive home, very far. Or to the police station, a bit closer, and there she could bleed all over some cop she didn't know, or even worse, one she did, and probably cry as she told him how stupid she'd been. Or…

"It's Meg, Charlotte. I saw the light and hoped I wouldn't be waking anybody up." Feeling exposed by the bright porch light, she shielded her face behind the now-bloody towel she'd found in the car.

Charlotte Birdsong turned the deadbolt lock and pulled the front door wide, and Meg stepped quickly inside. "I'm not seriously hurt," she went on. "This is just a nosebleed, honestly, and I think it's stopped. Don't be silly, George," she told Charlotte's shaggy Lab–poodle cross, who lowered head and tail and tried to pretend that the smell of blood hadn't misled him into growling at an old friend.

"Good heavens," said Charlotte faintly, as she got a good look. "What…? Never mind, you've come to the right person—the mother of a teenaged jock who is also an easy bleeder. And I'm here by myself; Val is filling in on third-watch patrol for somebody who has the flu, and Petey's sleeping at a friend's house. Come along."

Charlotte Birdsong was one of life's prizes, a friend who would mop up a mess first, ask questions later. Meg followed the smaller woman through the music room with its grand piano to the beckoning light and warmth of the big kitchen. There she pulled off her jacket, rolled the messy thing up, and tossed it and the towel aside before settling carefully into the tall wooden rocker that was her usual seat.

"Oh, dear." Charlotte reached out to touch Meg's face and thought better of it, turning instead to the sink. "I hate to tell you this, but I think you're going to have two black eyes. Just lean your head back and try to relax, and I'll at least swab away the gore."

Head back was easy enough, relaxing less so; Meg found that her hands were gripping the chair arms as if to keep her from being pushed off a cliff. But if she made them let go, they'd probably shake, as her chin was threatening to do.

"Why don't you unclench your jaw and tell me what happened?" Charlotte suggested, as she set to work with a washcloth and a bowl of warm water.

"We—a group of English and history teachers from the high school—had a meeting at the town library with the head librarian and her staff. Trying for some coordination in book purchases, because everybody's budget is so flat."

"I see. And one of the librarians got in a lucky punch?"

"Listen, none of those ladies could lay a glove on me. On my good days, anyway. But after the meeting, some of us decided to go out for a late dinner, and I left my car in the library parking lot." Meg clenched her teeth again and closed her eyes, content to be a child having her face washed instead of a woman looking at assault.

"There," said Charlotte a few minutes later, and handed Meg a towel. "Library parking lot?"

"Lucy Acuff dropped me off, there wasn't a soul around, or so I thought, and I decided to walk down that little path to the edge of the bluff, to smell the sea and listen to the foghorns for a few minutes. As I was coming back to the street, I saw a beam of light bouncing around and heard—oh, rustles and scuffles, I guess, and maybe mutterings and then this one long, sad howl. It was that street person, the skinny guy with dreadlocks who hangs around the library."

"I think he sometimes sleeps in the used-book bin," said Charlotte.

"Well, this gang of hoodlums had found him and was in the process of beating the bejesus out of him," said Meg. "I yelled and startled them, and he managed to get up and run off."

"But you didn't."

Meg shivered, the deer-and-wolves image looming in her memory. "I couldn't. I did yell Vince's name, that he was meeting me or something. That may have deflected them, because one of them called something to the guy who was hitting me, and then they all disappeared. Clearly there are times when it's an advantage to be married to the chief of police. Although," she added, "it's going to be less of an advantage when I have to tell him I forgot his warnings."

"Did you recognize any of them?"

"They had ski masks on." Remembering those featureless faces,

she squeezed her eyes shut and put a shaking hand to her own face, to the nose that seemed both numb and throbbing with pain.

Charlotte told her it didn't appear to be broken. "I think the blow was more glancing than direct, but it would probably be a good idea to have your doctor look at it tomorrow. Now let me help you off with that sweater—which I'm afraid is beyond saving," she added, as she eased the once-lavender cotton garment over Meg's head.

"Uck. Just toss it, Charlotte."

Charlotte took the bloody sweater away and returned with a clean white shirt. "This will get you decently home, at least. Would you like a cup of tea? A glass of wine?"

"Wine," said Meg without thinking, as she shrugged the shirt on. Then she looked up at Charlotte and said, "Oh, wait. Tea would be okay."

"No, it wouldn't." Charlotte poured two glasses of red wine, handed one to Meg, and settled with the other into her padded wicker chair. "I am a very moderate drinker. I drank moderately during my entire first pregnancy; Petey was born a week late, he weighed nine pounds and a bit, and he's quite bright and healthy."

"But I thought Val…" Charlotte was newly married to Val Kuisma, a young policeman on Vince's Port Silva force. Meg liked to think this made Charlotte her sister-in-law.

"I promised Val I'd avoid alcohol and caffeine entirely during the first trimester. And I did." End of discussion, said her expression. "And how is Vince?"

"Depressed," Meg said flatly. Vince's eighty-year-old mother, Emily Gutierrez, had died the previous summer after flatly rejecting her children's urgings to have surgery on her failing heart. Vince felt guilty about not having pushed more strongly for the operation, and besides that, he missed her. He was worried about his best friend and most dependable subordinate, Captain Hank Svoboda, who was in the hospital recovering with painful slowness from pneumonia. And he was being worn down physically and emotionally by this winter's unprecedented upsurge of juvenile and domestic violence.

All of which Charlotte, her good friend and confidante, knew already. "Believe me," Meg said, with a grimace that hurt her face, "the last thing Vince needs right now is to have his trouble-prone wife say, one more time, 'Don't worry, it's not as bad as it looks.'"

Charlotte sputtered, caught between a chuckle and a mouthful of wine.

Meg gave an unwilling grin and lifted her own glass cautiously, not sure what was where in her swelling face. "You know, when I came to Port Silva several years ago, I had all the big-city reflexes. Keep your house locked even when you're at home, your car doors locked while driving, don't even *drive* alone on a dark empty street, never mind walk. Then I got used to living in a nice safe little town."

"I know. Me, too."

"I just hate the idea that I have to go back to being that other kind of person. But those kids tonight…" Meg paused, remembering. "That's what they were, kids. Quick and lean, without the muscular bulk of grown men."

"The people who frightened me today weren't kids." Charlotte's round face was unnaturally somber.

"Frightened you? How?"

"My doctor's office is being repainted, and she has a temporary place in the old Port Silva Hospital. I went there today for my check-up, and I was in the middle of this crowd of demonstrators before I realized what was happening."

"Demonstrators?" Meg stared at her. "At your obstetrician's office?"

"No, at the fertility clinic there in the hospital. There were eight or ten people, men and women, waving signs I couldn't read in the rain, some of them clicking rosary beads. They obviously thought I was a patient at the fertility clinic, maybe because of the gray in my hair. One old woman came up and said right in my ear that my baby was sure to be a monster." Charlotte laid a protective hand on the gentle curve of her belly, and Meg made a noise deep in her throat.

"No, I'm all right. A young man, a nurse or at least he was in whites, came out to rescue me. He said these people, the protesters, will stay home and mind their own business for a while, and then something new sets them off. He didn't know what had provoked them this time."

"Oh. I remember a fuss there some time ago," said Meg. "The trigger then was a news story about a clinic in southern California that gave people's embryos—extras, I suppose—to other infertile couples. Without permission."

Suddenly aware of the depth of her own weariness, she looked at

her watch, groaned, and eased herself up out of the chair. "Helping people make babies seems to be almost as controversial as helping them get rid of babies," she added. "Which suggests more about humanity than I care to contemplate right now. Charlotte, thank you for refuge and restoration. I'd better get under way while I'm still able to move."

"You'll need a coat. Let me get you something of Petey's." Charlotte went into the back hall and returned a moment later with a well-worn down jacket and a big paper bag for Meg's own bloody jacket. "Would you like to call Vince from here, to prepare him?"

"That would just give him more time to worry. Besides, I'm going to do what I should have done thirty minutes ago. I'm going to the police station to report the attack."

Charlotte opened her mouth and then closed it.

"Hah. You're right, Vince would do it for me. But I got myself into this stupid situation, and I'll deal with it like an ordinary citizen." She reached out to give her friend a gingerly hug. "Thanks, Charlotte. I'll talk to you tomorrow."

Handling the Porsche's fairly sensitive gears made Meg wonder just how much time she had before all her joints, or at least those on her right side, froze up completely. Better get her report over quickly, or she'd have to call Vince after all.

She parked on the street in front of the police station and climbed stiffly out of the low car. There was a light over the door, and another, dim, inside; but no one was behind the desk. She lifted the telephone from the wall next to the door, and after what seemed a lengthy wait a man's voice grated, "Grebs here. What's the problem?"

Not a name she knew, not a tone she cared for. "Margaret Halloran here, to report an assault."

"Uh. Just a minute."

The man who came through the inner door was tall and gangly, with narrow shoulders and a soft middle; thinning gray hair was combed straight back from his long-jawed face. He approached slowly, walking as if his feet hurt; once close, he peered through the glass pane at her for a long moment before pulling the door open. Probably to the wary eye of officialdom she looked more like a derelict than a schoolteacher.

"Look, lady," he said, "we got no policewoman on this shift. You better go to the hospital for examination, and then somebody will get the rest of your statement tomorrow."

It took Meg a moment to realize what he was thinking. "Officer Grebs, I wasn't raped." She felt her throat tighten as she spoke the could-have-been, what felt like the barely escaped. "I was punched and knocked down by a gang of hoodlums, near the library."

"Well." He let her in, then closed the door and gave her a follow-me gesture with his head as he set off in the direction he'd come from earlier.

She trailed him down a surprisingly silent hall and into the squad room with its islands of now-unoccupied desks. The wall clock said five minutes to midnight, which meant that third watch had been on the street for almost an hour. Nobody here, it seemed, but charming Officer Grebs. She tried to remember why she'd decided to come in rather than simply calling.

Grebs sat down behind a desk and pointed her to the chair beside it. She sat, with some care for her sore hip. "As I said, my name is Margaret Halloran, and I'm here because I interrupted an assault about—I'd say forty-five minutes ago. And then was attacked myself."

"That sort of thing is better left to the police, ma'am. Why didn't you call us at that time?" His expression disapproving, he pulled a form from a desk drawer and rolled it into the typewriter.

"Because it happened too fast. And then because the telephone there at the library had been vandalized."

"Um. Margaret Halloran," he muttered, picking the letters out with two fingers. "And where have you been in the—forty-five minutes, you said?—since then."

"I went to a friend's house, to get the bleeding from my nose stopped and to clean up a bit." To a more receptive listener she'd have confessed to confusion, fueled by fear and probably vanity. "I…didn't call 911, because I was safe and I knew the attackers had gotten away. But then I realized that patrol officers should be warned about these people because…because they were more than just rampaging kids. I think."

"Well. Let's see what we've got," he said in neutral tones. He turned his attention to the typewriter and took her through the

obvious questions. Name, address. Occupation. Location and time of events in question. He asked why she'd been there late at night and by herself, his expression suggesting that women should stay sensibly in their homes after sundown. Upon hearing that she'd come from having dinner with friends, he looked up with a scowl. "Did you consume any alcohol during the evening, ma'am?"

"Two glasses of wine in two hours," she snapped. "And one afterwards at my friend's house," she remembered belatedly, with a flush of wholly irrational guilt. "Could we get this over with, please? So that I can get home to bed."

As she described the attack on the derelict, Grebs shook his head and sighed. "People like that—drunks, dopers, crazies—they're the reason nobody is safe on the streets anymore."

"It wasn't the derelict who hit me," Meg pointed out.

"No, ma'am, I understand, but that kind just draw trouble like sh—...garbage draws flies. Now what can you tell me about the people who did hit you?"

She tried to marshal her few clear impressions. "I believe I saw five. The way they moved made me think they were young. All of them had on dark clothes, probably jeans and windbreakers; it was cold and misty. Running shoes," she added, remembering the fluorescent strip on one pair going away. "The one who hit me was very tall, the others were...just medium, I guess.

"And they all had on dark ski masks. That's what made me think they weren't just wandering teenagers."

"Probably Mexicans."

"I beg your pardon?"

"You know, illegals. The town's full of them, and so are the schools and the emergency room and maternity ward, because some officials can't decide to enforce that law we all passed a while back."

Meg had the feeling that she'd stepped into a parallel universe for the second time tonight. "You mean Prop 187? The illegal immigrants' initiative? Not we all, not me."

He ignored that. "Like I said, they come up here with no education, no English, take our jobs or go on welfare, got no idea how to behave around civilized, Christian people. Some folks are pretty sure it's illegals behind the vandalism and assaults been going on." He paused for breath. "You maybe got off lucky tonight, ma'am."

If she let go at this troglodyte now she'd lose it all and dissolve into a screaming, sobbing mess. And never get home to her bed. "The only uncivilized people I ran afoul of tonight were young men speaking plain American English," she told him. "The one who hit me had fair hair and light-colored eyes. And when he said, 'Oh fuck,' it was not with a Spanish accent."

With a visible flinch at the four-letter word, he muttered, "Yes ma'am," and turned away for a brief flurry of two-fingered typing.

Meg's bruises seemed to be pulsing right along with her heart-beat. She was wondering whether she should ask Officer Grebs for some aspirin when the door opened and a uniformed youngster poked his head in, his apple cheeks and baby-blue eyes vaguely familiar to Meg.

"Hey, Al, did you see the chief? I want to ask him about my application for DARE training."

"Chief's not here. Hasn't been in tonight, far as I know."

"But his little red bomb's out front. His Porsche," he added in explanation.

"Oh, that's mine," said Meg.

Both of them looked at her.

"I mean, it belongs to my husband. Vince Gutierrez. Chief Gutierrez."

"Oh, right," said the boy cop. Adam something, she thought his name was. "Sorry, ma'am. I didn't recognize you. Guess I'll have to catch the chief some other time."

As he sketched a salute and retreated, Meg realized that Officer Grebs had turned into a statue and seemed to be holding his breath as well. Now he exhaled loudly and Meg turned to meet his eyes.

"You said your name was Margaret Halloran."

"That's true. It is."

"But you're that widow woman Chief Gutierrez married. How come you didn't tell me that?"

She honestly had not realized, until near the end of their...conversation, if that's what it was...that he didn't know. Or that it mattered. Except of course it did, particularly in a small town. "I'm sorry. I was hurt and confused." And accustomed to acting for herself, not a fact that would charm Officer Grebs.

He took a deep breath, and blinked hard; there was a patch of red

over each cheekbone. "I hope, ma'am, that you won't feel anything I said was out of line."

"Officer Grebs, I'm sore and upset and tired. I hardly remember what you said. But I hope you'll let patrol know about these people."

"Yes ma'am, I'll do that. Now if you'd just sign this?" He pulled the statement from his machine and got to his feet. As she rose and reached to take the sheet of paper from his hand, she met his eyes again and knew that she had unwittingly made an enemy.

Chapter 2

"MEG? WOULD you like me to fix you some breakfast?"

Meg rolled over, caught her breath just short of a groan, and squinted at the face of her bedside clock: eight A.M. and a bit. She could hear rain on the roof, falling steadily but gently. And if she moved very gently, she could probably sit up. "No, thanks. Is Katy gone?"

"Yup. Vonnie Meager's mother collected her half an hour ago, for whatever it is they do early Thursdays."

"Thursday. A gym workout with the basketball coach. Strengths and moves, Katy calls it." Sitting up wasn't too bad, Meg decided. Probably if she took a deep breath first she could even stand.

"Here," said Vince, and reached out to take both her hands and help her to her feet.

"I was just going to do that by myself."

"Hey, what are husbands for?"

"For decoration." She tried to smile at him, trim and darkly handsome in navy slacks and a Dress Stewart plaid shirt; but stretching her mouth made her face hurt. "I need to call school. After I go to the bathroom."

He trailed her across the bedroom, apparently decided she could manage on her own, and stopped outside the bathroom door. "I called already," he said. "Told them you didn't feel well and wouldn't be in today."

"Um." Meg leaned on the counter and looked into the mirror. "Amend that to 'Ugh.' Even if I could walk without a cane, I wouldn't dare take this face into a high school classroom. Obscene speculation would occupy at least half of every hour."

"It doesn't look as bad as I expected."

"Um," she said again. "Vince, go downstairs. I'll come down in a few minutes."

"I'll help…"

"If that banister isn't up to my weight, it's probably time we found out."

Clean of face and teeth, she pulled on a set of fresh sweats and made her way carefully down the spiral staircase that led from their loft-bedroom to the kitchen. Vince, perched on a stool at the counter dividing kitchen from dining area, leaped to his feet and reached for a coffee mug.

"Vince. Thank you, but don't hover," she said as she settled onto her own stool. He blinked and then grinned at this last, a recent code phrase usually his: I love you but back off. "Apparently I landed hard on my right elbow and hip," she added, "but they don't feel too bad now that I've moved around a bit."

He took a deep breath and nodded. "So far, there's nothing on the bastards who jumped you. The street guy whose beating you interrupted hasn't turned up either; but when we do find him, he's not likely to be much help. Cops who've dealt with him say he's barely coherent even when he's not drunk or stoned."

"Pretty fast on his feet, though," she murmured, and lifted the steaming mug of coffee he'd set before her. Its intense aroma cleared her head and banished the sullen tang of blood lingering at the back of her throat.

"Lucky him," said Gutierrez. "And one other person was maybe lucky last night, except she probably doesn't see it that way yet." Anger, or frustration, hardened his face for a moment. "A U.C. professor who owns one of those new houses on the bluff south of town. She goes to Garberville Wednesday nights to teach a class, and usually stays over. Last night she decided to come home instead, got in about two A.M., and found that her house had been burglarized and thoroughly trashed. Obviously a gang effort, and it *could* have been the same crew you ran into."

Meg felt a little shiver of remembered fear, just a ripple across her shoulders and up the back of her neck, and took a sip of hot, very strong coffee. Mocha Java, she thought. Not quite as dark-tasting as French roast. "You mean she was lucky she didn't get home earlier."

He ran a hand over his short, grizzled hair. "I'm professionally

embarrassed to be calling that 'luck,' but yeah, that's what I mean. There have been eight occurrences in the past six weeks, in Port Silva or in the county nearby, of incidents of theft or vandalism or both. Committed, looks like, by kids or at least young guys. We've been working our butts off on this and have made next to no progress. Nobody's talking, none of the stolen stuff has turned up, nobody so far observed spending more money than usual."

Gutierrez frowned at the coffee mug still in his hand, drained it, and set it aside. "Last Friday night they jumped a couple of U.C. students near the campus, stole their expensive mountain bikes and backpacks, and then roughed the girl up just this side of rape. They're getting bolder and meaner each time, a bunch of macho jerks who've decided they're invincible and can do whatever they want."

"I see." This was a tale with a purpose, Meg knew, and she resisted the urge to protest that it was unnecessary. Against the cheerful plaid shirt, Vince's dark face looked tired for so early in the day; there were patches like bruises under his eyes, and the grooves that marked his cheeks were deep and shadowed.

"So what I need to ask you to do, now that you've had a night's sleep and a cup of coffee, is to put yourself mentally back on that dark street and tell me if there's anything else you remember about the people. Please."

She took the mug between her two hands and bent her head to its aroma. After a moment he said, "I had the report faxed to me this morning. You said the guy who hit you was maybe six-feet-six. Figure how you were standing and where he was and tell me if that's still good."

"I was—terrified. Shrinking away as he came at me. So maybe he was a normal six-two or -three instead of a giant. Sorry."

"Meg, fear affects perceptions, has to. Besides, Grebs is not the most imaginative questioner, which is why I'm putting you through this now, with apologies. What about other senses? Did you hear anything strange?"

"No. And believe me, all the time they were coming toward me I was praying to hear a passing person, or car."

"After the guy knocked you down, they all ran off. Did you hear a car start up?"

"Not right away. And the—I wasn't listening anymore. I was trying to get myself together and away from there."

"Okay, did you smell anything?"

Smell. After a moment she said, "Sweat. Probably from fear, the guy who hit me was frightened. Beer, used beer. Wet wool. And...Opium!"

"Opium?"

"The perfume, dummy. It's awful, I hate it."

"The tall guy was wearing perfume." Vince's voice was flat.

"I don't think so. I think it was somebody else in the group; you can probably smell that stuff a mile away. Vince, I guess I'm a sexist after all. It never occurred to me that one of them was a girl. But I bet one was. Is." For some reason this discovery shaped remembered fear into present anger, warming her face.

"Opens up new possibilities," he said, scribbling in his pocket notebook.

"Officer Grebs believes they were Mexicans," she said in a rush. Last night she'd kept the mean edge of the police-station exchange to herself. Now she reverted to adulthood and told the chief of police what he needed to know about his subordinate's behavior and attitude.

Vince surprised her with a grin. "Singe the old bastard's fur a bit, did you?"

"Vince. I tried to be, um, restrained."

"I bet. Anyway, don't worry about it." He looked at his watch and moved to the coat closet for his slicker. "Past eight-thirty already. Look, I can bring you some breakfast from Armino's. And then take you to your doctor. Or I could just bring Dr. Gabe back here and let him have a look at you."

Ah yes, Thursday morning and Vince's weekly breakfast date. "No, thanks. To both." Meg, who didn't care much for Dr. Gabe Ferrar, tried to keep her voice and her expression noncommittal. Vince loved the arrogant old man, and since his mother's death had made an effort to see him regularly. "I can find something to eat. And I'll call Edith later." Her own doctor, so unworldly as to make the odd house call.

"Well. Okay," he said. "I should be back at the station by ten at the latest. You need anything, just call and I'll come or I'll send

somebody. You ought to get some benefit from being married to the chief of police."

"You mean, in addition to all the other good stuff?"

This brought another grin. "Right. Now you be good, take it easy, and I'll see you tonight."

She heard a whine at the back door: her big dog. Big tough dog. "Vince, before you go, please let Grendel in."

Vince Gutierrez knew half a dozen places in Port Silva that served a good breakfast, but Armino's Bakery and Coffee Shop had one big advantage: the comforting aroma of baking bread. Besides, he'd been coming in here most of his life. Now he hung his slicker on the coat tree, ran a hand over hair dampened by the light rain, and nodded to the pretty, dark-haired girl who came to greet him. One of the current crop of young Arminos—Vicky, he thought.

"Hi, Chief Gutierrez. Dr. Gabe isn't here yet, but there's a window table open."

He followed her across the uneven, creaky wood floor, appreciating the swing of the solid little butt in the tight jeans: her mother's daughter for sure, and evidence that heredity could be a fine thing. Settling into the chair on the far side of the table, he nodded acceptance of "Coffee right away?" and turned his gaze to the misted, rain-streaked window in its frame of red-and-white checked curtains. The rain, heavier now, was likely to go on all day, and maybe Dr. Gabe had chosen to stay sensibly dry at home.

Maybe he should just get himself a newspaper and go ahead with his meal. He had half risen when he saw a long red hood slide into view on the other side of the street: Dr. Gabe's ancient Cadillac, and thank God there was a two-car space open over there. The old man shouldn't be driving, particularly on a day with such poor visibility; but no one in town, including the chief of police, had quite enough nerve to ask him to give up his license.

Gutierrez turned his gaze resolutely away from the window; he wasn't a traffic control officer, after all. He contemplated the menu without interruption from blaring horns or crunching metal, and a short time later the door swung wide and Dr. Gabriel Ferrar sailed in on a gust of rainy wind.

Vicky hurried to help Dr. Gabe out of his raincoat and old hat; he

boomed a thank-you at her and came across the room in strides only
faintly irregular, using his cane to motion two other customers out of
his way. At age eighty-five Dr. Gabe was still long-legged and barrel-
chested, although his height had shrunk an inch or two from its
original six-feet-five. He had a wild thatch of rusty-white hair and
fierce ice-blue eyes under troll's eyebrows; in the dim light, as long as
he didn't focus too hard, Gutierrez could still see the red-haired,
roaring giant of forty years ago.

"Damned rain makes me think I ought to bring charges against
that quack bastard who pinned my hip." He settled with some care
into his seat, then watched with undisguised pleasure as Vicky Armi-
no leaned across the table to pour his coffee cup full.

"Three eggs over easy, bacon, hash browns, and two biscuits," he
said, when she'd straightened. "Same for you?" he asked his table-
mate.

"Cut the eggs to two for me," said Gutierrez. "With toast instead
of biscuits."

Dr. Gabe watched the girl prance away, then sighed and reached
for his coffee cup. "Not near as much fun being a dirty old man as it
was being a dirty young one," he said. "And how about you, young
Vincent? You look a bit down-in-the-mouth to me; that handsome
wife of yours not taking proper care of your needs?"

"Listen, Meg does first-rate work when she gets the chance," said
Gutierrez, with a grin that faded as he remembered what his wife
had looked like this morning, and why. Catching Dr. Gabe's inquir-
ing eye, he told the old man in some detail about Meg's misadven-
ture of the night before.

They both fell silent as Vicky approached with a double armload
of plates; when she'd served them and left, Gutierrez picked up his
fork and stabbed viciously at the yolk of an egg. "You know what my
first thought was when she got home last night? That she was lucky
she wasn't raped. *Lucky!* I'm chief of bloody police in this damned
town," he muttered, "and I can't even keep my own wife safe on the
streets."

"Port Silva isn't a 'damned town,'" said Dr. Gabe, slathering butter
on a biscuit. "This is a mean, shitty time in the world, young Vince.
People who used to think of themselves as decent are hunkered down
trying to protect their own heads, and out on the street the bastards

are running around spitting and punching and polishing up the worst stuff in their various religions to use on each other. Yeats wrote a poem about times like this."

He piled strawberry jam atop the butter-dripping biscuit, took a big bite, and chewed thoughtfully for a moment. "That's another sad thing about getting real old. Been paying any attention, a person's likely to lose faith in the whole idea of progress. Human progress, anyway."

Gutierrez, nodding grim agreement, found to his surprise that he was hungry. After some time devoted to chewing and swallowing, he paused for a sip of coffee and looked around him. At a few minutes before nine A.M., in a room he recalled as always crowded from five until around ten, nearly half the tables were empty. The quality of the cooking had not changed, he could attest to that; and the prices were, if anything, a little lower. Unless a flock of new restaurants had opened in town without his notice, there were just fewer people out spending money for breakfast.

He mentioned his observations to his companion. "The good old jobs are gone. The timber industry has shot itself in all four feet, and as for fishing, I've heard there may not even be a commercial salmon season this year; the guys who haven't put their boats up for sale are trying to survive by running whale-watching trips."

"My granddaughter says the University of California has jacked up fees again, high enough so some people who expected to attend won't be able to. Including Jocelyn, unless Granddad helps out. All of which maybe explains the current run of hoodlum behavior," added Dr. Gabe. "But it doesn't excuse it."

"No," said Gutierrez, pushing his plate away and signaling to Vicky for more coffee. As she filled the cups and began to clear away the dishes, he remembered Meg's other story, of the people who had menaced Charlotte Birdsong the day before. "Did anyone tell you that the fertility clinic is being picketed again?" he asked, and when the old man shook his head, Gutierrez related what he knew of the events.

"Why, the trespassing sons of bitches!" Dr. Gabe's eyes glittered. "That hospital is still by God my own personal property! I'll put a load of birdshot in my twelve-gauge and go over there and blast their asses!"

Probably bluff. But with Dr. Gabe, you couldn't be absolutely
sure. "Never mind," Gutierrez said quickly. "We're taking care of it."
"You do that." Dr. Gabe sat back in his chair and shook his head.
"Shit, what I ought to do is sell the place," he went on with a gri-
mace. "It's nothing but a damned albatross around my neck. I don't
know why I let Jimmy talk me into it anyway, opening his clinic
there."

Family feelings, thought Gutierrez. Or guilt over the lack of
them. Dr. James Ferrar was a smallish, self-contained man who had
achieved a solid reputation as a fertility specialist. But in more than
fifty years of life, he had never managed to please his father.

Dr. Gabe, coffee cup in one hand, reached for the check and
waved Gutierrez to silence. "My turn. Thing is, I don't think much of
the fertility business—not in vitro fertilization, anyway, making ba-
bies in petri dishes for spoiled rich women. Or, my God, juicing up a
sixty-year-old uterus so it can gestate a donated egg. What a nefari-
ous use of training and skill! Gotta say I come close to agreeing
with the damned papists on this: seems to me an immoral kind of
tinkering."

Gutierrez frowned. "Gabe, I remember my mother saying, some
years ago, that you were the only doctor in town willing to perform
therapeutic abortions."

"Look here, young Vince. Abortions and birth control informa-
tion work to the benefit of the young, the poor, and the stupid. Folks
that need all the help they can get." He drained his cup and set it
down. "Funny thing, though. My boy Jim can't seem to make a good
living for himself even working with rich folks. He wants me to give
him the hospital, deed it right over to him."

The "hospital" had begun life as a big Victorian house on a large
sweep of ground near what was, in 1880 or so, the north end of
town. Dr. Gabe had bought the house in the late 1930s, had lived
there and seen patients there, had gradually remodeled and added
extensions to what became, finally, the Ferrar–Port Silva Hospital.
According to Gutierrez's mother, Dr. Gabe had run the place as a
virtual private kingdom until government regulations and insurance
strictures shut him firmly out of the hospital business and reduced
him to plain doctoring. He had given that up only three years ago,
after breaking his hip in a fall.

"Probably he just wants to relieve you of the responsibility," said Gutierrez. "It's an old place, must take a lot of upkeep."

"Probably he just wants to be able to knock it down for some glass-and-cedar monstrosity that would fit right in at Sea Ranch," snapped Dr. Gabe, referring to a carefully planned upscale development some miles south. "Or sell it; that's a prime piece of property."

When Gutierrez made no reply, Dr. Gabe let his square shoulders sag a bit. "Sorry, Vince, not your problem. Why d'you suppose we can send a man to the moon, and make babies in dishes, and still a father and son have to act like two bull elks in rut?"

"Gabe, I read somewhere that humans are the only animals that expect the males to tolerate each other across the generations."

The old man gave a bark of laughter. "Right you are, and it's expectation doomed to failure. Be glad you're raising a daughter. Listen, Vincent my boy, what I'd like to do is plan a trip up to Trinity County soon as the weather clears, to that woods camp Emily left you. We can take the .22s or maybe just the pistols, blow a few bottles off a few stumps, drink a little rum and play some cribbage. What do you say?"

Before Gutierrez had a chance to say anything, Vicky approached at a rapid pace. "Chief Gutierrez? Telephone."

Gutierrez pushed his chair back and hurried to the wall phone. He was back in a moment, shrugging on his slicker. "Gotta go. Thanks for breakfast, and next week is my turn."

"What's up?" Dr. Gabe used his cane to help himself upright.

Gutierrez blew out a long breath. This would not be a secret for long. "A fisherman called in to say he saw what looked like a body, just below the bluff at Pelican Point."

"What kind of body?"

"All we've verified so far is that it's where he said it was. Look, Gabe, I have to get out there."

"Could you use a little help? No, I suppose not," the old man added glumly.

"I don't think so. Not at that site, not in this weather. You go on home, and I'll be in touch."

"Yeah. Right."

Chapter 3

THE SOUTHWESTERLY hook of land called Pelican Point, part of a parcel privately owned but vacant, was a bleak expanse of gluey mud, ankle-deep potholes, and sodden, weedy grass. Gutierrez parked his unmarked white sedan at road's edge behind two black-and-whites and paused to change his leather boots for a black rubber pair, the kind worn by fisherman. As he slammed the trunk of his car, a knot of onlookers in the street spotted him and one called out; he simply nodded and continued on his course toward the edge of the bluff.

"Hey, you! You can't... Oh, hi, Chief." Officer "Hub" Hubbard, a watch cap covering his bald pate, made a brief effort to suck in the belly that made his yellow slicker resemble a maternity smock, but gave it up. He was past sixty, nearing retirement, and not really trying to fool anybody about being fifty pounds overweight.

Hub put a foot on the yellow tape to let Gutierrez step over. "Somebody had to stay here to chase off civilians, so I volunteered," he said.

"Fine, Hub. Is the doctor here yet?" The city had a contract with Good Samaritan Hospital to provide medical assistance.

"Nossir, not yet. There was several bad car smashes this morning, dumb outlanders driving too fast for the roads and the weather. Besides, I figure none of them doctors was crazy about the idea of climbing down a cliff face in the rain."

"Can't we get to the body from the beach access point just north of here?" asked Gutierrez.

"Nossir, 'cause there's just this piddly little strip of beach below Pelican Point, that you can't hardly get around the rocks to except at low tide. Which I believe won't be until around five this afternoon."

"I see. Too bad," Gutierrez said glumly, and set off across the mud, trying to keep to grassy patches and avoid adding footprints. No local person had been reported missing; the Coast Guard had had no word of a local boat down or in trouble. Shoving his hands deep into his pockets, he had the mean, selfish hope that the dead person was someone he didn't know, wouldn't recognize.

A Jeep wagon with a heavy-duty front bumper and a winch was nosed up to the edge of the bluff, its wheels chocked. Ray Chang's Jeep, Gutierrez thought; and at that moment the sergeant's head appeared over the edge of the bluff. Chang grabbed the bumper with one hand, reached out with the other for the arm extended by big Bob Englund, and surged to his feet on solid ground.

"Chief," said Chang, tossing back his heavy sheaf of wet black hair. He had two camera cases slung by straps around his neck.

"What do we have?" asked Gutierrez, approaching the edge to look down. The body was supine near the cliff face, bobbing in the restless surf as if somehow anchored there: long legs in dark pants, torso wrapped in muddy red, long dark hair floating around the head and partly obscuring the face.

"We have a woman who is dead. Just how she got that way will require some time and expertise to determine." When Chang was upset, he spoke rapidly but precisely, in dry, light tones that carried echoes of his Cantonese-speaking mother.

"Has she been in the water long?"

"No, sir, I don't believe so. She's rigid, her skin is still fairly tight, and the crabs haven't really gotten to her yet." Chang cleared his throat, turned aside to spit, then wiped his mouth with the back of his hand.

Gutierrez scanned the scene around them. This stretch of mud and grass was unprepossessing-looking, but it lay only about half a mile south of the shoreside municipal park that was home to Port Silva's post office, exhibition hall, and library. People, kids especially, came here a lot, to fly kites or hell around on dirt bikes. It seemed unlikely that the dead woman had been down there before dark yesterday; someone would have noticed her. "If she went in last night," he said slowly, "you'd think she'd have been taken out with the tide; it must have been high around midnight."

"Right, except whenever it was, she got a leg caught in the rocks

and didn't go anywhere." He opened a flap on one of the camera cases and pulled out a deck of Polaroid photos, which he handed to his boss. "She didn't have any identification. And I don't know that even her family would recognize her immediately."

Gutierrez turned his back on the wind-driven rain and sheltered the photos inside his open slicker as he shuffled through them. Several were for the scene, and the position of the body; then came close-ups. The face was so battered that only its general shape was evident: broad across the cheekbones, low of forehead with the hairline showing a faint widow's peak, jaw probably square. Her long hair was black, thick and straight.

"Her eyes are—were—dark, too," said Chang. "I'd say she's an adult but fairly young. With that hair, I thought at first she might be Asian, but she's large for an Asian woman—probably five-six or -seven, with big bones. So I figure, probably Hispanic."

Gutierrez made a noncommittal sound and stepped to the bluff edge again. This spot had not in his memory been used for suicide; the cliff was not high enough for a dependably fatal fall, the seastacks a barrier to being swept quickly out to deep water. But if she'd been new to the area, and desperate... "How soon can we get her up?"

Officer Bob Englund, who'd been listening in silence, now spoke up. "We can wait for dead low tide, and come across from the access behind the library. Or try bringing a boat in through those rocks. Or we can climb down, put her in a body bag, and winch her up."

"Well. Maybe I'll go down and have a look."

"Chief Gutierrez?" The call came from the direction of the street. Gutierrez turned to find Hub Hubbard trudging across the mud; following him was a tall figure in a blue two-piece rain suit, wheeling an expensive-looking mountain bike. And so much for preserving the scene, thought Gutierrez, irritated.

"Your girl called from downtown," said Hub. "Says the mayor wants to talk to you, his office at city hall at ten-thirty sharp. She said to remind you that you've got a clean uniform at the office, in case you don't want to go all the way home to change."

"Thank you," said Gutierrez stiffly. Alice Murphy had meant the message helpfully, he was sure. But Hubbard, old-style cop and local good ol' boy, was clearly pleased to view the exchange as an implied

calling-down of a citified boss who was too good to dress like a cop except on formal occasions.

Next to a meeting with Mayor Lindblad, Gutierrez thought scrambling up and down wet rocks would be a treat. And he really needed to get a close look at this woman. Besides, it would take three of them—two below and one on the winch—to bring the dead woman up.

"This fella here says he knows you," said Hub.

Gutierrez brought his thoughts back to Hubbard, and then looked past him to the second man, who had pushed his hood back and was reaching out a hand in greeting. He was William Ferrar, called Will or Willie; and in one of those generational leaps genes sometimes make, he was not neatly middle-sized like his father but well over six feet tall, big-boned and broad-shouldered, his face in its frame of curly light-brown hair a smoothed-down version of his grandfather's craggy features.

". . . says he's a medic or somethin' like," Hub was saying.

"Hi, Chief Gutierrez."

Gutierrez reached out to shake the extended hand. Not a doctor, Willie, but a nurse. He was also, according to his grandfather, an athletic outdoorsman: skier, surfer, hiker, and rock-climber. Like Dr. Gabe, he didn't look his age; somewhere near thirty, he had the expectant, what-next? look of a teenager.

"I was out for a ride, get some exercise before going to work," he said, still ruddy-faced and breathing deeply. "Then I heard one of the guys out in the street say somebody had gone over the edge here. Can I do anything to help?"

Gutierrez looked at his watch and accepted his fate. "Will, I believe you can. Come over here and let me introduce you."

Five minutes later Gutierrez was on his way to the office. If he hurried, he could change clothes, call to check on Meg, and still get to the mayor more or less on time.

Chapter 4

"SENT HER OFF to Good Sam already," said Hub Hubbard an hour and a half later, bending to speak into the window of Gutierrez's car. "I'm still here to keep the civilians off so's the sergeant can finish looking the place over for evidence or whatever."

"I see." The onlookers at Pelican Point had dwindled to half a dozen, all of them staying outside the yellow tape. Ray Chang and Bob Englund, now busy with camera and measuring tape near the edge of the bluff, didn't need his help.

"I just want to say I'm real sorry, Chief," said Hub.

"Sorry? For what?"

"I hear that poor dead woman was one of your people."

"One of... Ah. Officer Hubbard, anybody murdered in this town is one of my people. One of yours, too." He rolled the window up and pulled out into the street.

Vincent Gutierrez was the middle child of seven born to a Mexican American father and an Anglo mother. His father had traveled in South and Central America as a mining engineer; his mother had settled in Port Silva to raise their brood and to run things: the school board, the library board, the historical society.

But Emily Butler Gutierrez had died six months ago; and as the town's memory of her faded, her son the police chief seemed to be turning into just another brown guy with one of those names. In some eyes, anyway.

From an objective point of view the circumstance might be called interesting, thought Gutierrez, as he pulled into the parking lot at Good Samaritan Hospital. From the viewpoint of a busy cop who wanted to get his job done, it could turn out to be a serious, complicated distraction and a general pain in the butt.

Gutierrez stepped out into the misty rain, not bothering to put on his hat; he locked the white sedan and simply stood there for a moment, looking at the building to which he'd paid far too many visits over the last year. The main structure, three stories of gray stone and pebbly gray stucco built in the Thirties, had a vaguely ecclesiastical look in keeping with its beginnings as a Catholic hospital. Rain suited it, dripping mournfully off cornices and leaving dark streaks on the stucco.

Flanking wings, added many years later, were lower and friendlier, smooth cream-painted stucco with green trim and green shrubs gleaming wetly against the walls. Hank Svoboda, his police captain and good friend, was there in the right-hand wing, light spilling from his window onto the shrubs. Gutierrez hunched his shoulders and headed not for the big front doors but for the steps to the left of them, leading down to a basement entrance. The dead woman first; then he'd look in on Hank.

Inside he paused to shake water from his slicker before setting off down the brightly lighted corridor to the room at the very end. There he peered through a window, then rapped once on the right half of the set of doors before pushing it open. The middle-aged doctor who worked as pathologist for the western section of the county said, "Yes, yes," irritably, but kept his eyes and his attention on the form on the high metal table. The sweep of wet black hair hanging over the edge of the table struck Gutierrez as incongruously vital in this place of death.

"Dr. Munroe?"

"Chief Gutierrez, you're just in time. Come have a look."

Terrific. Gutierrez stepped forward and swept the naked figure with a reluctant glance that noted breadth at shoulder and hip; long, smoothly muscled arms and legs; breasts that were flattened in this supine position but upright, swinging free, had probably drawn admiring glances. Whoever she was, she'd had a good strong body, meant for another forty or fifty years of work and pleasure; the surge of bile at the back of his throat came not from squeamishness but from pity and rage.

He swallowed, gulped a couple of deep breaths, and looked again. After the swollen, battered face, the most noticeable injury was to the right leg, bent from the knee at an unnatural angle by the rocks that

had held her and the sea that had pulled at her. Once past that, Gutierrez noted that much of the woman's body looked bruised, as if someone had worked her over with fists. Probably not, probably sea and rocks did that damage, too.

"How old do you think she was?"

"Mm, early- to mid-twenties. Less than thirty."

Apart from the bruising her skin was olive in tone, several shades darker than his own; the pubic bush and faint lines of body hair were black, the nipples large and brown. There wasn't much extra flesh over the ribs—Gutierrez saw a depression there, probably one or two ribs broken—but he noticed with a jolt that the belly was slightly rounded, its skin loose-looking.

"Was she pregnant?" he asked.

The doctor shook his head. "I've already photographed and x-rayed her, and there's no fetus. But it's clear from the stretch marks and enlarged nipples that she has borne a child, or children, and nursed them."

So she'd left children. Probably, from her own relative youth, young children. "Can you tell yet whether she drowned?"

"You'll have to wait for the full P.M. on that. But from the bruises on her neck, I'd say somebody had a good try at strangling her to death manually, and maybe succeeded. Poor woman had a hard few days, looks like."

So, not a suicide. Somehow Gutierrez wasn't surprised. He'd have to get in touch with his troops, tell them to widen the angle of their... Belatedly, he registered the doctor's last remark. "*Few* days?"

"Quite a lot of the bruising, on her face as well as her body, looks to me to be two or three days old. But she hasn't been dead that long; say ten or twelve hours."

"So somebody really worked her over, and then came around later, same guy or somebody else, and finished the job. And threw her in the water."

"So it appears. I'd say this lady didn't keep very good company," added Dr. Munroe, with what Gutierrez thought was a ghoulish cheerfulness.

"Was she raped?"

"Probably not on the second pass, anyway. There's bruising in the pelvic area and on the thighs, see there?" he said, and laid two

plastic-gloved fingers gently on the woman's inner thigh. "That's consistent with rape or at least rough sex; but it didn't happen last night. And that's about all I can tell you until I lift the hood and take a look inside."

"Will you do that now?" Gutierrez asked.

Munroe shook his head. "I have two bodies the sheriff sent in, old people who probably died of natural causes but were alone at the time and hadn't been under a doctor's care. I've scheduled this young lady for tomorrow morning. If I find anything startling I'll try to remember to call you. Otherwise, you can call here in the afternoon."

Gutierrez considered pushing for priority, but decided it wasn't worth the fuss. "We'll be in touch, then. Thanks."

Plodding head-down along the bright but quiet hallway, Gutierrez heard a deep sigh and admitted, after a moment, that it was his own. One of those little involuntary signals that he was feeling low and useless, but at least today there was reason. What he really wanted to do was protest this latest outrage with a good loud noise, just throw back his head and howl. Not a terrific idea here, however; orderlies would probably spring from behind closed doors and slap restraints on him.

He climbed the stairs to the main-floor lobby, where the hands of the big clock over the desk pointed straight up. He was tensing himself in anticipation of the noon whistle's blast when he remembered, sadly, that with the lumber mill's purportedly temporary shut-down, that long-familiar sound no longer measured Port Silva's days.

Nevertheless, it was lunch time. He was a little embarrassed to find himself hungry, and decided he'd think about that after he'd called Chang with the latest on the dead woman; and after he'd seen Hank Svoboda. He hoped his savviest colleague was well enough to have his brain picked; murder was presently Gutierrez's most dramatic professional problem, but it was far from the only one.

The door to Hank's room was ajar. Gutierrez listened, heard nothing, pushed the door wider, and stepped inside to find the nearest bed empty, covers thrown back.

"He didn't die, just got hauled off for therapy. I'm sorry to say," added Hank Svoboda in a thinned-out version of his usual deep

voice. "Most boring guy I ever run into. Come on in, Vince."

Gutierrez stepped inside, then turned to close the door behind him.

"The man has described to me, in great detail, the particulars of every Ford engine he's ever owned or driven," said Hank. "And he's seventy years old."

"How are you, old buddy?" asked Gutierrez. Intending to reach out for a handshake, he instead leaned over the bed to hug the pale, rawboned ghost of his best friend. Partly in greeting, he thought, partly to assure himself Hank was still warm. "You look like hell," he said as he stepped back.

"Good. That's the way I feel. But the nurses say I'm gettin' irritable, which I guess is a good sign. What's happening in the real world?" Svoboda settled his bony shoulders back against his pillows and put on a hopeful look.

Gutierrez pulled up a chair. "To hit the boring stuff first, the stuff you'll be glad you missed, I'll tell you about the very long hour I just spent with our mayor." Mayor Lyle Lindblad was a local boy, a sheep-rancher's son who had abandoned the lambing pens and dipping vats to make his living as an independent insurance agent in town. He had hearty blond good looks, a deep, warm voice, a sincere handshake, and political ambitions.

"Ol' Lyle's problem," said Svoboda, "is, he spent his formative years in the company of sheep."

"Here's his current agenda. Along with the local merchants, he wants the recent wave of vandalism, robbery, and random assaults stopped *now*. Along with local homeowners, he wants response time to 911 calls cut in half, now. He wants more officers on patrol, including those presently being 'wasted' as a domestic-violence response team or supervisor/instructors at the youth center."

Svoboda groaned.

"Right. But if we do all that, fast, maybe he can talk the city council out of cutting the police budget for the next fiscal year by fifteen percent."

"Vince, that's not boring. That's scary."

"True. But it's the least of our problems at the moment." Gutierrez slid lower in his chair, seeing in his mind's eye the bruised body, the battered face, the spill of black hair. "We've got what looks like a

murder. Young woman as yet unidentified; we pulled her out of the water below Pelican Point this morning."

"Shit," said Svoboda, and Gutierrez was horrified to see tears well up in the pale blue eyes.

"Sorry," said Svoboda, and blinked hard several times. "I'm so goddamned weak, I get weepy if a bird makes a suicide smash against my window there. Pneumonia, not senility. I think."

"All we know so far is that she was beaten and possibly throttled before she went into the water, and that she's maybe Hispanic. When there's more information, I'll let you know. But right now, I need your take on some local bad actors." Gutierrez had spent his childhood and adolescence in Port Silva, but after graduating from high school had paid only once-or-twice-yearly familial visits here until returning for good ten years ago; Hank Svoboda, born here, had stayed except for a stint in the navy.

Gutierrez pulled a folded sheet of paper from his pocket and handed it to Svoboda. "What started out, or at least looked like, opportunistic vandalism by kids is getting heavier," he said. "More stuff, marketable stuff, is being stolen, and there's more physical violence involved." He decided to skip the story of the assault on Meg for the moment; it would upset Hank almost as much as it had him.

"And you think somebody besides kids might be involved," said Svoboda, scanning the list.

"It struck me as a possibility. So I had Johnny Hebert pull up the names of local guys who'd been in fairly serious trouble and were still around or had come back."

"Mm. Apodaca was more a feisty little scrapper than a crook. And I hear he's married some Finnish girl from upcoast who's keeping him busy. Tommy Griswold got saved last year, and when I ran into his mother at church a couple months ago, she told me it took this time, he's a real born-again and working in Willits.

"But Doug Hamm, now—he's as mean as everybody else in that family, and he spent some time hanging around in Sacramento, I think, after he did two years in Susanville for setting fire to this fishing boat after the boat's owner punched him out in a bar. He could've made connections for gettin' rid of stuff. I'd put him at the top of my list."

"Done."

"Micky Marino did a stint in Susanville, too, for runnin' down his girlfriend with his car; then he came back and went to fishing. But I heard his old man lost their boat, so probably Micky's out of work. Ev Olson was another bad guy, but now he's got that stiff leg from a motorcycle smash when he was said to be pushing something or other in San Francisco. I think he's staying home now with his kids; his wife is that big blonde who waits tables at Hungry Wheels."

Hank folded the list and handed it back. "Bo Tetter I can't offer an opinion on. In high school he was a guy to get real rough with girls, and my youngest daughter didn't have great judgment at that time. I took my badge off and beat him to a bloody pulp, and nobody's mentioned his name in my hearing since."

"Sorry," said Gutierrez. He was penciling notes on the list when the door opened and a nurse came in, followed by an orderly with a tray.

"Lunch time," she said cheerily, and Svoboda groaned.

"I'd better get moving," said Gutierrez. "Thanks, Hank. I'll be in touch."

"You better be," said Svoboda.

Spirits lifted by the knowledge that Hank was recovering, however slowly, Gutierrez decided to forgo lunch and head for the office instead, get right to work on some of the problems that had the mayor running off cliffs in all directions. He reached the lobby, turned to make for the door, and ran head-on—chest-on, actually—into a familiar figure.

"Oops," he said, gripping the other's shoulders to steady him. "Sorry, Jimmy. James."

Dr. James Ferrar shook his head, a smile warming his austere face. "Jimmy's okay, Vince. That's the price for coming home; everybody remembers you with gaps in your teeth."

"Is that my problem?" wondered Gutierrez aloud.

"Or in your case, with a bloody nose and clenched fists," added Dr. Gabe's middle-aged son.

Gutierrez made a mental note to pass this memory on to Meg as one more thing that he and she had in common. "So what's up? You have patients here?"

James shook his head. "Not today. I just stopped by to tell the

Nazi who runs this hospital what I think of him. He'll be lucky if I don't..." He stopped short and jerked his chin up sharply, fixing a narrowed, assessing gaze on the uniform under Gutierrez's open slicker. "I need to talk to you, too."

"To me?"

"To the chief of police." He glanced at his watch. "It's lunch time and I was about to go across the street for a sandwich. Perhaps you could join me?"

Gutierrez didn't want to have lunch with James Ferrar, not now or ever one of his buddies. He wanted to go to work and play Nazi himself, kick butt in several cases where it was overdue. "Okay. I can only spare about forty-five minutes, though."

Eddie's was another Port Silva institution, a bar and sandwich shop with dark wood floors, bare wooden tables, and unpadded captain's chairs. You could probably take in a week's worth of cholesterol in a single sitting, and the only salad ever on the menu was coleslaw. Gutierrez ordered a ham sandwich and a bowl of beans, with a mug of Sierra Nevada pale ale; James asked for the same, and then excused himself to go to the rest room.

Gutierrez watched him pick his way across the room, a slightly built man no more than five-feet-seven or -eight with high, tight shoulders and a narrow head lightly thatched with fine gray-brown hair. James's trousers, miraculously free of mud splatters, were an off-shade of pale brown that probably had a name, his rainwear not a slicker but something British-looking with buckles and straps. Did he think dressing well would finally, at long last, win his father's approval? Or did he still care?

Probably he did, thought Gutierrez glumly, and reached for his mug of beer as soon as it was set before him. He himself still felt guilty, after almost forty years. At twelve, his own father dead and his older brother gone from home, Vince Gutierrez was skinny, fast, fierce—and lonely. He had set himself to win the admiration and affection of the most interesting man he knew, Dr. Gabe Ferrar; and in the process had elbowed aside one-year-older Jimmy, a pale, quiet boy who lived in San Francisco with his divorced mother and saw his father only on holidays and summer vacations.

Over the rim of the frosted mug, Gutierrez watched James coming back across the room. The father and son rupture had probably

been inevitable, but he had played his hungry part in it. He wished he could regret the old man, or like the younger one better now.

James and the food arrived at the table together. Gutierrez picked up his sandwich, thick slices of succulent ham on a large hamburger-style bun, and was nearly halfway through it before the silence began to get to him. Why had the guy asked him to lunch, anyway? He swallowed and said, heartily, "So how's the fertility business?"

"Burgeoning," said James, and Gutierrez choked over his beer mug. James waited politely until he had regained his composure.

"I want to register yet another protest, as officially as possible, about the behavior of local citizens at my clinic. It's indecent," he added, and lifted his mug for a good mouthful of beer.

"We're aware that you had demonstrators again yesterday," said Gutierrez mildly. "And the men patrolling that beat have been alerted to the problem."

"Why me, for God's sake?" James snarled, and took another swig of beer. "As I've told everyone who would listen, all I do at my clinic is help people—married couples—who desperately want to have a baby. And very conservatively at that; if donation is involved, we use semen from the most carefully controlled sperm bank in the state, donor eggs from women who have had successful pregnancies, surrogacy only within a family. No 'clonning', as one idiot misspelled it on his sign; in practical human circumstances, I wouldn't know how.

"It's harassment pure and simple," he added vehemently, "and I want it stopped. For good." James cut his ham sandwich in two and went to work on one half, biting and chewing as if eating were an assigned task that didn't interest him much.

"So long as protesters keep back the prescribed distance, and don't interfere with passage of people along the sidewalk or into the clinic, they're within their rights to be there."

"And what about the rights of my patients?" demanded James. He put the sandwich aside and picked up his beer mug again. "I am dealing with couples who have been trying for long, hard years to conceive a child. Their very presence at my clinic is an admission of failure of the most personal kind."

"I understand, but..."

"I seriously doubt that you do. One of my patients yesterday was a woman there to receive the two good embryos achieved from the

eggs we'd coaxed from her single remaining ovary. This was her fourth and probably last attempt at pregnancy. All perfectly legal, and by most people's lights moral as well. Hectoring, terrorizing, a woman in her situation is absolutely indecent."

"I agree," said Gutierrez quietly. "And I'll do what I can, within the limits of the law. For instance, I can arrange to have an officer available to escort patients you think need that kind of support."

"Well. For the moment, I suppose, that will have to do." James tipped his head, as if to catch and review his own words. "Sorry, that was ungracious. I appreciate your help, and I'll call when we need escorts."

"I'll see that the necessary people know what's up," said Gutierrez. He finished the last of his sandwich, and then remembered James's earlier remark. "What kind of Nazi activity are you running into across the street here, anyway?"

"Sometimes a patient of mine needs to be attended to in a fully accredited hospital," James said, and paused for a bite of his own sandwich. Gutierrez waited.

"And Good Samaritan is still run by people who were associated with it when it was a Catholic institution. Recently I wanted to admit a woman who would undergo selective reduction of an impossible multiple pregnancy, and the administrator, Brian Hollings, refused to permit it."

"Selective reduction?" Gutierrez thought this had the sound of major euphemism.

"This patient produced five good embryos on her second IVF cycle. Because she was nearly forty, we agreed to transfer all of them; and against our expectations, all survived. We wanted to do injections, under ultrasound, to reduce the number to something manageable."

"Oh. Abortion," said Gutierrez.

"That's the simpleminded view," said James quietly. "I don't as a rule perform abortions. But the McCaughey septuplets notwithstanding, the statistics on multiple pregnancies are dire. I gave this patient my best professional opinion, that her chances of bringing five babies anywhere near term and healthy were virtually nil."

Simpleminded was a fair enough term, Gutierrez conceded. "So what happened to her?"

"I sent her to a colleague in Sacramento. She's continuing her pregnancy with two fetuses."

Gutierrez tried to get his mind around this dilemma. Try and try and probably pray and pray, and Eureka! Five babies. Potential babies. Three of which—of whom—any kind of good sense directs you to eliminate. Do you wonder, later, about those three? Who they might have been? Spooning up beans, he cast a look at the expressionless face opposite: did Jimmy Ferrar agonize over these circumstances with his patients, sweat their decisions? Or did he simply lay out the possibilities and go on to the next case?

"And as a result of that bastard Hollings's loose mouth, those idiots picketing my clinic today were waving anti-abortion signs and pictures as well as their usual crap about 'meddling in God's work.' Disgusting!"

Immoral tinkering, Dr. Gabe had called it. No wonder these two didn't get along.

"Did my father tell you I'm trying to cheat an old man out of his property?"

"What?" Gutierrez set his spoon down and met the chilly brown stare.

"I drove by Armino's on my way to the clinic this morning, and I saw the pair of you in the window."

"Dr. Gabe and I get together for breakfast most Thursdays," Gutierrez said stiffly.

"I know. And I know he enjoys your company and values your opinions. Vince, I'm not trying to cheat him in any way. If that building were in my name, I could get the necessary loans for renovation. I could set about getting hospital accreditation, which would free me from having to dicker with Good Sam over every procedure."

"He, um, does think you're pushing him. I guess it's a power issue—the big luxury car he's always driven, the hospital he built himself. Old people can be stubborn about giving things up." In the past year Gutierrez had learned more than he wanted to know about this subject; and he hated thinking of Dr. Gabe in these terms.

"My father is eighty-five years old and doesn't believe he's ever going to die," said James crisply. He gestured to the waiter for another beer; Gutierrez caught the man's eye and shook his head.

"And I certainly hope he won't, for a while yet; there's no reason he shouldn't live to be a hundred," James went on. "But in the meantime that building is decaying, he won't do anything about it, and I can't afford to pay him what he insists it's worth."

He's jerking you around, another thing they do. "I think," said Gutierrez carefully, "he has a problem with your kind of medicine. Maybe he's just too old."

"You know, I didn't want to be a physician," said James in conversational tones. The waiter set a full frosted mug before him and he picked it up for a drink. "I was a senior in high school when Watson and Crick and Wilkins won the Nobel for discovery of the molecular structure of DNA; and I decided then and there that I'd be a pure scientist, a molecular biologist. I already knew that I was happier in the lab than with people.

"But when I finished my B.S., my father said there was money only for medical school; otherwise I could go out and look for a job." He took another drink from the mug, keeping his eyes locked with Gutierrez's. "So I went to med school, and I was lucky enough to find a specialty that uses my skills and makes my personal inadequacies less important.

"When my father broke his hip three years ago and I came up from Sacramento to help him, I thought the move was temporary. But I found that I like living here, and so do Will and Jocelyn," he added. "Besides, coming to a beautiful, relatively remote place like Port Silva seems to work well for my patients. With a decent facility, I'd add staff, and Marilyn and I—my embryologist, Marilyn Wu, is incredibly talented and skillful—could…"

James sat forward, eyes gleaming. "For instance, there've been recent exciting advances in solving *male* infertility. If a man, for various reasons, has no viable sperm in his semen, it's sometimes possible to take sperm directly from the testes. And while this was initially done by slicing the testicle open, which was painful and expensive, now there's a new technique involving a fine-needle aspiration, much simpler and cheaper. Then we inject the sperm directly into the egg, and…"

As Gutierrez resisted a strong urge to cross his legs, James closed his mouth and flushed slightly, embarrassed by his own enthusiasm. After a moment, he said, quietly, "I would eventually have more work

than I could handle and be able to pay my father back. So I don't think what I'm asking him for is unreasonable."

Gutierrez frowned. "Your father is my friend. I don't tell him what he should do with his life or his family."

James said nothing, didn't even blink.

"But if he should ask me, I'll tell him that the plans you talked to me about seem—worth considering."

James's smile was, for him, a grin. "Thank you. I hope he hears you. What were *you* doing at the hospital today? Do you have someone who's ill?"

"No. Well, I do, but that's not what I was there about. We took a dead woman off the rocks below Pelican Point this morning. I was there to talk to Dr. Munroe, the pathologist."

"Accident?"

"We won't know for sure until after the postmortem."

"Was she a local woman?"

"We don't know that yet, either." Gutierrez described the woman, feeling his anger return as he spoke. Too bad he had to go to work; he'd be the better for another beer. Glancing enviously at James's half-full mug, he noted the clenched, two-handed grip, and realized that the other man was sitting very still.

"Do you know her?" Gutierrez asked quickly, leaning forward. "Tall? Maybe twenty-five years old?"

"I...since I opened the clinic, we've employed a number of Mexican or Central American cleaning women." He met Gutierrez's gaze and flushed slightly.

"James, I'm not doing the INS's work for them."

"We employed them through an agency; their documentation was the owner's responsibility. Anyway, I hope I'm wrong, but the woman you describe sounds like Espy. Esperanza Moreno," he added. "She was a good worker, more efficient than most of the others. Smarter and better-looking, too—a handsome young woman."

"*Was?* You mean she hasn't worked for you recently?"

"I...don't think so. We simply contract with the cleaning agency for a given number of workers; we don't specify individual women or keep records on them."

Bullshit, thought Gutierrez. Or at least evasion. "But you knew Ms. Moreno, even knew her nickname."

James tightened his shoulders and tucked his chin close. "*Mrs.* Moreno, I believe she was. Is. We keep irregular hours at the clinic: various procedures must be performed not just when it's convenient but a given, specific amount of time after, say, an injection. So the cleaners sometimes work while we're working." He picked up his mug of beer and took a sip.

"Anyway, as I've said, Espy was an appealing person—bright, cheerful, and eager to make a better life for herself and her children. We chatted now and then, and when she told me she was interested in practical nursing, I gave her some things to read, and talked to her about possibilities." He lifted the mug again and drained it in several long swallows.

Gutierrez said nothing, too much the policeman to break into the flow.

James set the mug down. "Anyway, I got busy, and one day I realized it had been some time since I'd seen her. I guess I assumed she'd found a better job, or perhaps gone off to study nursing. That's what happened, surely, and the woman you've found is someone with a superficial resemblance to her."

"I guess we'd better go across the street and have a look." Gutierrez pushed his chair back and got to his feet as he spoke. After a long moment James stood up as well.

"Yes, I suppose we should. Just to make sure."

Chapter 5

ALTHOUGH SHE HAD awakened several times during the night, to take aspirin or simply to reposition her aching body, Meg had somehow managed to sleep through both Gutierrez's coming to bed (very late) and his getting up (very early, she suspected). It was now almost eight-fifteen; and although she could hear noises downstairs, she was quite sure they were not of her husband's making. Not unless he had suddenly acquired a taste for what she thought was called grunge rock, played very loud.

Meg dragged herself upright and out of bed, finding as she had expected that the second day was worse than the first. This was a middle-aged phenomenon, and one she resented more than gray hair or crow's-feet. She looked worse, too, she learned from the bathroom mirror. Damned good thing she'd called school yesterday afternoon to advise them she'd need a second day of sick leave.

Not much she could do about her looks: two black eyes and a swollen bruise that spread in both directions from the bridge of her nose. But moving her body became easier as she did more of it; by the time she'd dabbed a washcloth gingerly at her face, brushed her teeth, and pulled on a robe, she figured she could handle the world or at least her own short staircase. And her own daughter.

Several creaky moments later she stepped into the kitchen and snapped, "Turn that off!"

Katy jumped, said, "Oh shit!" and reached under the counter to silence the stereo receiver. "I'm sorry, Mom, I guess I just thought you were..." She turned, looked at her mother's face, and said, softly, "Oooh, yuk."

"'Oh, you poor thing, how may I help you?' might be more appropriate," said Meg.

"Oh you poor thing can I make you a cup of coffee?" offered Katy, moving to the stove to turn on the flame under the kettle. "See, I thought you'd gone to work. I forgot you were hurt."

You forgot I exist, thought Meg. Perfectly normal attitude for a fourteen-year-old high school freshman. "Yes, please, I'd love you to make me a cup of coffee," she said, and climbed onto one of the tall stools beside the counter where Katy had been standing to eat— yogurt, Meg noted. With homemade granola and raisins. Made her teeth ache to think of it. "And good morning, Grendel," she said to her dog, who came to lay his shaggy white head in her lap. "Ouch. Please do not nudge.

"Did you see Vince?" she asked, as Katy put a scoop of fine-ground coffee into the one-cup filter.

"Uh-uh. I heard the door close right after my alarm went off, and he was down the driveway before I could even get to my door to wave. But he left you a note."

The message board was on the wall at the end of the counter, just over the telephone. "7:15—gotta get to work, shit piling up on several fronts. Take it easy today, and call if you need anything. Love and kisses, VG."

"Love and kisses," said Katy with a snicker. "Vince is getting mushy."

"And why not? Marriage is supposed to be mushy."

Katy didn't answer, using all her concentration to pour steaming water into the filter cone. She waited a moment, added more water, and then set cup and filter in front of her mother. "I guess he's working on this murder?"

"Probably." Meg stifled a yawn as she set the now-drained filter cone in the counter sink. Vince had been at home only briefly the evening before, to see how she was feeling and to grab a bite to eat before the city council meeting. He'd been reluctant to talk about the apparent murder, and she, deep in her own irritable discomfort, hadn't been interested enough to push him. "Did you hear about the murder at school yesterday?"

"A little. But more in the paper today," she said, gesturing toward the copy of the Port Silva *Sentinel* that was spread out by her yogurt bowl. "It sounds really sad. She—the lady who got killed—had a couple of little kids. I don't want to even *think* about them."

"Nor do I, Katy. Let's not." Meg pulled the paper to her side of the counter.

"Jesús and Angel must have known her, the dead lady; they live in that motel, too, that place down on Hyde Street. I wonder if they'll be in school today?"

"Who?"

"These two Mexican guys at school—at least, I guess they're Mexican. Their last name is Gonzales, and they speak Spanish. All the girls just grab each other and go, 'Lust! lust!' whenever Jesús or Angel walks by. They're just these incredibly sexy studs." Katy rolled her eyes and pretended to fan her face with both hands.

"I can imagine," said Meg, who had lusted after a sexy Mexican stud or two in her own long-ago high school days in Arizona. Although if she'd used those exact words, her mother would have fainted. "Katy, it's getting close to bus time."

As Katy groaned and swept her breakfast leavings from table to sink, Meg sipped cautiously at hot coffee and read the front page. Esperanza Moreno, Mrs. Rubén Moreno, found dead below Pelican Point Thursday morning, had been beaten and apparently strangled, probably on Wednesday night; postmortem results were still to come. Mrs. Moreno, believed to be a Mexican citizen, had lived in the Winner's Circle Motel, home to a number of Spanish-speaking persons. She had two small children, a boy and a girl. The whereabouts of the children and of Rubén Moreno were not yet known to the *Sentinel* staff. The Port Silva Police Department was pursuing a vigorous investigation, and the *Sentinel* would report any results as soon as they were available.

"Um?" Reading, Meg had apparently missed some request of her daughter's.

"The dance tonight," Katy said with a dramatic sigh and another roll of her eyes, heavenward this time as if in supplication. "At school. Charlie Silveira can drive us, but then he has a date. I told the kids maybe you—or Vince?—could bring us home."

"Oh, Katy, I'm not sure. God knows what time Vince will get home, if at all, and I…what time would it be?"

"Maybe eleven. Like I said, I forgot you were hurt. Probably you shouldn't be up that late. There is this one guy," Katy said slowly, "who has his own car. He actually asked me to go just with him."

"Heh heh heh," said Meg. Tall, slim Katy, with her cap of thick dark hair and her lushly fringed electric-blue eyes, was on the verge of turning into a knockout, a fact which made her doting stepfather increasingly nervous. "Whoever he is, you don't get in his car until Vince checks his driving record, his medical history, his grades, and probably his teeth. I'll drag myself out, baby. Who are the other kids?"

"Pete and Kimmie and Jason and Vonnie and Eddie."

Katy and her friends still led their social lives in groups; but Meg noted that tonight's group was gender-balanced. Interesting. "I can handle that many, if I get the van out," she said. "We can settle the details tonight at supper. Now you'd better scoot, kid, or you'll miss the bus."

"*Quel dommage!*" said Katy, who was in her second semester of French. "See you tonight, Mom. You take it easy."

Face too sore for her usual toasted bagel, Meg scrambled two eggs, topped them with salsa, and read the rest of the news story as she ate. Esperanza Moreno had lived in Port Silva for more than a year, and had worked for A-One Home and Office Cleaners. Ed Morgan, owner of A-One, expressed sorrow at her fate and declared that she had been one of his best employees. "Hard worker and real honest," said Mr. Morgan. "Spoke real good English, too."

"So how's your Spanish, Eduardo?" muttered Meg. And what about her kids? Where were they? Meg, and Katy with her, had spent a long, worried week the previous summer trying to make life normal for two children whose mother had disappeared…temporarily, it had turned out. Even if the Moreno children were safe somewhere, she knew too well how painfully different their lives would now be.

Equally clear was her sense of how Vince must be feeling. Not a naturally peaceful, contemplative soul like Dan Halloran, Meg's first husband, Vince Gutierrez was a volatile man who had taught himself to control his own temper; he was offended when others couldn't or wouldn't do the same. Murder, in the town he loved and served, was to him the ultimate insult. Vince would be suffering.

Her eyes fell on the newspaper again, the first paragraph of the murder story. Pelican Point. No more than half a mile south of the spot where she, Meg, had been attacked. A chill, like a little wind of

fear, touched the backs of her hands, the V of bare skin at the neck of her robe: could have been her down there in the water. Maybe they'd run from her resistance and noise, and then stumbled across another woman out by herself at night. A quieter woman.

The bastards. Even if they weren't killers, she hated them for recalling her to fear here in her own house. For making her grateful, for a nasty moment, that it was somebody else who got really hurt.

She made herself another cup of coffee and took it upstairs to her desk, and her rollbook. Port Silva High School, with a student population of somewhere around a thousand, was the only secondary school in town and served the surrounding county as well. Now in her fourth year of teaching English there, she had taught or at least seen around campus most of the local teenagers.

But of the one hundred fifty students presently in her classes, no name brought to mind the young man she'd faced in that dark street. She shoved the rollbook aside and went to the bookcase to flip through yearbooks from the past three years, scanning faces, prodding her brain and memory, and finally admitting defeat. Her glimpse of her attacker had been too brief; that tall, pale-eyed bastard could be any Olson, Hanson, Johanson, or Peterson kid in the west county.

Disgusted with her failure and her fear, she put the books away and began to dress, choosing whatever was soft and warm. She felt as if she'd been in this house for about a year, hiding in corners. She needed to go out and breathe real air, to revive her spirits and stiffen her spine.

As she stood before her dresser to wield a hairbrush against the badger-colored mane that seemed to double its volume in wet weather, she reminded herself that personal vanity was not one of her failings; if she wore dark glasses, her face would probably not frighten strange dogs or small children. Not that she needed to see any of those.

As Grendel's bark and the doorbell sounded together, she nodded at her reflection, picked up her purse, and headed for the staircase. The delivery boys from Mack's were right on time with her Toyota, tuned up and smogged, and with automatic transmission and power steering, far kinder to battered joints than Vince's Porsche. She moved as quickly as she could to the door, opened it, and looked out

to see her silver-blue sedan there in the graveled parking area next to a small, rust-marked pickup truck.

Another pickup, a big blue number with MACK'S GARAGE emblazoned on its tailgate, was just disappearing down her driveway. Meg turned unwilling attention to the person standing on her doorstep, met a rainwater-gray stare in a face set in a habitual expression of harried petulance, and knew that God or somebody definitely had it in for her.

"Here," said Mary Louise Gutierrez, thrusting a key ring and a piece of paper at Meg. "They said you could call if there were any problems. Honestly, I looked at the bill and I can't believe what those people charge. How can Vince afford it?"

Vince's youngest sister always made Meg feel both irritated and vaguely guilty. The woman had moved through forty-some years of life resolutely making bad choice after bad choice, always expecting this time to be better and always sure, when it wasn't, that the resulting mess was someone else's fault. "Mary Louise…"

She sidled past Meg into the house, pushing back the hood of her shiny-pink quilted raincoat. "Tell that dog to go away, okay? I don't like the way he looks at me. I need to see Vince right now."

"Grendel, go to your bed," said Meg. She watched him trudge off to his bed in the corner of the living room, heard him sigh as he settled there. "Mary Louise, it's ten o'clock. Vince is at work."

"Oh, dear," said Mary Louise, who never swore. "Maybe you could call him for me? See, he has to do something about Cass. Maybe you could have her here again?" she added, looking around as if to find a corner where her teenaged daughter could be stashed like a piece of spare luggage.

Cassandra Gutierrez (like her mother, she'd reverted to the family name) was Mary Louise's last, lorn child of three; she'd left the older two with their stepfather when she left *him* to find herself or at least to have more fun. Several years later, declaring herself unable to cope with a rebellious teenager, Mary Louise had dumped Cass on her Uncle Vince's doorstep. In the two years since, Meg and Cass had reached a wary mutual respect that came close to friendship.

"Cass knows she's always welcome here," Meg said now. "But the spare bedroom isn't very big, and she doesn't like our kitchen. What's the problem, Mary Louise?"

Mary Louise sighed and trailed herself and her coat into the kitchen, where she perched on one of the stools. "Would you believe it, she's threatening to kick me out of the house. Her own mother! Have you got a Diet Pepsi or something?"

Meg gave up and set her purse down on the counter. "Would you like coffee?"

"No. I hate that strong stuff you guys drink."

Meg could feel her jaw tighten as she opened the fridge and surveyed its shelves. "Plain Classic Coke is the best I can do."

"Well. Okay, I guess." Mary Louise eyed the red can with disfavor. "Do you have a glass?"

"I do," said Meg, and set one on the counter. "Mary Louise, why does Cass want you out of her house? I thought the two of you were getting along."

"See, that's the problem, *her* house. I mean, she's a seventeen-year-old girl, and I'm—older. Mama shouldn't have done that, it's unnatural!"

"Mm." Vince and Mary Louise's mother, Emily, had been as decisive with her estate as with every other element in her life. She had left her mountain camp to Vince, who loved and used it; divided her money in twenty-some-thousand-dollar lumps among her other six children; and left her big old house to her troubled granddaughter, Cassandra.

Mary Louise was still talking. "I think Mama was crazy just before she died. Senile. Len thinks so, too. He says I ought to see a lawyer about it."

"That would be very expensive and probably get you nowhere. Who is Len?"

"My boyfriend." Mary Louise lifted her chin and used both hands to smooth back light brown hair that fell in long, permed wisps from a center part in a way that reminded Meg of her dog. "He's a nice man, Vince met him once. But he's had bad luck."

I bet, Meg thought.

"Len lost his job when the mill cut back last year, his rotten wife got their house when she divorced him, and now he's been kicked out of his apartment for getting behind with the rent. And my own daughter is so unchristian that she won't let me give him a place to stay, can you imagine?"

"You wanted to move this man into the house with you and Cass?" Barely controlled anger touched Meg's face with heat, tweaking to pain the bruises there.

"It's my house, too, or should be. And Len and I are going to get married, as soon as he gets back on his feet. Besides, Cass has been acting strange lately, hanging around the house instead of going to work or to school. It would be good for her to have a father figure in her life, somebody who'd take a firm hand with her."

"The same kind of 'firm hand' some of your other boyfriends took, Mary Louise?"

Mary Louise shrank back into her coat at Meg's tone. "I—never meant for anything bad to happen to Cass, not ever. And she doesn't always tell the truth, you know. Anyway, I'm going downtown to talk to Vince, and just stay right there in his office until he does something," she added, getting to her feet. "He's the trustee for Cass, he can make her behave."

"Mary Louise, *sit down!*" Meg waited until the smaller woman had resumed her seat. "Vince is tired, worried, and overworked," she said more quietly. "He cannot in good conscience take your side in this; so all you'll do is make him more tired and more worried. I won't let you do that."

"Pooh. What are you going to do, borrow Vince's gun and shoot me?"

"Here's what I will do." Meg took hold of the counter edge and leaned forward to stare into the gray eyes. "I will creep into your house in the dark of night. I will tie you up and gag you. Then I will cut off all your hair and shave your head completely bald. I promise."

Mary Louise blinked rapidly, and after a moment, closed her mouth. "You wouldn't do that."

"Try me."

"Well." She picked up her glass for a sip. "I wouldn't want to bother my poor brother anyway, if he's so busy. What's happening in this town that the chief of police has to work so hard?"

"Murder."

"Oh, I read about that."

"Then there's been vandalism, robbery, assault. And some nasty protest demonstrations at the Family Fertility Clinic."

"Hah!" said Mary Louise, regaining her normal self-righteous air.

"The doctor who runs that place is not a nice man; Pastor Fink at the Pentecostal Holiness Church says the practices of his clinic are a sin. Besides, he, the doctor, refused to do anything for me."

Meg hated herself for prolonging this conversation. "What did you want a fertility doctor to do for you, Mary Louise?"

"Help me have a baby. I'd really really like to have one more baby before my, you know, biological clock runs down," she said, blinking back tears. "And Len would like it, too. But that Dr. James Ferrar said I'd chosen to have my own tubes tied, and I already had three kids, so he wouldn't take me as a patient."

Bless you, oh sane, sensible man! thought Meg fervently.

"Besides, he's been in trouble. I looked him up in the newspaper and he's been sued for malpractice or something. He was accused of molesting women patients, and I believe killing babies, too. You know, abortion. I'm thinking of suing him for refusing to treat me. Doctors have to help you, it's the law."

"Only if your life is in danger, I think," said Meg. "Mary Louise, I have errands to run. You may tell Cass for me that she's welcome here; but please, don't try to move your friend in against her wishes."

"I know you think I'm a rotten mother." Mary Louise pulled a tissue from her coat pocket and wiped her eyes. "But I love my children, and I never mean to hurt them. It's just that things seem to go wrong sometimes."

"I know, Mary Louise." Towering over the small, teary-eyed woman, Meg felt once again like a mean-spirited witch. "I'll tell Vince you came by, and ask him to call you. Maybe the two of you can get together for lunch sometime soon, and talk."

"Hmph." Mary Louise turned and marched toward the door. "He *is* my brother, you know. You don't own him."

Last word. Well, welcome to it, thought Meg, as her sister-in-law pulled the door shut behind her. Her own free day was fast evaporating, along with her energy. Passing the hall mirror, she grimaced at the battered face that Mary Louise had not commented upon, probably because she hadn't noticed it.

So. Boots today instead of shoes. And something against the rain. She was pawing through the coat closet in search of her short slicker when something bumped her from behind, tipping her into a welter of coat sleeves and a moment of dry-mouthed panic.

"*Damn* you, Grendel!" she said to her huge dog, who knew Mary Louise was afraid of him and had stayed obediently on his bed until she left. Now he gave a piteous little whine, and Meg remembered that he had not had a run yesterday. Or probably the day before; she and Katy both shied away from exercising him in wet weather, because his corded coat took so long to dry.

Another whine. "Oh, all right. But you'll have to submit to the indignity of wearing your raincoat." As she unearthed the thing from the box in the rear of the closet, it occurred to her that having a hundred-plus–pound komondor in the back seat of her Toyota would probably make her a more serene person.

"Tell you what, Grendel. If you wait patiently through a grocery stop, and maybe a library stop, then I'll take you for a run on the beach."

Chapter 6

THE WINNER'S CIRCLE MOTEL was a single-story, mud-colored stucco structure that curved in a semicircle behind a low wall of the same color. The place came by its name and its grimly rustic appearance honestly; it had begun life as a stable. Gutierrez figured horses must have smelled a lot better than the overflowing Dumpster serving as garbage receptacle.

He stood bareheaded in the fine mist and surveyed the scene. Two black-and-whites were parked in the muddy forecourt in company with four aged sedans of various American makes; the Dodge van that served as Port Silva's version of a mobile crime lab was pulled across the open door of the east-end unit. That had to be room, or rather apartment, number one, formerly occupied by Esperanza Moreno.

What looked like a horde of small children gave a hectic sense of life to the scene, popping up to peer out of windows, darting from unit to unit in casual disregard of the wet. An elderly man stood in the open doorway of apartment number two, as if on sentry duty; a gray-haired woman bobbed out from behind his shoulder and then shrank back out of sight. The door of another room opened and a young woman was framed there, her features sharp against a frizzed mass of dark hair, her mouth a slash of bright purple-red; she stood for a moment like a wary animal before turning to disappear into the room, and the door vibrated with the force of its closing.

"Juanito!" came a high-pitched shriek, and a very small child shot from the westernmost doorway and came barreling toward Gutierrez and the street, head down and fat, short legs churning.

"Not so fast there, Juanito," Gutierrez said, moving to block the child's way. Juanito caromed off braced legs, said "Yow!" and righted himself, and was about to try an end-sweep when Gutierrez scooped

him up and handed him to the young woman who was chasing him.

"Juanito, you little…" She slapped his bottom, slung him astride her right hip, and said a breathless, "Thank you." Then she looked hard at Gutierrez, widened her eyes, and poured forth a torrent of Spanish that began with *"Gracias, señor…"*

"I'm Chief of Police Vincent Gutierrez," he told her, "and I'm sorry, but I don't speak Spanish."

"Oh." She was just a girl, he decided, maybe sixteen or seventeen, with smooth olive skin and long black hair that was wisping around her face in the damp air. It was an oval face, with strong bones beginning to emerge from baby fat and green eyes that would be striking when they weren't puffy and reddened.

"You have a handsome little boy," he told her. "Fast, too."

"Eeh! He's my sister's, not mine," she said quickly, her English only faintly accented. "I don't have no kids…yet," she added, with a glance down at the belly rounding the front of her T-shirt.

"I see. Do you live here, Mrs.…?"

"I'm Graciela. Graciela Aguilar. I live here with my sister, Dolores, and her husband, Luis Acuña."

"And did you know Mrs. Moreno, Esperanza Moreno?"

She blinked hard as tears flooded the green eyes. "Juanito. Go to your mama," she said to the boy, setting him on his feet and delivering another rump-swat to urge him on his way. "Yes, Espy was my friend. She was…" Graciela sniffed and palmed the tears away as a child would. "Espy was like my real sister. She talked to me, treated me like a grown woman. I love…loved her."

Another sniff, and then, fiercely, "And if you don't catch him, I'll find him myself and cut his fuckin' *cojones* off, that…" Here she exploded into a hissing spate of Spanish, of which Gutierrez made out only *"pendejo"* and *"hijo de puta."*

"Who?" he asked.

Graciela sniffed again and looked at him as if he were dim-witted. "Her husband, who else? That Rubén! He ordered her around, beat her up, made her pregnant all the time. He was too old for her anyway, too ugly and stupid. She was going to get away from him for good, she told me. I bet she told him, too, and that's why he killed her. You know, like if he couldn't have her, nobody else could," she added in dramatically lowered tones.

"Was there anyone else?" he asked quickly. "Did Espy have a boy-friend?"

"Espy? No. She could have, for sure. She's—she was—real pretty. But she never said nothing to me about no boyfriend." In the falling mist they had both been ignoring, her face was now shiny-wet, the T-shirt clinging to her narrow shoulders and fragile-looking collar-bone. "We was real close, like she gave me maternity clothes and stuff. I know she'd have told me."

"Mrs. Aguilar, have you spoken with Sergeant Chang about this?"

"Spoken? Not really," she said, turning to look over her shoulder at the building where, presumably, her sister and brother-in-law waited.

"Look, you'd better get in out of the wet. But someone will talk to you soon. Bring you downtown to make your statement, if you like."

"Luis won't let me."

"Oh yes he will," said Gutierrez. "Sergeant Chang will see you soon. Or Officer Alma Linhares," he said, thinking she might prefer to speak with a woman.

"Well. Okay." With a gleam of defiance in her green eyes, she tossed her head and set off for the building.

The door of the west-end unit opened as she reached it, and Gra-ciela and Ray Chang did a polite little dance around each other that ended with her moving inside, Ray stepping out and pulling the door shut behind him. Gutierrez had put Chang in charge of the investi-gation not just because he had been first on the scene to find the body, but because he was the only person on the force who spoke Spanish.

Chang caught sight of his boss and came quickly across the fore-court. "Hi, Chief. You want to talk?"

"If you have time. I've only glanced at the reports from yesterday."

Chang gave the characteristic head-toss that flipped his heavy hair back from his face. "Long time since breakfast. Want to hit the little doughnut and coffee shop up the block?"

"Fine," said Gutierrez.

"I'll just let the crew know I'm leaving."

"The basic story's still the same," said Chang, when the two of them had settled at a table with a plate of doughnuts and mugs of coffee.

"She was last seen here Wednesday night at about ten."

"Right. Esperanza lived in unit one, and her next-door neighbor, an elderly woman named Mrs. Gonzales, happened to be letting her cat out at about that time. She saw Esperanza getting into her car; says she waved, but Esperanza didn't see her. It made her cry to tell me that."

"That was the only sighting?"

Chang nodded as he reached for the plate and a chocolate frosted twist. "Everybody else was either sleeping or watching TV. So far nobody has admitted seeing her return, or seeing or hearing anyone else in her apartment that night. Oh—her car was found this morning, just down the road from Pelican Point in the parking lot behind that fish-and-chips shack. Looks like it sat there all night in the rain with windows down; it's a soggy mess inside and basically empty."

"What about Esperanza's son and daughter? Have they turned up?"

"Apparently they're with the husband," said Chang. "In fact, this looks a whole lot like a domestic."

Gutierrez made a wordless sound that resembled a snarl.

"Yeah." Chang took a bite of his doughnut and paused to lick chocolate off a finger. "First, I probably don't need to tell you that information is coming hard; this is not a relaxing time or place for people with brown skins who speak Spanish."

Gutierrez merely nodded. California's more conservative politicians had recently cranked up voters' paranoia about illegal immigrants in a successful effort to pass a statewide initiative banning bilingual education. The secondary result, no surprise, was increased suspicion of anyone whose origins were south of the state's border.

"But," Chang went on, "this guy named Acuña, in the other end unit, is your basic know-it-all, talky type. So he finally told me that Esperanza Moreno's husband, Rubén, who lives in Mexico, spent a few days here recently. He left real early Monday, and Acuña's fairly sure he took the kids with him. When I asked Mr. and Mrs. Gonzales about it, they basically agreed with Acuña."

Gutierrez reached for a fat glazed doughnut, something he knew would sit like a rock in his empty stomach. "If he left on Monday, chances are he's the one who beat her up. At least. Did anybody admit knowing about that?"

"Not directly. Mrs. Gonzales did say that Esperanza didn't go to work from Monday on. Says she knocked on the door and asked if everything was all right, and Esperanza just called out that she was sick but she'd be okay." Chang finished the doughnut, poured milk and lots of sugar into his coffee, and reached for another doughnut.

"Acuña," he added, "says he didn't notice anything heavy going on between Moreno and Esperanza, says his friend Rubén Moreno is a good man and a loving husband and father. Then he said that a wife, after all, is supposed to obey her husband, and he's entitled to punish her when she doesn't."

"Do you know the difference between a Mexican husband and the ordinary U.S. kind?" Gutierrez, who'd dealt with more cases of domestic violence in the past winter than for the whole preceding two years, didn't wait for an answer. "The Mexican will tell you he has a God- and church-given right to beat the bejesus out of his woman. The American will say he got drunk and lost control and won't do it again...until the next time. Did Acuña know where his buddy Rubén was headed when he left town?"

"Sort of. Here's the story as he told it." Chang settled back into his chair. "Rubén Moreno came to Port Silva from the San Diego area with his family maybe a year and a half ago, and worked on fishing boats here and up north. When work dropped off with cold weather coming, he decided to go back to Mexico, Acuña says to some fishing village in Baja near Ensenada where he, Moreno, came from originally. Esperanza had a good job here and so she stayed. She was a U.S. citizen, incidentally—born in this country; same with the kids. Rubén is a Mexican national."

"Ah," said Gutierrez.

"Anyway. Seems Rubén has got himself more or less established down there in Baja, and figures he should have the wife and kids with him. Turns up here last Wednesday or Thursday to collect them."

"Esperanza was willing to go along with this plan?"

"Acuña says she absolutely was. Mrs. Gonzales just shakes her head and cries. Anyhow, on Monday Rubén took off with the kids, and Acuña understood that Esperanza was to follow, maybe the end of the month, after she'd squared things away here."

"You gave them this information downtown?"

"Yessir. But Acuña doesn't think Rubén was going straight home. He talked about taking his kids to visit friends and relatives first, in maybe San Diego and Tijuana. Acuña also denied knowing any names or addresses, or the license number of the car Rubén was driving. All he noticed, it was a two-door, and old, and green. American, he thought."

"So we're looking for one Rubén Moreno, somewhere between here and an unnamed Baja village, in an old green car with two kids. What do you suppose our odds are?" Gutierrez tasted his now-cooled mug of coffee, grimaced, and added sugar. "Never mind," he added after a moment. "Just give me a quick rundown on the Winner's Circle and the people there."

Chang laid his pocket notebook on the table but didn't open it. "There are ten units. The highest-priced, the ones at the ends, have two rooms each, a bath, and a kitchenette. The others are basically one room, with a bathroom and a curtained-off corner for kitchen stuff.

"Anyway, the Moreno family had unit one, as you know. The Gonzaleses are in number two, and they manage the place."

"That would be the elderly couple I saw in the doorway."

"Right." Chang bit off a chunk of doughnut and chewed for a moment. "They're legal immigrants, not citizens. Anyway, in exchange for their room, Mr. Gonzales keeps an eye on the other tenants and collects rents and makes small repairs. Mrs. Gonzales helps him and does some cleaning and baby-sitting. I'd say they do a pretty good job; except for lack of space, the place isn't that bad. But they aren't much into record keeping, don't have names and addresses for the more transient tenants."

"Or they don't want to talk about it."

The sergeant ducked his head in polite acknowledgment of this possibility. "But they liked Esperanza Moreno. Said she was a nice woman and a good mother. Kept her kids clean and quiet, paid her rent on time, was always polite, and helped Mrs. Gonzales a time or two when the old lady's back was bad. Mr. Gonzales said all this, while Mrs. Gonzales was crying."

"It's nice somebody's crying for her," said Gutierrez.

"Right. Okay, the Gonzaleses have their teenaged grandsons in unit three: Jesús, age fifteen, and Angel, seventeen. From L.A.,

mother dead and dad out of work. They've been here since October, go to high school, have had no local problems. Mr. Gonzales says they liked Esperanza and are very sad about her death. They're at school now, I figure we'll talk to them later."

Gutierrez nodded.

"So. Units four and five are empty at the moment. Eight and nine are—were—transients." Chang paused and pulled himself straighter in his chair, face going slightly pink. "I guess I'd better tell you I blew it there."

"They took off," said Gutierrez.

Chang blinked and blushed further. "I sealed the Moreno unit last night, and told the patrol to pay special attention. But the young transient guys—Mrs. G. says there were three to each unit; in summer or when the fishing is good there'd be four to six or more—somehow got word of what was going down and hit the road. Didn't even come home last night to pick up their stuff, looks like. I'm sorry, Chief."

"Did any of them connect with Esperanza Moreno in any way?"

"The Gonzaleses don't think so."

"Okay. What about units six and seven?"

"Two young couples from El Salvador, friends, with a total of five kids between them."

"In two rooms."

"Right. They all have work papers, maybe valid."

"At the moment that's not our problem. Don't tell the mayor I said that."

"No sir. The women work downtown as motel maids, the guys drive their wives to work and maybe help out there or find what they can as pickup labor. They've been here only a few weeks and say they didn't know Esperanza Moreno well; but the women didn't like her much because she acted like she was better than everybody else. They say."

"Maybe she was," said Gutierrez.

Chang gave his boss an odd look. "Okay, that leaves the west-end unit, the other big one, where we've got Luis Acuña, his wife, Dolores, her sister, Graciela Aguilar, and three little kids. They're Mexican in origin—Acuña was born on this side of the border, the women the other. He works for a nursery, his wife works in a

laundry. The sister stays home with the Acuña kids and baby-sits some of the others for money."

"What did the women have to say?"

Chang shook his head. "Luis did all the talking; like I said earlier, he's a bossy little guy. Dolores is tired-looking and probably not very bright; Graciela is just a kid herself, pretty, pregnant, and very upset—couldn't stop crying. I think she and Esperanza were friends. Her husband's up north on a fishing boat, and I guess Luis is her guardian, self-appointed."

"I had a chat with Graciela," said Gutierrez, and related the conversation to Chang. "Maybe she's dramatizing, maybe she knows something. I told her you or Alma would talk to her later, somewhere away from Luis."

"Right," said Chang, and scribbled briefly in his notebook.

"What did Luis say about Esperanza?" Gutierrez asked.

"That she was a good woman who worked hard and took care of her kids and sent money regularly to her husband. Whatever Esperanza did or said that set Rubén off—if that's what happened—I don't think Luis knew anything about it."

Chang got to his feet and moved to the urn on the counter to refill his mug. Gutierrez sat where he was, thinking of another person who had admired Esperanza Moreno. Espy, Dr. James had called her. And that very self-contained man had been obviously, unprofessionally shaken by the sight of her dead body. He'd pulled himself together quickly, however, to reiterate his claim to have had no contact with Esperanza since May or maybe June of last year. And there was never, he'd said quietly but firmly, anything personal between them, nothing beyond brief, friendly chats at the clinic.

"Espy was an attractive, energetic young woman," Gutierrez remarked as if to his coffee mug. "People in town who knew her, liked her." He looked up to meet Chang's puzzled gaze; probably the poor guy was thinking his chief was losing it. Might even be true; the fact that Esperanza meant "hope" kept bothering him. Maybe Vince Gutierrez had spent too many years wading around in this kind of shit.

"Somebody gave Esperanza Moreno a real working over," he said slowly, "probably including rape, two or three days prior to her death. From what you've found out, it seems likely that was Rubén, assert-

ing his husbandly rights. Then Wednesday night somebody put his hands around her neck and squeezed until she died, and tossed her over the bluff like a piece of garbage. I don't know, Ray, does it feel right to you? That Rubén would have come back to town to do that, to his wife and the mother of his children?"

Chang shifted uncomfortably in his chair. "I don't know, either. Men—do a lot of shit, I've thought lately."

"I've thought, lately, that maybe all men between the ages of, oh, fifteen and fifty should be kept behind barbed wire and let out only under strict supervision."

"Except for us."

"Well. Maybe. For the moment, we're needed on the job."

"Yessir." Chang drained his coffee mug, wiped his fingers clean of sugar, and got to his feet, stepping back to let his chief precede him to the door.

Outside, in mist possibly lighter than before, they set off for the Winner's Circle. "One of the few things that makes me feel foolish," Gutierrez said, as they walked, "is the fact that with my name, and my face, I don't speak Spanish. I finally asked my mother about it, not long before she died—why she didn't insist that I and my brothers and sisters learn to speak our father's language. You know what she said? She said that in our time and place, which was fifty years ago, it was really important that somebody with my name and my face speak good, unaccented English. I thought she was being racist."

"No sir," said Chang. "She was being a very smart lady."

At the motel, Gutierrez stopped at the Moreno apartment to talk with Officer Alma Linhares, who had just finished a second, thorough inspection of the place. Nothing spectacular or illicit, she told him; no bodies, bloodstains, or signs of struggle, no stash of money or drugs. Very few children's toys or clothes, and those old and probably discarded; clothing in drawers and closet that was obviously Esperanza's.

"There were these cotton smock-things, for cleaning work, I guess. And a couple of dresses, and jeans and shirts, ordinary stuff. But she had a thing about silk, looks like—the kind of panties you have to wash by hand, a couple of nifty nightgowns, and this long, creamy robe that made my mouth water and my fingers itch." Alma

grinned and made a slow shrugging gesture, as if pulling heavy silk over her shoulders. "Either she saved real hard, or she had a generous friend."

Graciela had said no lover. But the husband of a cleaning woman, thought Gutierrez, might have read a drawerful of silk underwear as a very bad sign. Especially if his wife had told him she meant to leave him.

When he didn't speak, Alma went on. "There was an empty purse, a lined straw one she probably used in summer. Whatever she was carrying now must have been taken by the killer, because I haven't found any of the stuff everybody totes around: no wallet, driver's license, or insurance card; no library card or checkbook. No money beyond a few singles and some change in a little bowl in the kitchen cupboard.

"And hardly any personal papers at all," Alma added, gesturing toward an open pink shoe box on the kitchenette table. "A few picture postcards, a last-year's reg card from the community college, her own birth and baptismal certificates, the pink slip on her car. Oh, and the hospital pictures of her kids," she added, moving to pick up two shiny-paper folders, one edged in blue and one in pink. "Baby Boy Moreno, born just over five years ago, nine pounds fifteen ounces. And Baby Girl Moreno, almost three years ago, nine seven. Ouch. The lady really had big, healthy babies."

Gutierrez looked from the folders to the wall over the sofa bed, where a crucifix and a framed color photo hung side by side; from the photo two round-faced, combed-and-polished children grinned at him. Recalling Graciela's remark, he wondered if two children in five years qualified as being "pregnant all the time."

"Cute little bastards. Excuse me, Chief," Alma added quickly, eyeing his face. "Anyway, I'll call my friends at the local banks, see if anybody knew her. She worked regularly, and mostly lived frugally, looks like. Unless she kept her money in a coffee can buried in the yard, she's got to have a checking or savings account somewhere."

"Good," he said. "And you'd better check the silk things out, see if you can find where they came from."

"Second move on my list, Chief."

"Good." He looked at his watch. "Okay. Give the full report on your search to Ray when you've finished. And one of you will need to

set up a private interview with the young woman in unit ten, Graci-
ela Aguilar; Ray can tell you about her. I'll probably talk to you again
tomorrow. Or Monday," he corrected himself.

"Monday? Are you kidding? Chief," she added in belated atten-
tion to protocol.

"I don't know how much overtime I can authorize," he told her
grimly. "The mayor has us counting paperclips and planning layoffs."

"Hey, I'll work on my own time."

"Do what you can. And so will I."

"I'll leave you to it, you and Linhares," said Gutierrez moments
later, as Chang walked him to his car. "Get the search for Rubén
Moreno going, but don't stop at that. If I were doing it, I'd bring not
just Graciela but everybody downtown later today or tomorrow, talk
to them one at a time. Several times if necessary. And I'd…never
mind, your case. Just keep me posted."

"Yessir," said Chang, with a squaring of shoulders and a jut of
chin that suggested a salute.

"I'm going back to the shop. I'll probably see you there later."

Chapter 7

HERE WAS a moral question of great simplicity, thought Meg: Was it evil of her to let Grendel chase shore birds? On a state beach one day, an officious ranger had told her that it was, that her dog was pointlessly terrorizing the creatures who had first and best right to the place. He'd given her a ticket, too, a twenty-five-dollar fine for having her marauder dog off-leash.

But this was not a patrolled beach, just one of the many sandy stretches that lay along the incurves of the coastline north of Port Silva, and the second they'd stopped at today in her attempt to work some soreness out of her bones and a general irritability out of her mind. Clearly no one else had come here for exercise or solace on this drizzly Friday; the footprints she was meeting now were only theirs, hers and Grendel's.

A chorus of shrill *pee-eep*s brought her around to watch a flock of tiny gray-brown birds take flight, sweep past her in a masterly exhibition of wing tip-to-wing tip coordination, then dip and swoop and sweep back in a flash of pale underbodies that made them appear a different group entirely. And alight, and scurry across the sand to the lump of kelp that was home to hordes of tiny insects—sand fleas? Apparently delicious, anyway.

Grendel skidded to a halt at water's edge and watched his intended prey, a large gray-and-white gull, wing away shrieking insults. Meg whistled, and he came more slowly than was his norm. "Don't be sad, friend," she said. "You'll never catch him, but he'll be there to chase tomorrow. And a pox on officialdom. Come on, let's pick up the pace a bit."

The light rain had changed to a misty, drippy fog that lifted now and then to allow a glimpse of the rolling sea. When she first came

here from Arizona, eyes trained to brilliant light and intense colors, she had found the northcoast landscape uniformly gray. Now she had learned to see endless subtle shadings and variations of colors: scan a stretch of ocean from shore to horizon, and you could discern half a dozen colors that might be all called green. Or blue, depending on the light.

The bleakly beautiful shoreline looked eternal, but Meg knew better. Winter storms could tear it, earthquakes tilt and shift it; oil companies, fought off in the past, could come back and win, bringing ugly derricks and killer spills. Indifference or greed could shred the fragile web of coastal protection laws, ending with the whole sweep sold off to those who could afford it and would surely fence it off from the unruly masses and their dogs.

Thus preserving it, of course. But what of the town? she wondered as she strode on past rocky tidepools and over strands of kelp. Port Silva was a small town—fewer than ten thousand people before the arrival of the university a decade earlier, around twenty-four thousand now—and still something of a backwater, a place where children could grow up playing with cousins and eating Sunday dinner with grandparents. Four years ago, newly widowed with a young daughter, she'd viewed the place, probably romantically, as a refuge.

Now it seemed that she belonged here; it was Vince's home, Katy's home, there was nowhere else she herself wanted to be. And the town, her town, was suffering. Stick to the north end, where old lumber barons had built big homes that university faculty now owned, and things didn't look too bad; students were always out and about, and the businesses to serve them were mostly flourishing.

But drive through the town proper, along Main Street and streets paralleling it, and "flourishing" was not a word that would leap to mind. So gradually that a busy, self-absorbed person could fail to notice, the empty storefronts had begun to appear. J. C. Penney was long gone, the Sears catalog store more recently. Picturing the streets in her mind, Meg counted among the missing a small food store, a shoe store. A store selling kitchenware. A family-owned jewelry store. And Aisle of the Blest Books, gone more than a year, and she still mourned it. Some of the empty places had metamorphosed into antique shops, to Meg's mind a deadly sign of civic morbidity.

"The trouble is," she said to Grendel, "little towns like ours, way

off in the outback, suffer more than big cities do in hard times and recover more slowly, because we have fewer resources and no political clout. Don't you think?"

Grendel was not a dog for vocal responses; he simply twitched a polite ear.

The kids, of course, were suffering along with their unemployed fathers, oftentimes men who had previously made decent livings in the woods or on the boats and were unlikely to adapt to positions as golf-course groundskeepers or motel maintenance men. Many of her students were slow and sullen these days, given to grim silences broken occasionally by outbursts of fury; others couldn't stay awake in class, worn out by the part-time, low-pay jobs they were working to help their families survive.

"Here's a precept, Grendel, a revealed truth. Suffering does not ennoble; suffering shrinks people's souls and makes them mean. Probably does the same to dogs," she added.

Grendel's head came up, and his tail, too; he moved a bit faster, on his toes. Suddenly he erupted into a fusillade of barking and shot off ahead of her, plaid raincoat flapping around him.

"Grendel! Wait!" This was where they'd come down to the beach from the road, and her car was still the sole vehicle in the makeshift parking area. "Grendel!" she called again, and the next command died in her throat as a tall figure loomed out of the mist beside the Toyota.

The dog roared and lunged; the slicker-clad intruder yowled in fear or pain, flung long arms up and stumbled backwards. Meg found her voice and wailed, "Grendel, hold! Watch!" Oh, God, bad idea— whoever it was, let him go! "Grendel, wait!"

This time he obeyed, more or less, growls subsiding to a rumbling deep in his chest, as with powerful strokes of his hind legs he kicked clods of sandy mud over something on the ground beside the car. As she picked her way up the slope, pain flaring in her bruised hip, she saw the shiny black back of the intruder as he fled, and moments later heard the crunch of a slamming door, the whine of a starter, the roar of an engine. The dark bulk of a vehicle across the road and a dozen yards north disappeared into the mist almost before she had registered its presence, the loose, metallic rattle of its departure suggesting an empty pickup truck.

"Good boy," she told her dog, in a voice that quavered embarrassingly. Maybe she'd become gun-shy about tall figures looming out of fog or dark or anywhere at all, but if that guy was honest and well-meaning, he'd have stopped to say so. Or to complain about being attacked by a dog. She gulped a great mouthful of damp air and said again, "Good boy." And then, "What are you doing?"

Still stiff-legged with outrage, he moved away from the muddy heap; she stirred it with a booted foot to uncover a hunting knife, a wicked-looking thing with a leather handle and a six-inch blade.

"Very nasty, you were quite right to bury it," she said, and put a shaking hand on his hard, wet head. Did whoever it was draw his knife in defense against the dog? Or had he held it ready, awaiting her return to her car?

"Damn it to hell! Will you look at that!" The right rear tire was flat—slashed, she found as she bent to look closer. "Good boy!" she said yet again, fervently; she took hold of his collar and the pair of them made a circuit of the car to find the other tires undamaged. Only when she'd made sure of that did she notice the sheet of paper folded limply over the passenger-side windshield wiper. Felt-pen red letters already bleeding from dampness made their point clearly: SHUT UP! OR YOU AND YOURS WILL GET REALLY HURT!

"By God we won't!" she muttered, resisting the impulse to ball the vile thing up and tossing it, instead, onto the passenger seat. "Anyway, you stopped the bastard at one tire," she told her dog. "Could have been worse."

Maybe she should have that phrase tattooed on her forehead. At least she had a good spare and a good jack. And the finger-crunching job of changing a tire in the mist, on uneven, sandy ground, should quickly warm her from fear to fury. As she opened the car door and reached down to pull the trunk latch, a jolt of pain in her injured elbow reminded her that she'd have to do most of the work left-handed.

"Consider him a Seeing Eye dog!" Meg pulled off her dark glasses and glared at the young cop. "Is the chief here?"

"Jeez, I'm real sorry. Uh, no, he's not, he's out on, you know, this murder. Boy, that's some big dog."

Meg rested her hand on Grendel's head. "He was bred for driving off wolves, and he takes his work seriously. What about..." Not

Hank Svoboda, unfortunately. She had not wanted to come here, had needed to quell a strong desire to go straight home and crawl back into bed. She would certainly not tell her new tale to some stranger, or to the bigoted bastard she'd seen Wednesday night. "Is Detective Hebert available?"

"Oh yes, ma'am. He's in Captain Svoboda's office right now. I'll take you—both—back."

His expression suggested not helpfulness or compassion, but hungry fascination. "Never mind, I know where it is. Heel, Grendel."

The inner hall was low-ceilinged, the overhead fluorescent tubes bathing everything in a cold white glare. Probably made her battered face even more gruesome. She reached the door whose plate read CAPT. H. SVOBODA, knocked, and blinked back sudden tears as a familiar voice said, "Come in."

Johnny Hebert got to his feet as she entered, his smile of welcome fading to a grimace of dismay. "Oh, Meg. Bummer." He gripped her outstretched hand and pulled her close against him, long, strong arms encircling her warmly. She leaned into the embrace with a shaky sigh, and her dog gave a small worried whine.

"It's okay, Grendel," said Johnny. "Here, Meg, sit down. You want some coffee?"

"Thanks, but no." She seated herself, blinked again, and tried to smile up at him. Johnny Hebert was six-plus feet tall, curly-shaggy of hair and beard, with eyes as blue as Katy's and a suggestion of plumpness Meg thought was deceptive. He was the department's computer person, puncturer of balloons, chewer-over of complicated problems. When she was twenty, Meg would have thought him whatever the word was then for nerd; at thirty, she'd have married him. At her current past-forty pinnacle, she simply enjoyed him.

"So what else has happened?" he asked, pulling his own chair close.

Of itself her hand reached out to rest again on the dog seated at her side. "I'm not hurt. But somebody slashed my tire, and left me a threatening note."

"Tell me," he said.

"It was at that little beach called Whalehead, I guess because of the big rock jutting up from the water," she said, and described the incident. "The note and the knife are in my car," she added. "So is

the tire, but I've changed it and I can't imagine there are prints or anything on it by now."

"Tell me about everything from the time you left your house," he instructed. When she'd finished, she sat quietly for a moment, watching him make notes. "I suppose it must be the same guy who hit me the other night," she said finally. "Clearly he knows who I am. The bastard."

"Looks like," said Johnny. "The other thing is, he apparently thinks you know who he is."

"But I don't!" She heard the fear in her own voice, and realized that this was a fact she'd been avoiding. Was rank cowardice another disgusting trait that sneaked up on you in middle age?

"If he thinks that, chances are good he's somebody local, most likely a student or former student of yours," said Johnny.

"Oddly enough, I'd thought of that. But I looked over my class lists this morning. And the yearbooks. No luck, the glimpse I got Wednesday night was not enough for recognition." She paused, squaring her shoulders and lifting her chin. "You know, it's possible he'll try again. And next time, Grendel and I won't hold back or run away."

Hebert opened his mouth, closed it, and took time for a thoughtful tug at his beard. "Whoever he is, he's stupid and scared. It would be smart for you to not tempt him."

"What is this, Hebert, a cop's standard advice to potential rape victims? No leg, no cleavage, and stay out of bars? Bullshit!"

"You'd rather go looking for trouble? I thought that was a guy thing, and women had more sense."

"Another sexist heard from," she muttered.

"Meg…"

"Relax," she said, getting to her feet. "I am neither stupid nor scared. Well, maybe scared, but definitely not stupid."

"Just exercise normal caution, okay?"

"I'll try. Thank you, Johnny, for being here. Now can you let me out the back door? The way that that baby cop up front looked at me when I came in, you'd think black eyes were a sin. Or a turn-on."

"Baby? Oh, Boatwright. I'll talk to him. After I walk you to your car, to get the knife and the note."

Chapter 8

"GOOD BREAKFAST," said Gutierrez, in tones only faintly tinged with surprise. "Thanks, Meg."

"Bacon is difficult, and French toast is nearly impossible. I was up all night preparing it," Meg told him.

"Then who was that woman in my bed?"

"Beats me," she said, and got to her feet after a glance at her watch: five minutes to spare. She scooped up the empty dishes and carried them to the sink, pausing as she passed to drop a kiss on the back of his neck. "Oops. Sticky. Sorry."

"That's okay. I'll smell like maple syrup all day and it will remind me what a great weekend we had."

"In San Francisco, remember."

"Oh. Right. And I've got time for maybe another half cup of coffee before it's over."

"Stay there, I'll get it," said Meg, adding another gold star to those figuratively aligned on her forehead. Friday night Vince had come home weary and on edge, and her slightly edited report of the tire-slashing encounter had tipped him into full-blown, save-the-women-and-children paranoia. And the immediate result, his announcement that Katy could absolutely not go out at night even to a high school dance—Meg shrank from the memory of the furor that had ensued.

So Margaret Halloran, dutiful wife and mother, had soothed hurt feelings and arranged compromises: Katy would be chauffeured to the dance by Charlie Silveira, picked up from there by Vince and delivered to the Silveiras' home, ultimately to spend the weekend there with Kimmie. Vince would take the weekend off for necessary relaxation in the guise of a trip to the city.

In fact, Vince and Meg had simply stayed home, in their hillside

house that presented no more than support posts and the underside of the deck to any glance from the road below. With Katy away, the answering machine taking calls, and the Porsche hidden in the garage, only the smoke from their fireplace would have betrayed their presence.

Three minutes. Meg finished clearing the table and tucked everything out of sight in the dishwasher. Although Vince had spent much of the time hunched over his laptop computer grinding away at the police department budget, and she had graded three sets of essays, they had accomplished this work in companionable quiet before their own fireplace. And if her still-creaky muscles had made their lovemaking more cautious than usual, at least they'd had time to take their time.

And any moment now she'd be swishing her dirndl and trilling the sugary songs from *The Sound of Music*. Outside the kitchen window, the gray overcast was shredding to admit glimpses of blue and occasional flashes of sunlight. Everything was wet and shiny out there; maybe they were heading into one of the brief late-winter warm spells that never failed to surprise and delight coast-dwellers. Maybe her students would be more cheerful with this break in the weather.

"Well. Gotta go meet the real world," Vince said with a sigh, reaching past her to set his coffee cup in the sink. His kiss on her cheek was just a brush of lips, his pat on her bottom more perfunctory than lustful.

"Hang in there, love," she told him.

"Right. You, too." He lifted his leather jacket from the back of a chair and pulled it on. Halfway to the door, he turned and came back to grab her for a real kiss. "And try to stay out of trouble, okay?"

"Vince!"

He ducked and moved quickly away, and was out the door with a wave. Meg noted with pleasure that his shoulders were straighter than on Friday night, his step lighter. What weekends were for, after all. And it please the gods, perhaps she could now survive a Monday with the one hundred fifty adolescents who would soon be awaiting her at Port Silva High.

Once in his unmarked but officially equipped and easily identifiable

police sedan, Gutierrez took a deep breath and aimed himself back into a world as predictable as the blue uniform he'd chosen to wear today, as demanding as the dead woman haunting the back of his mind.

At the bottom of the steep driveway he paused to let two lumber trucks growl and rattle by, then pulled out onto Coast Highway One and turned left, south, toward town. The sun had topped the forested ridges to the east and was sending a wash of pale gold across his windshield. With the sky clearing and the fog hanging well out, the Pacific was a calm gray-blue; a few fishing boats were on the hunt, superstructures rearing and then falling away out of sight or nearly as the roll of the ocean seemed to swallow them.

The ocean disappeared behind the upsweep of headlands and buildings, and the road curved left; Gutierrez slowed to time his arrival at the now-red traffic light marking the entrance to the university. A steady stream of vehicles turned in there, mostly cars and light pickup trucks, with the occasional bicycle or motorcycle.

The bustle of activity around the North Main Street delis and small restaurants reminded him that the coffee cannister in his office was nearly empty. He pulled to the curb on Main just short of one-way-west Locust, trotted across at the first break in traffic, and joined the line in front of Coffee Connection halfway up the block. He was on his way back ten minutes later with a half-pound bag of ground Colombian in one hand and a lidded caffè latte in the other when a vaguely familiar figure loomed directly in his path.

"Jesus!" His quick lateral footwork turned collision into sideswipe, the only damage a trickle of hot liquid over the back of his right hand.

"Oops. Sorry, Chief Gutierrez." The young woman caught herself and swung around to face him. "All I saw was the uniform. Please, there's a bunch of dipshit idiots parading in front of the clinic and my dad...I just *know* he's going to say something dumb and get punched out. Which won't do the patients much good."

By now Gutierrez had recognized her. Jocelyn Ferrar was short and somewhat chunky, with a round, plain face, mid-brown hair in a long single braid, and a habitually fierce expression intensified by mismatched eyes, one brown and one blue. Now she reached out, seized the latte cup with one hand, and gave his arm a peremptory tug with the other.

"Come on!"

Suppressing a sharp reply, Gutierrez followed the girl and his coffee. Probably the clearing skies were encouraging activity in protesting demonstrators along with everybody else, but dealing with this kind of stuff was a pain in the butt at any time, and right now he had more important matters at hand. "Hasn't patrol been by?" Gutierrez called, as she darted ahead of him across Main. His instructions on Friday had included an order to increase the frequency of drive-bys at the clinic.

"Not in the past half hour!" She wore running shoes and jeans, and had a longer stride than he'd have expected. "Then when I called the police station and asked for an escort, at first they didn't know..." A woman pushing a stroller took up the middle of the sidewalk, and Jocelyn swerved around her, barking, "Look out!"

Gutierrez jogged past the woman with a muttered "Sorry," and caught up with Jocelyn. The Ferrar Hospital, and the Family Fertility Clinic, lay at the end of this block.

"...what I was talking about," she finished. "Then they said they didn't have anybody to spare. For escort. And Will's not coming in until ten and I can't get hold of him. Goddamn! Get out of there, you jackasses!" she yelled, as she reached the gate in the iron fence surrounding the dignified two-story shingled structure that had been Dr. Gabe Ferrar's hospital. The gate stood wide, and the broad flagstone walkway to the entrance was lined with maybe a dozen chanting people.

"God makes babies. Men make monsters."

Catching his breath from the run, Gutierrez registered the words and felt very, very tired. "People," he called, in a from-the-diaphragm voice that penetrated the chants, "you are on private property. Please leave now."

Voices went silent, and for a moment the only sounds were the hum of passing traffic, the rustle of shifting feet, and a cough from someone.

Gutierrez planted his feet, put his hands in his jacket pockets, and surveyed the assembly. "Rick Pastori? You and May have better things to do. And Ben Blakemore, Wendy—how would the two of you feel if a bunch of vegetarians blocked the entrance to your steakhouse?"

Four people, the men probably early forties and the women a bit younger, stood straighter and looked variously shamed, nervous, and confused.

"And Father Horvath. I'm surprised at you. Does Father Doran know what you're up to here?" The old man, a kind of priest emeritus at St. Joseph's, lifted his white head shakily and continued to finger his rosary beads. Two teenaged girls standing with him shrank back a bit.

"I'm not here as the voice of Holy Mother Church," quavered the old man. "I'm protesting immorality as a private citizen of the Catholic faith."

Gutierrez raised his eyebrows. The old priest wore what was surely the first full-length black cassock seen on the local streets in years. "Whatever you say, Father. You are a private citizen breaking the law, and I'm a public servant in my uniform of office asking you to stop doing that."

One of the girls reached to tug at a rusty black sleeve. "Come on, Father. My mom will have a fit if I let you get busted."

"You heard Chief Gutierrez. Your presence here is illegal and I demand that you leave immediately," said Dr. James Ferrar, who stood in the open doorway at the top of the steps. "We are busy people with work to do."

Gutierrez drew his shoulders tight and his mouth as well; good old Jimmy Ferrar, really knew how to work a crowd. As Jocelyn shouldered her way past Gutierrez and moved toward the steps, she tossed a glance back, and he could read similar thoughts in her mismatched eyes: Back to your lab, Daddy.

"You call that work? Messing around with women for money?" This from the broadest of a trio of boys—or young men, Gutierrez corrected himself. Past high school age, anyway; and from their looks, and their presence here on a workday morning, better equipped with muscle than with brainpower.

"And when you make a mistake, you just hit it with a needle or flush it down the toilet," drawled another of the trio. Gutierrez, watching muscular shoulders hunch and sneaker-clad feet shift, was seriously sorry he wasn't wearing a truncheon or even a big flashlight.

"You watch your filthy tongue!" Ferrar started down the steps and thought better of it, probably influenced by his daughter's grip on his arm. "Or you'll be hearing from my attorney."

"You are an evil man doing the devil's work!" The speaker was a gangling, fair-haired man in jeans and windbreaker who had a pre-school-age child at the end of either arm. The children were fair also, and blue-eyed; the girl had a thumb in her mouth, and was tugging backwards against her father's grip.

"These perfect children," the man cried, "were made by the Christian God and a Christian man and wife! Not by an atheist in a laboratory!"

The hard part here, besides watching faces and shoulders and fists, was trying to remember that most of these people took themselves very seriously. "All of you are trespassing on the private property of Dr. Gabriel Ferrar," said Gutierrez loudly, "and you have been asked to leave. I'm asking you again to return to the public sidewalk outside the gate, and to stay at least eight feet away from anyone approaching this place of business. That's a city ordinance."

In the muttering and shuffling that followed his words, he tossed a quick glance toward the steps and Jocelyn, who would be his best help. He only vaguely registered the slams of car doors on the street; but then came footsteps on the flagstones, and a forceful "Please let us by."

The man had a disappearing hairline and some lines in his face; but his shoulders were broad under a good tweed sports coat, and he moved with long-legged ease. He had a proprietary grip on the elbow of a thin woman with a tired, puffy face and threads of silver in her short dark hair.

As if on a signal the chant rose again: *God makes babies, men make monsters.* The three youths grunted to each other and rolled up onto the balls of their feet. The Pastoris and the Blakemores stood tightly together and kept casting wary glances at Gutierrez as they chanted. Two gray-haired women Gutierrez didn't know began to sing together in creaky sopranos: "Jesus loves me, this I know, for the Bible tells me so. Little ones to Him belong, they are weak but He is strong."

"What the hell is this? Get out of my way!" snapped the tweed-coated newcomer.

As the women squeaked up to "Yes, Jesus loves meeee!" the man with the perfect children let go of them and moved to block the walkway, head thrust forward and hands out in a pleading gesture. "Don't go in there, my friends. Trust your bodies and your children's

souls to God, not to atheists in white coats." He reached out toward the woman, as if to grip her shoulder.

"Keep your goddamned hands off my wife!" In a smooth series of motions the newcomer set his companion to one side, shifted and planted his own feet, and delivered two or maybe three punches that sent the other man flying.

As their father hit the ground, the children began to wail, the singers took up their song with increased volume, Father Horvath began to pray in Latin in his scratchy, thin voice, and the three young toughs charged, roaring.

Looks like the weekend's over, Gutierrez told himself, noting that the tweed-coated man was coming up behind his right shoulder and presumably preparing to take part in the rest of whatever this turned out to be. Gutierrez set himself in the path of the bull-necked leader, feinted to his right, then stepped left and met the boy's rush with a hard yank forward over his own outstretched leg.

The boy sprawled full-length on his belly and started to roll over; Gutierrez flipped him flat again with a good upward thrust on one flailing arm and a knee in his back. A flash of movement to their left turned out to be Jocelyn Ferrar; Gutierrez looked up just long enough to see her fling steaming liquid into the face of another boy, who howled like a stepped-on puppy.

"Stop right now. You're under arrest," Gutierrez snapped to the boy who was writhing and cursing beneath him. Cursing from somewhere else, too, and sobs; the tweed-coated man was astride the prone body of the third boy, delivering rhythmic slaps to the back of his head that banged his forehead against the ground.

"Okay, everybody, enough!" Gutierrez got to his feet and brought his captive along, pushing the bent arm up a notch. "What's your name, fellow?"

"Grebs, Arnie Grebs. Listen, my old man...ow!"

Grebs! Another jackass from that slow-witted, mean-spirited clan, surely one of Officer Alvin's all-male get. Gutierrez controlled himself and merely brought Arnie up on his toes with another nudge. "I can cuff you and take you downtown. Or I can let go of you, and you'll behave yourself. Which is it going to be? The same goes for everybody else!" he said loudly, looking around.

"I'll behave," said Grebs in a near-whimper. One of his friends

simply nodded, face wet and jacket-front stained with what Gutier-
rez, sniffing, identified as good strong coffee—his latte. The third
boy was still face-down on the ground, staying right where he was as
the man who'd flattened him stood nearby brushing himself off and
shooting his cuffs. His wife was near the steps now, being herded
along by Jocelyn. And Dr. James stood at the top of the steps like
some kind of high priest. No bruised knuckles or strained muscles
for Jimmy Ferrar.

"Dr. Ferrar?" called Gutierrez. He let go of the Grebs boy and
stepped to one side, to widen his field of view. "Dr. Ferrar, I'd appre-
ciate it if you'd give me a call when you've finished here."

James nodded curtly and turned to follow his patient, Gutierrez
assumed the woman was, and his daughter, into the building. The
tweed-coated man took a step in that direction, and Gutierrez called,
"Sir? Chief of Police Vince Gutierrez. If I could speak to you for a
moment?"

He turned, frowning. "Look, I don't have time for this." He
reached into the inner pocket of his coat, pulled out his wallet and
extracted a card, to hand it to Gutierrez. "I'll see you later. Right now
I'm supposed to be in there getting ready to jack off into a bottle."

"Ah," was the only response that came to mind. Gutierrez pocket-
ed the card and turned to face the now considerably diminished
group of protesters. No matter. The three not-so-toughs were still
here, he knew everybody else except the two elderly women, and he
could locate them if necessary.

"I'm going to bring charges against that man, Chief Gutierrez."
The God-assisted father, whose name was something Toler—Ralph,
maybe—was holding a handkerchief to his jaw. "You're my witness.
He attacked me."

"Not without provocation," said Gutierrez mildly. "But you do
what you want to. Now. *I* want everybody except for these three ya-
hoos to go home. And from now on, confine your protests to public
property. Or else."

"They're dirty people," spat one of the women, her face red as she
shot a venemous look after the man just disappearing into the build-
ing. "They talk dirty, they do dirty things in there. They're breaking
God's laws, it's *them* you should arrest."

Gutierrez drew a deep breath and felt the twinge of a pulled

muscle in his chest. "That kind of enforcement we'll leave to God, ma'am. It's out of my jurisdiction."

As she snorted and turned away, he barked at the youth who looked ready to follow her. "Just a minute, Grebs. And you two guys—names."

The hefty, dark-haired boy was local, from out in the county, and Gutierrez knew the family slightly. The smaller boy, skinny and spotty-faced, was a visitor from Redding. Gutierrez delivered a brief, low-voiced chewing-out that the trio took with heads lowered and mouths closed; then he announced that he wasn't going to waste his or the court's time on them today, but more of the same and they were dead meat.

Off they went in a rush, lumbering across the street just in front of the red Cadillac pulling to the curb. A moment later Dr. Gabe clambered out the passenger door of the Cadillac, which meant, Gutierrez noted with some concern, that he'd let somebody else—his grandson Will, who loomed now from the other side of the car— drive him. "Dr. Gabe? Are you okay?"

"Hell, no!" snarled the old man, leaning on his cane as he came slowly to his full height.

"I stopped to see him this morning," Will told Gutierrez, "and called here, and one of the other nurses told me the religious loonies were harassing us again." He swept the departing protesters with an angry glance. "So Granddad insisted on coming down."

"It's *my* place," said Dr. Gabe, waving his grandson away and moving onto the sidewalk. "Poor damned old pile that it is."

In bright morning light, the hospital's main building did have a derelict quality about it; several shutters hung crooked, shingles were missing, and no one had laid a controlling hand on the surrounding grass and shrubs in a very long time.

"Never looked like this in my day," muttered Dr. Gabe—not quite accurately, Gutierrez knew. "There's no goddamned respect for age these days," the old man went on. "Way it's being neglected, I ought to sell it. Pull it down for lumber. Burn it to the ground."

"Come on, Granddad," said Will soothingly. "Things are cool here now; let's go have breakfast, and you'll feel better."

"A few concerned citizens were expressing what they thought was God's opinion," said Gutierrez with a shrug. "It was touchy for a

moment; but Jocelyn and I handled it, with some help from…" He pulled the tweed-coated man's card from his pocket. "From a Bernard Hegarty."

"Hegarty?" Will frowned and looked at his watch. "The Hegartys weren't due for another hour."

"Well, they were just early, Willie." Jocelyn had come running down the steps of the clinic and now grabbed her tall brother by the arm, much as she had Gutierrez earlier. "You haul your gorgeous ass in there on the double and get to work. Poor Mrs. Hegarty needs your hand to hold and your shoulder to lean on, and you might even have to sing to her."

"You mean that poor woman ran into these cretins? By God, if any of them laid a hand on her, I'll find him and wring his neck!" Will said through his teeth, and set off at a lope for the clinic.

"What do you suppose the world would be like," said Jocelyn conversationally, "if everybody kept to his own beliefs and left other people to theirs?"

"Seriously different," said Gutierrez.

"Sometimes I think God or whoever should just scrap this whole failed experiment and try again," said Jocelyn. She seized Gutierrez's hand for a quick grasp, then turned and stretched to kiss her grandfather on the cheek. "Gotta go, eleven o'clock seminar," she announced. "Keep 'em up, guys."

If Will was a slightly blurred physical duplicate of Dr. Gabe, she was nearly his opposite. But in the set of her shoulders and the angle of her jaw, in her take-on-the-world attitude, Jocelyn Ferrar struck Gutierrez as the old man's true heir.

"Ain't she a pistol?" said Dr. Gabe, as they watched Jocelyn unchain a bicycle, fling herself astride it, and speed away in the direction of the university. "The nerve of a burglar, and the best brain the Ferrars have produced. Too bad balls didn't come with the package."

"Hey!" said Gutierrez, startled.

Dr. Gabe leaned on his cane and shook his head. "Sorry, young Vince. But you know I'm a totally unreconstructed male chauvinist. Get right down to it, women are too soft, too distractible, for the real work of this hard old world. Until they're about sixty, anyway. Then they're fine. Hell, I'd vote for a woman for president if I was sure she was postmenopausal."

Chapter 9

MEG SURVEYED the semi-recumbent bodies and blank gazes of the nineteen seniors who had actually made it to her first-period class. Your standard eighteen-year-old—supercilious, world-weary, glumly horny, or proudly hung-over—was particularly unlovely at nine A.M.; next year she'd request freshmen as starters. Crickets instead of toads.

"Since it's obvious that none of you has read the assignment..." she began, and a hand waved wildly above each of three offended female faces.

"Let me amend that. Since not enough of you have read 'Heart of Darkness' to make a class discussion worthwhile, I'm going to give you the rest of the hour to finish, or perhaps begin, that reading. Tomorrow there will be a quiz."

"Multiple choice?" This from Aaron Frankel, who probably had read the assignment but was always determined to be cool.

"Ho ho ho," said Meg in hollow tones. "The usual. Three questions, from which you'll choose one and write a short essay."

A chorus of groans greeted this; and from the rear of the room, several muttered phrases, just loud enough to be heard but soft enough, Meg decided, to be ignored this time. "And for any of you who may have forgotten his or her copy of *Great Short Works of Fiction*, there are extras on the bookshelf at the rear of the room."

So now she had condemned herself to—she checked the clock—thirty-five minutes of stultifying boredom; she'd have to move around just to stay awake. The would-be troublemakers in the rear of the room, Johnny diMarco and Greg Johanson, finally got to their feet under her glare and retrieved books. Propped them open on their desks but would not, she'd bet, turn a page in ten minutes. She made

a mental note to talk to the counselor's office again about these two; if they failed this last semester of English, a serious possibility, they would not graduate.

"Mrs. Halloran?"

"What is it, Rachel?" she said quietly to the ponytailed blonde, who had undoubtedly read not only "Heart of Darkness" but everything else in the book as well.

"I—I hope you won't mind my saying this, but my mother is, well, she's a therapist who volunteers at the battered women's shelter and…"

"I know, Rachel; I've met her."

"See, she says that sometimes it's educated women who have the hardest time asking for help. Because they think battering shouldn't happen to them. It's called denial."

"I've heard the term. Would you care to put it in context here?" Meg forgot to keep her voice low, and every head in the room came up.

Pink-faced now, Rachel persisted. "Well, everybody's been saying that you…that your husband, Chief Gutierrez…uh, cultural differences that can sometimes…" Her voice trailed off.

"*Everybody* has? How very interesting." Facing the rows of suddenly alert adolescent faces, Meg saw instead Officer Grebs, sour and suspicious, and baby-cop Boatwright, looking, in an old family phrase, as if he'd just killed a bear. She strode to the front of the room and turned to face the group. "Class? Listen up now.

"As most or all of you know, I am married to Chief of Police Vincent Gutierrez. Chief Gutierrez, who incidentally was born and raised in Port Silva, is not a man who beats up women—or anyone else. Chief Gutierrez did not do this." She gestured with both hands at her own face, from which the swelling had receded and the bruising faded to yellowing purple smears.

"But since this nasty subject has come up, I believe I should tell you that I was struck in the face, and then knocked down, last Wednesday night when I tried to stop a gang of boys who were beating up a derelict. It seems there are some young men in this town who think that sort of behavior is cool, or macho. I think it's cowardly and sick, and so does Chief Gutierrez. He also thinks it's illegal."

"Do you know who they were, the guys?"

The voice was so soft as to be unidentifiable, even genderless. And no one was looking now at anyone but Meg. Well, she thought, and in the breaths-held silence that seemed to fill the room she searched for the pale, wide eyes she'd seen that night. Didn't find them, or at least she didn't think so. Certainly not in the face of any male who, standing, would measure six feet or better. Tell them no, she instructed herself, but the best she could manage was, "Not yet."

Lieutenant Carl Hanson might have been to the uniform born; the color suited his Scandinavian fairness, the cut his trim, erect frame. If he had a flaw, it was his total lack of a sense of humor; not that humor would have helped much here, thought Gutierrez, as he looked over Hanson's shoulder at the proposed duty rosters.

"I take full blame, Vince," said Hanson. "I didn't get the order into the right channels, that's clear."

If Hanson was unwilling to identify the wrong channels by name, Gutierrez would leave it at that. For the moment.

"Ideally, we'd just post an officer down there for a few days. But with what the flu's doing to us, I would be hard put to justify that use of manpower."

"Maybe we could issue the mayor a sidearm and send him down," said Gutierrez. "Okay, Carl, just see that patrol makes the place a priority. And we will have someone to respond when specifically requested, even if it has to be me. Or you."

"Yessir." Hanson made a note.

"For the rest of it, you're right, it's our only choice," he said. "Except, I'd start beefing up those outlying patrols earlier, at the start of second watch. With the mill shut down, guys are heading for the Fisherman's Rest or the Double-Bit right after lunch."

Hanson nodded grimly. "And twice last week we got calls to back up sheriff's deputies out in the county, at the Rainbow Tavern. There are too many bars around here. What we ought to do is shut them all down for a while."

"So out-of-work guys could just drink at home and beat up on their families instead of each other? Besides, bar owners have rights, too."

"Yes sir. But the downtown merchants are going to raise several dozen kinds of hell about pulling protection out of their area."

The downtown merchants, who were a majority on the city council, which was determined to cut the police budget. Gutierrez bit back a reply that would have turned Hanson's ears pink and said, instead, "Don't worry about it. It's my job to take the heat, and the calls. Now here's what else I mean to do." During his weekend at home Gutierrez had shuffled and reshuffled his stretched-thin force.

"I'm not assigning anyone to replace Captain Svoboda," he told Hanson. "I'll put in a few more hours myself, and I'll be talking to Hank regularly. Since Lieutenant Markham has extended his leave of absence, I'm moving Johnny Hebert up to acting lieutenant, Investigation, and I'm shifting Linhares and Kuisma to Investigation on a temporary basis. With Chang, that makes four. We'll have to pick another team, preferably a man and a woman, to handle domestic violence response—you work that out, and don't be noisy about it because his honor Mayor Lindblad thinks it's frivolous use of personnel.

"And if any officer wants to complain about any of this, tell him or her to see me."

"Yessir," said Hanson in tones of relief. He swept up the papers scattered across Gutierrez's desk, shuffled them back into their folder, and headed for the door.

"Oh, Carl," Gutierrez called after him. "Grab Chang and Linhares and send them in, will you? And Hebert, if he's around."

But the man who put his head in the office doorway moments later, after the most perfunctory of knocks, was Mayor Lindblad. "Vince? Got a minute?"

"Oh, I think so. Come in, Lyle."

Lindblad smiled, stepped in, and closed the door. He came quickly across the room, pulled the wooden captain's chair from before Gutierrez's desk around to one end, and sat down, adjusting the knife-edge crease in his light gray trousers as he did so. His black loafers—Bally, Gutierrez thought—had not negotiated any sheep pastures recently.

"Sit down, sit down," the mayor said. "Just a couple of questions about how things are going, won't keep you long. I'm not one to interfere in the schedule of a busy man—run a tight ship myself."

Gutierrez nodded and sat.

"I understand you personally helped to, um, defuse the situation at Dr. Ferrar's clinic this morning."

Oops, thought Gutierrez. Jimmy complaining, no doubt. And in fact the man had reason.

"I did, but it shouldn't have been necessary. Someone here apparently didn't understand that last week's order for an officer available for duty there is in effect until countermanded. My fault, and it's been taken care of."

"Good. That's good. I don't know whether you realize it, Vince," said Lindblad, leaning forward in confidential fashion, "but Dr. Ferrar has plans for his clinic that could give a real boost, a real cachet, to our community."

"I've heard something about his plans."

"You see, what he envisions is a full-fledged hospital with extensive staff, with possibly a kind of residential facility connected so that, for instance, a husband and wife could be together in comfort in the intervals between these…procedures, whatever they are. Dr. James Ferrar is a very talented, valuable man, a star in his profession. He could really put Port Silva on the map."

"It sounds like something that would bring jobs," said Gutierrez.

"Right! Exactly right. So you can see how important it is that no scandal attaches to his clinic; we don't want to appear on national television as the kind of place where people wear garlic necklaces and wave crosses around." The mayor, Gutierrez knew, was a hardrock Baptist. Probably he regarded rosaries as toys of the devil.

Now Lindblad shook his head sadly. "Dr. Ferrar told me that another couple, scheduled for an appointment this morning, arrived as you were quelling the protest; they drove right past and called to cancel. We can't have that."

"No, of course we can't. We won't."

"I felt sure that would be your position," said the mayor, getting to his feet and reaching a long arm across the desk for a firm, manly handshake. "With the belt-tightening every city department is having to do, I know your staffing is thin, but I'm sure you'll wrap up this nasty business with the illegals quickly."

"Illegals?" A stiffness gripped Gutierrez's shoulders and neck and threatened to reach his jaw.

"This Mexican woman who got herself killed."

He made an effort to keep his voice easy. "Her name was Mrs. Esperanza Moreno, and she was a U.S. citizen, born in this country. And a tax-paying employee of a local company."

"Hm. You know, I have to agree with our governor that granting citizenship to the children of illegals simply because they happen to be born here is not sensible."

"Maybe not. But it's constitutional."

Lindblad blinked, and then narrowed his greenish eyes. "Don't presume to instruct me in the Constitution, Gutierrez. I've studied law, and plan to finish my degree as soon as I have time."

Listen, buddy, mine is bigger than yours, said Gutierrez silently. Possessor himself of a master's degree from Cal, he was fairly sure that the mayor had put in, at most, two years at Humboldt State. "Mrs. Moreno was murdered in Port Silva," he said in flat tones. "It's my sworn responsibility, and that of my officers, to find out who committed that murder. I *hope* we can do it quickly and efficiently."

"I hope so, too, Chief Gutierrez. I just wanted to be sure we agreed on our priorities here; we don't want to give any suggestion of an...ethnic bias. Do we?"

"We absolutely do not," said Gutierrez with total sincerity.

"Good. Well, I'll let you get on with your work," said Lindblad. At the door he turned and said, with a toothy smile that made Gutierrez think of the possum Grendel had recently cornered in the garage, "Be sure and keep me posted."

"Absolutely," Gutierrez said again, lying with a completely straight face.

By the time his team arrived five minutes later, Gutierrez had scanned the latest reports on the murder investigation. The memory of Esperanza Moreno's abused body was still making knots in his gut, but so far nothing had turned up to disprove Chang's original belief that this was a domestic crime. And if Rubén Moreno had indeed killed his own wife, Gutierrez wanted that fact established as quickly as possible, both as Espy's due and in the best interests of his edgy, troubled town. Let justice not only be done, he thought grimly, but be seen to be done.

He tossed the sheaf of papers at his desk, poured himself a mug of

coffee from the coffeemaker atop a low bookcase, and waved the others to coffee or seats or both. Johnny Hebert slumped his big body into the chair just vacated by the mayor, and filled a mug with tea from the stainless steel thermos he'd brought with him. Alma Linhares grabbed a mug, slopped coffee into it, and yanked a straight chair away from the wall to perch on its edge. Ray Chang, as usual, chose to pace the room in long strides.

Gutierrez propped his rump against the front edge of his desk and held his own mug in both hands, eyeing his most experienced, capable troops. If they were resentful of his unaccustomed meddling in their work, they were concealing it well. "As of an hour ago there's been no word," he told them, "from any agency here in the state, or from the California–Mexico border towns, or the Mexican authorities in Baja, on Rubén Moreno. Or on any vehicle and group fitting the description of the Moreno car and family. I've asked everybody to keep looking."

"Esperanza's car isn't telling us anything," Ray Chang said. "Prints everywhere, hers and probably her kids'. Smears on the wheel, no usable prints there—maybe she wore gloves to drive, maybe somebody wiped it. Lots of the usual debris—paper cups, candy and fast-food wrappers, a pink plastic hair clip and a couple of those elastic things for braids or ponytails. A box of used crayons. Nothing at all that looked like it belonged to anybody but the lady and her kids."

Gutierrez nodded. "Alma, have your bank friends turned up anything?"

She ran a hand through her mop of blue-black hair. "Like I said in my report, I didn't find anything under Esperanza Moreno—no checking account, no savings account, no safety deposit box—not in Port Silva or Mendocino or Boonville.

"But," she added, holding one hand up, "I've made a list of other names she might have used—from her baptismal certificate—and I got a snapshot of her from Graciela Aguilar on Saturday, had it blown up, and I'll hit the banks this morning. And the shops that might have sold the silk stuff, too, I've got a couple of leads there."

"Fine," said Gutierrez.

"Thing is, supporting herself and two kids and sending money to her husband, could be she never had enough left to need a bank account," Alma added.

"Could be," said Gutierrez. "Ray, how long had Espy worked for Ed Morgan at A-One?"

"That was interesting," said Chang with a thoughtful tilt of his head. "She started with him about a year and a half ago, shortly after she and Rubén came to town. She worked into the following summer, mid-August, and quit. She came back, uh,"…he paused to riffle through his pocket notebook… "first of December, he put her right to work, and she was still officially his employee until she was found dead."

"Did she give him a reason for leaving in August?" asked Gutierrez.

"Not in so many words. But he figured she was just going home to Mexico to have her baby with her husband and family around."

"Hey!" Alma snapped to attention. "Not one person at the Winner's Circle said one goddamned thing about a new baby!"

"When I pursued this," said Chang, "he shrugged and said that when he was hiring mostly these young Hispanic women, somebody was always pregnant. As he remembers it, Esperanza looked pregnant."

"But look," said Alma, "with two kids born in this country, why would Espy amble off to give birth to the third in Mexico? Especially with the illegal-alien situation so iffy in California. Doesn't make any sense to me."

"And it doesn't jibe with anything we've heard about her—from Graciela in particular." Or from Dr. James, Gutierrez added to himself. "Doesn't Ed Morgan still employ Hispanics?"

"Not anymore," Chang said. "He says he's got very nervous recently about being fooled by forged papers. Also, he said there are so many local women in need of jobs right now, women whose husbands are out of work, that he doesn't feel right about hiring immigrants."

"Hah!" said Alma. "What he means is, if he can get white women cheap enough, then he doesn't have to mess with brown ones who talk funny."

Gutierrez ignored this. "But he rehired Espy Moreno?"

"I asked him about that. He said she was his best worker. And he said he liked her."

Everybody liked Espy. Except somebody, thought Gutierrez. He drained his coffee mug and set it on the desk behind him.

"Saint Esperanza," said Alma. "Everybody loved her but her

husband. And probably he thought he did, too."

"Probably," said Gutierrez glumly. "Okay, putting the pregnancy business aside for the moment, did anybody at the Winner's Circle think Espy had a secret life of some sort? A boyfriend?"

Alma shrugged and spread her hands. "The two women who said they didn't like her? They said she went out sometimes in the evenings—by herself in her own car—and must have had a boyfriend. Mrs. Gonzales says Espy was a good girl and wouldn't do that; she sometimes had cleaning jobs at night, and anyway she never came home very late. Nobody will admit to seeing her with a man there at the motel—nobody came to pick her up, nobody visited her."

Virtuous, hardworking, likeable, and keeper of her own secrets. Gutierrez shook his head in irritation. "The only person who's come across as close to her was Gracie Aguilar."

"Best bet," Chang said with a nod. "I tried to pry her loose from her relatives Saturday, but I couldn't manage it; turns out she is not married, is not quite seventeen, and Luis insists he's her guardian. What I figured is that today, after the sister and brother-in-law go to work, I can get to Gracie. Maybe bring Alma along to watch all the kids, and I'll take her out for coffee."

"Good," said Gutierrez, before indignant Alma could get her mouth open.

Gutierrez refilled his coffee mug and moved around to sit behind his desk, where he riffled briefly through one set of papers. "The Gonzales boys. Anything?"

"A pair of macho little hoods," said Chang flatly. An eldest son who'd spent the last five or six years helping his widowed mother raise his two younger brothers, he had a jaded view of adolescent males.

"No, they're not!" retorted Alma. "The big one was polite, and very sweet to his grandma. The little one kept flashing his teeth and making muscles, but he got tears in his eyes when we were talking about Espy. They were on the fringes of a gang down south—mostly the little one, Jesús, I bet—and their dad sent them up here to his parents. They attend school regularly, and have not been in any trouble."

"They insist they were home on Wednesday from supper time on," said Chang. "And no one at the motel will say otherwise."

"Okay. Now, on one of our other major problems—which probably doesn't connect, but who knows?—Johnny?"

Johnny Hebert slouched back in his chair, his comfortable belly and hooded blue eyes lending him the look of an affable Buddha. "You all know about the burglary last Wednesday night, at Dr. Ederle's place on Plover Drive?"

Chang nodded, and Alma said, "Right, Karen Ederle. She took the self-defense class I teach at the Y. Nice woman."

"She lost a lot of high-quality electronic gear, jewelry, a very expensive racing bike, a coin collection, and some money. The burglars also pulled her house apart and trashed it, which is why we think it was kids. But we've had a call from a very upset man who lives two doors from Ederle. He and his wife drove to San Francisco Wednesday morning, got home Saturday afternoon, and found that their place had also been burglarized and torn up. Probably the same night as Ederle's."

"Hey!" said Alma. "Didn't we look the neighborhood over, when we answered Karen Ederle's call?"

"'We' didn't," said Hebert. "As Sergeant Dunnegan was seriously disappointed to hear."

"Pissed, I bet."

"Right. Seems the officers responding rang a few doorbells nearby, found nothing amiss, and didn't bother to check the houses where no one was home."

"And I can guess who the lazy bastards were, too," said Alma, her eyes flashing. "Alvin and probably…"

"Sergeant Dunnegan will take care of it," said Gutierrez, in tones that brought Alma's mouth shut with a snap. "Johnny, go on."

Johnny Hebert's face lost its amiability. "Mr. and Mrs. Woods did what they've done in the past when spending several days in the city—left their dog in their heated back porch with an automatic feeding-watering arrangement and a dog-door access to the backyard. The people who broke in killed the dog, cut its throat. A totally unnecessary bit of meanness," Hebert added. "It wasn't a watchdog, just a half-blind old family pet that had never bitten anyone in its life and wasn't even much of a barker. My point is that these guys are getting meaner and enjoying it more. We need to find them."

"Did you turn up anything on Svoboda's short list?" asked Gutierrez.

"Nothing that would get us a search warrant, and none of them is on parole or has any kind of charge pending right now," Johnny said with a grimace of distaste. "Marino has been in Alaska since last fall, according to his sister. The other three worthless humanoids are lying low and crying poverty. Olson lives a bit better than Hamm or Tetter, but he has a working wife. We're staying on them, as much as we can."

"Bastards!" said Alma through her teeth. "We need to push them harder." Alma's vast Portuguese family had lived on the north coast for generations, and there was little that went on in Port Silva or the county nearby that some brother or aunt or cousin didn't know something about or know somebody who did or could find out. Now she rose and squared her shoulders and ran smoothing palms over her hair: gearing up for action.

Vince Gutierrez had known Alma most of her life. Now in her midtwenties, she was a strong, handsome woman, broad-shouldered and deep-chested, full of energy and humor and self-confidence. Like Esperanza Moreno. Like Meg. And he hated the thought of any of them being out on the streets with the people who beat up derelicts and killed old dogs. He stopped himself just short of admonishing Alma to be careful. Instead, he said, "Val Kuisma is going to work with Johnny on this; they're going down to the high school this afternoon, to talk to the counselors. So you stay with Ray on Esperanza Morales. And find out from Graciela Aguilar or Mrs. Gonzales whether Esperanza was pregnant. And if so, when."

"It's interesting," said Alma. "Maybe she got rid of it, and her husband found out and killed her. Or maybe it wasn't his, and he…"

Gutierrez frowned at Alma and made a waving-off gesture with one hand. "Look for evidence, but keep your speculations to yourself. Sometimes thoughts leak, and turn into rumors. Nobody needs rumors."

Chapter 10

IT WAS NEARING two o'clock and Gutierrez was beginning to feel the pangs of a missed lunch when a discreet knock sounded on his office door. He looked up to see his secretary, Alice Murphy, and then, peering from behind her at shoulder level, a round face with mismatched eyes.

"Vince!" Jocelyn Ferrar sang out, as she lunged at him for the second time today. He managed to get to his feet just in time to meet what turned out to be a vigorous hug. Alice blinked, shrugged, and left, closing the door behind her.

"I came to tell you how grateful we are, Daddy and I, for your help this morning."

"Just doing my job," he said, and then grinned at the pompous sound of that. He returned her hug before setting her away. "You just made not only my day, but Alice's."

"Your secretary?" Jocelyn tossed a look toward the door. "She was not eager to have me come in here. I bet she's in love with you."

"For my health, you'd better hope not," said Gutierrez, pulling a chair forward and then retreating to his own, behind the desk. "Sit down. Alice's husband is an ex-Marine logger twice my size."

Jocelyn leaned over to set a package in front of him, then sank gracefully into the across-the-desk chair. A clinging white shirt with a wide V-neck was tucked into belted jeans, revealing a tiny waist and the lightly freckled tops of full breasts. Noting that his earlier judgment, "chunky," was obviously all wrong, he wondered why she was wasting this display on an old guy like him.

"You forgot your coffee," she said, with a gesture at the package; and he belatedly recognized the damp and grass-stained bag from Coffee Connection. "I guess you dropped it when the action started,"

she went on, "and by some miracle it didn't split. But I still owe you a latte."

"Forget the latte; it saved me a punch," he said. "But I'm glad to see the coffee. Jocelyn, you can tell your father I've made it clear around here that the clinic is to have protection, and an escort when requested. Is it quiet there now?"

She grinned widely. "Good guys one, assholes zip, thanks to you. So I came to apologize for practically kidnapping you right off the street. And to let you know," she added, sobering, "that we, that the clinic, is not going to be a constant problem for you guys. Generally the place is just like any medical office. Most of the clients have come for interviews, physicals, preliminary workups and consultations; they're not going to panic at the sight of a few demonstrators."

"The mayor was saying today that your father would like to develop a real hospital, with a residential facility."

"That would make it easier at the end, sure. What happens is, once a couple's been accepted as good candidates, Dad and his staff set up a treatment schedule. After that, the day-to-day stuff—shots to goose the ovaries into overproduction, blood tests for hormone levels, ultrasound monitoring of follicle development—is often done by the woman's own gynecologist. All depending on where she lives, how much her own doctor wants to be involved, what his lab facilities are, like that.

"But when it gets to the final countdown, about a week later," she went on with a grimace, "Dad and Marilyn Wu—she's an embryologist Ph.D., not an M.D.—do the heavy-duty stuff. By the time a patient has reached that stage, she's got no energy to spare for pushing her way past foul-mouthed mental defectives. *That's* why I tackled you today."

"My pleasure," he told her.

She grinned again. "My dad asked me to tell you that he won't need escorts until Wednesday, when the Hegartys come back. Tomorrow he'll be at the hospital here, Good Sam."

Gutierrez raised his eyebrows. "I thought he was having trouble getting privileges at Good Sam."

"Depends on the procedure." She propped her elbows on the chair arms and tented her fingers under her chin: professorial. "What's on tomorrow is called GIFT—gamete inter-fallopian

transfer. No pregnant-in-a-dish, test-tube-baby stuff, no embryos for mere humans to mess with, just a transfer of capacitated sperm and retrieved eggs to the fallopian tubes. But it's a surgical procedure and has to be done in an operating room.

"Now if Good Sam were still officially a Catholic institution," she added, "even GIFT would be a no-no, because of course it involves masturbation instead of a 'conjugal act.' Isn't that weird? But for the present at least, the hospital administration draws a slightly more liberal line."

"So what was happening with the Hegartys today?"

"That was setting up for a standard IVF—in vitro fertilization. Eggs are retrieved by needle aspiration under ultrasound, mixed with sperm, and incubated for a couple of days. Then the pre-embryos, if there are any and they look good, will be injected into the woman's uterus with a catheter. Test-tube babies, these are, considered evil by many Catholics and some other people. But it's the only way for Mrs. Hegarty, because her tubes are totally shot." She frowned at Gutierrez's expression, reached for a piece of paper that lay on his desk, picked up a pencil, and sketched rapidly.

"Okay, look," she commanded after a moment, and presented a drawing that looked vaguely botanical. "Even if you have a healthy ovary producing a good mature egg..." she pointed with the pencil "...and a hearty little bugger of a sperm that's managed to butt his way through all the physical and chemical obstacles ahead of about a gazillion of his buddies, it's all a waste unless there's a clear tube, here. That's where they need to get together. Then it's on down to the uterus, there, where other problems may arise." She dropped the pencil, sat back, and dusted off her hands. "But that can wait for the next lecture."

Gutierrez felt a pang of guilt as he remembered the pale, tired-looking woman who'd been forced to run a gauntlet at the clinic this morning. "How is Mrs. Hegarty?"

"Tired, and probably sore," said Jocelyn. "But let me tell you, the women who go through this shit are the toughest people on earth. The guys get their egos bent some, and they hate having to look at dirty pictures and jack off on command.

"But the women—they let themselves be poked and prodded and invaded over and over again with instruments and lights and

cameras. Sliced open here and there. Inflated," she added with a grimace. "And chemically messed with, so that an ovary will produce not one but a whole litter of eggs. Which then get inspected and *judged* by my father and Marilyn. I cannot imagine ever wanting *anything* as much as those women want a baby," she said flatly.

"Are you a nurse, like Will?" he asked.

Her head-shake was accompanied by a slight frown. "No. I got my degree in biology, and for the moment I'm doing some grad work and trying to decide about med school."

"But you know enough to be of help to your father."

"I'm mostly go-fer and muscle, plus clerical. In addition to lacking training, I've got absolutely no talent for dealing with people. My brother got the charm as well as the looks in our family," she added cheerfully. "The other nurses at the clinic are good, but Will is awesome. When he puts on his serious look and explains exactly what's going to happen, dear, those ladies just lie back and smile.

"I think," she said more slowly, "that Will is so lovely with women because he was really close to our mother, spent a lot of time with her when she was sick. I was only seven when she died, but Will was seventeen."

Before Gutierrez could frame a reply, there was a rap at the door and a somber-faced Ray Chang looked in, nodded, and took a step in retreat.

"Ray. Come in. This is Jocelyn Ferrar. Jocelyn, Sergeant Ray Chang—one of my right-hand men."

Jocelyn stood up and settled her purse over her shoulder. "Hi. We were just having a little biology lesson. It always surprises hell out of me that guys know so little, when they're the ones who cause most of the trouble. And make all the rules." She nodded at Ray, handed him her drawing, said, "Thanks again, Vince," and left.

Chang stood where he was for a moment, his gaze following Jocelyn down the hall. "I don't think I ever knew anybody with different-colored eyes. Is she from around here?"

"She's a grad student at U.C.," Gutierrez said. "And her grandfather says she's a pistol. Are you coming in?"

"Oh. Yeah." Chang looked at the drawing in his hand, then folded it twice and tucked it into a pocket. He moved inside, closed the door, and glanced hopefully toward the coffee pot.

"Help yourself. It's fresh," said Gutierrez, and sat back to wait. His sergeant was not happy, which probably meant he believed he had failed in some way. Chang was his own harshest judge.

"Thanks." Chang poured coffee into a mug, spilled in some sugar, and came to stand before the desk. "First thing, I have to take the hit for another fuck-up. Graciela Aguilar is gone."

"When?"

"Last night, some time after eleven o'clock. She waited until Acuña and her sister had gone to sleep, then took Acuña's car keys and drove off in his car. Apparently she wasn't planning to come back; she took most of her clothes and personal belongings." Chang was holding his shoulders high and stiff. "Sorry."

Gutierrez hoped the apprehension knotting his gut was not reflected in his face. "We couldn't have held her, we don't have the manpower for full-time surveillance, and I wouldn't have thought she was a major flight risk. Sit down, Ray."

"Yessir," said Chang glumly, and obeyed.

"What did her people have to say? Did they report her missing?"

Chang shook his head. "Luis Acuña figures this is family business and none of ours. But his wife, Dolores, was upset enough to ignore him and tell me what happened."

He paused for a sip of coffee, then sighed. "Graciela's boyfriend, the one who got her pregnant, is due back here soon from Washington state, where he's been fishing. He's more than willing to marry her. Graciela doesn't want to get married; Luis told her she has to, he wasn't going to feed and house a slut and her bastard. Graciela kept saying no; Luis slapped her around some and was taking his belt to her when Dolores made him stop."

"So she took off," he said, letting his shoulders slump. "Poor little Gracie, she's just a kid herself."

"Did Acuña file a stolen car charge?"

Chang shook his head. "He says the last thing they want is the Highway Patrol coming down on a poor pregnant Hispanic girl. But Dolores figures worse than that could happen, so she gave me a description of the car and its license number. I put out a bulletin, saying we wanted her stopped and held as a material witness."

"That's about all we can do," said Gutierrez, hoping the spirited girl-child he'd talked to in the rain was in fact on the road with a safe

haven in mind. "Did her sister have any idea where she might be headed?"

"Probably south. They lived in L.A. for several years, and Dolores thought Graciela might have kept in touch with a school friend there. The two women don't have any family in the U.S."

Gutierrez rolled his chair back and got to his feet, to move around and stretch against the onset of stiffness from his morning tussle with the Grebs boy. Not much exercise in his life these days; he should get into a program. Should cut back on the booze and rich food, too. So he could live to a creaky, cranky old age and be even more useless than he presently felt.

"What more did you learn about Esperanza Moreno?"

"She lost her baby. Women always say it that way, and I always think it's strange," he added parenthetically. "She was definitely pregnant, Mrs. Gonzales says from when Rubén came for a visit last February. Mrs. G. says Esperanza wasn't very happy about this pregnancy but she'd have gotten over it once she had a sweet little baby to hold."

"But she didn't get the chance."

"Last August, when she was some six months along, she told Mrs. G. that there was something wrong with the baby, and she was taking her kids and going away to a special doctor who'd been recommended to her. When she came back, that was the very end of November, all she'd say was she'd lost the baby. Just talking about it had Mrs. G. in tears again."

Gutierrez poured himself a mug of coffee and returned to his desk. "Did either of the women know who her doctor here was?"

"Mrs. G. said that so far as she knows, Esperanza just went to 'that place for women,' by which I think she meant the Women's Wellness Group downtown. Dolores Acuña had an idea that Esperanza was seeing a private doctor; Graciela's the one who would know, she says." Chang grimaced at this reminder of his own failure.

"Anyway, I'll check with all the local doctors who do obstetrics. It could be that whatever went wrong with the baby was something Espy's husband blamed her for, and that's why he beat her up. And maybe came back and killed her."

About to suggest that he add Dr. James Ferrar to the inquiries list, Gutierrez reconsidered. Jimmy was in a complicated position at the

moment, anathema to some and sacred cow to others. Better handle Jimmy himself.

"Another possibility," said Chang, "is that she had an encounter with her local friend, the guy who bought her the silk underwear. Maybe she told him she was leaving town with her husband, and it made him mad."

Gutierrez tried to imagine getting mad enough to do what had been done to Esperanza Moreno—either time. The fact that it happened every day didn't make it any more comprehensible. "There's something else we should keep in mind," he said, setting the coffee mug aside with a grimace.

He was definitely not going to give up booze. In fact, in—he looked at his watch—about two hours he'd be sipping a martini on his deck. Maybe wearing a windbreaker or even a down vest, but definitely on his deck and definitely a martini.

"Like what?"

"Like the fact that Esperanza was killed near the time, and possibly near the area, where my wife and the dreadlocks guy ran afoul of the gang that might be our housebreaking vandals. Suppose she was out that night for whatever reason, down there by Pelican Point, and they happened on her. High from beating up people, ransacking houses, killing dogs."

Gutierrez got up again, to open his door and look down the hall. "Kuisma should be back soon; he was going to the high school to sniff around. If the vandals are local, as I think they are, they're either in school, or have recently dropped out or graduated. And probably they have brothers or sisters or cousins there. Somebody has got to show up nervous, or scared, or maybe even just suddenly prosperous."

"Maybe I'll run into Val," said Chang, getting to his feet. "I'm going over there for another chat with those Gonzales kids. There's a chance they saw Graciela last night or even talked to her. They're close to her age and lived practically next door."

About to tell him to soft-pedal his approach to the boys, Gutierrez wondered for a moment whether he was demonstrating ethnic bias. Probably was. Too bloody bad. "Walk easy with those kids," he said. "Their age, their background, they'll sure as hell meet tough with tough, and you won't get anything but trouble."

Chapter 11

HOPING SHE HAD the stamina for coping with one more adolescent, Meg turned off Main Street and headed into the tiny Finn Park neighborhood, where a cluster of cottages and the historically registered Finn Hall were what remained of a turn-of-the-century Finnish commune. She parked in front of Charlotte Birdsong's neat wooden house, got out, and looked up and down the quiet street with mingled disappointment and relief; Cass's little red Subaru was nowhere in sight. So much for her "chance" encounter with Vince's niece.

Maybe Charlotte had rearranged her piano-teaching schedule. Should have called first, she told herself, as she climbed the front steps and pressed the doorbell. "It's Meg, Charlotte," she called. "Don't hurry."

The door opened on a waft of warm apple-and-cinnamon-scented air. "I think I'll just stand here and breathe," Meg said to her friend, who wore a long denim apron over her jeans and shirt.

"Come inside to do that; it's getting chilly." Charlotte closed the door and tilted her head to look up at Meg's face. "Um. Not bad. But after a full day at school, I'll bet you're ready for a glass of wine. Cass didn't come for her lesson today," she added over her shoulder as she led the way to the kitchen.

"Oh." Meg didn't bother to ask what had made her unannounced quest apparent. Charlotte Birdsong's perceptions were so sharp as to startle anyone who didn't know her well. Nothing psychic or mystical about it, Meg had decided; more a matter of focus, a mind not susceptible to distraction.

"Did she say why she wasn't coming?" Meg sat down in the rocker and accepted a wineglass glowing with what proved to be a nice

fruity zinfandel. "Thank you, Charlotte."

"It feels like a day for a red," said Charlotte. "Although I'll have milk, to get my quota. Cass didn't call to cancel; she simply didn't turn up."

"I'm sorry."

"Good heavens, it's not your fault. She's been here only in body for the last two lessons; her mind was somewhere else."

"No wonder," said Meg, and told Charlotte of the most recent conflict between Cassandra Gutierrez and her mother. "Mary Louise is so stupid!" Meg said through gritted teeth. Then, after a sip of wine, "No. She isn't stupid, nor even really mean; it's just that she has absolutely no imagination. Nothing beyond her immediate perceptions has any reality for her."

Charlotte took two baking sheets from the oven, set them on a shelf at the back of the stove, and came to sit in her wicker chair. "Cass isn't very musical, but she's been dogged about practicing. It seemed to me she was re-inventing herself—filling in the experiences she thinks she would have had if she hadn't gone off the rails. But she also enjoys spending time with me, and talking about cooking. That's why I'm a bit worried."

"Off the rails" was as good a term as any for Cass's former life. Enjoying her freedom in a new town and job, Mary Louise had failed to notice (or maybe hadn't cared) that her live-in, unemployed boyfriend was routinely forcing sex on her thirteen-year-old daughter. When the boyfriend moved on, honor-roll student and gymnastics team member Cass drifted gradually into truancy, alcohol, and occasional drugs, and finally a position as "one of the girls" in a gang of lawless hoodlums.

Charlotte had heard much of this sorry tale, in snippets from Cass subsequently edited by Meg. "She hasn't paid us any of her usual drop-in visits lately, either," said Meg. "And if I hadn't been so wrapped up in my own miseries, I'd have checked on her sooner. May I use your phone?"

Charlotte merely nodded toward the instrument on a nearby counter, and sat quietly as Meg called first Cass's house, where there was no answer, and then the truck-stop restaurant where she worked.

"Very strange," said Meg, when she had replaced the receiver. "Cass quit her job over a week ago. The manager was more unhappy

than angry; he says she was a good worker and a helluva cook."

"There's nothing dogged about Cass in a kitchen," said Charlotte. "She has wonderful instincts and limitless patience, and she's going to be a fine chef someday."

"From what I've heard of chefs, she has the temperament for it," said Meg. "Testy, arbitrary, uncommunicative. But she's not going to get there unless she finishes the work-study program her counselor worked out—especially for her, I might add—and gets her high school diploma."

"Hungry Wheels was not her best slot," said Charlotte. "Boring, she said. And sometimes she had to wait tables. She hated that."

"But it paid better than the others," said Meg. "And I know she liked the money. She's still repaying Vince for her car; at least, I think she is. Well, damn, I guess I'd better sneak in to see her counselor tomorrow. I try not to get between Cass and her mother. Nor even between Cass and Vince."

"Noninterference, your most difficult role," murmured Charlotte.

"Damn right," said Meg, and paused at the counter to pour herself another half glass of wine before resuming her seat. "So, let's see what news I can bring from the outside world. The school population was on edge this afternoon, because a couple of cops—Johnny Hebert and your Val, in fact—were there asking questions about something. Probably trying to get on the trail of the housebreakers. And I heard there was another fuss at the fertility clinic this morning."

"I am a well-informed stay-at-home," said Charlotte. "Petey told me about the cops; the poor kid wanted to be indignant about civil rights, but was having a hard time because the big bad cop was also his hero and stepfather. And when Val came home for lunch, he told me about the clinic. Which made me indignant, I have to say."

"Pregnant women should hold calm thoughts," said Meg, schoolteacher fashion, to the calmest person she knew. Then, with a frown, "I have a colleague who's attempting to get her insurance company to commit to paying part, at least, of a shot at in vitro—which I understand can involve five to eight or ten thousand up front. She's been trying for years to conceive, and she's about run out of time." Meg gave a push with one foot to set the chair rocking. "Charlotte, how would you feel if you wanted to have a baby and couldn't?"

"Surprised."

Meg gave a bark of laughter, and Charlotte shrugged and laid a hand on her belly. "I didn't do this on purpose. I'm pleased about it, though, because Val is thrilled, and because he's promised it will be a girl."

"*Has* he! And what has he offered as guarantee?"

"Six sisters," said Charlotte with a grin. She sobered then, and shook her head. "Most women I know have the opposite problem: avoiding pregnancy. As I would have, had I been either married or— friendlier. But I think this particular failure turns into obsession, and I don't understand obsession."

"I might. If I gave it a try. But I'd rather not." Meg stood up, carried her empty glass to the sink counter, and looked out the window. "Clouding up again, what fun. Thanks for wine and conversation, Charlotte. Vince is so—so sad, and angry—these days that I try to get home before he does and start a fire in the fireplace, put some good music on the stereo. Make a cozy haven so we can pretend not to hear the barbarian hordes at the gates."

Charlotte gave a little shiver as she got to her feet. "Ooh. A cauld grue, my mother used to say. Let me put some tarts on a plate for you to take along—comfort food."

The Gutierrez family home—Cass's house now—was also wooden but about four times the size of Charlotte's cottage, with a full second story and a deep porch across its front. Meg pulled to the curb near the driveway; nothing was parked there, but the single-car garage at the rear was closed tight.

From here the house looked dark. With some misgivings about sticking her nose in where it would be unwelcome, Meg turned off her engine and got out; she hurried up the short walk, climbed the wooden steps, and crossed the wooden porch without attempting to keep her booted feet quiet. She rang the bell once, then again, setting off a dog somewhere but bringing no response from within. She shaded her eyes with one hand and peered through the door's glass pane into the depths of the house.

On the left, the staircase rose dimly into darkness. But at the end of the lower hall Meg thought she saw a glow of light from the kitchen or the little breakfast room adjoining it. She kept her eyes on

the hallway and reached out with her left hand to press the doorbell and hold it down.

After more than a minute, a small figure appeared at the hall's end, backlighted. Meg kept the doorbell ringing, kept her face close to the pane; and finally the figure came reluctantly to the door.

"I figured it had to be you," said Cass. "I guess you might as well come in."

"Thank you, Cass." Meg followed the stiffened-in-silent-protest back of her stepniece along the hall to the kitchen and through to the breakfast room, where chintz-cushioned wooden chairs framed a round oak table now covered with books. Cookbooks, Meg noted. And a tall stockpot was simmering on the stove, its set-askew lid emitting little puffs of steam.

"I was working," said Cass. She turned as she reached the table and stood facing Meg, arms folded close and shoulders high. Cass was short, with her mother's small, neatly joined bones; rake-thin when Meg first met her two years earlier, she was now almost plump, with the winter-sallow look of someone not much interested in fresh air or exercise.

Now she focused on Meg's face, and her own face tightened in a tooth-baring grimace of shock, or perhaps distaste. "Did you and Uncle Vince have a fight?"

Meg had forgotten her bruises. "Of course not!" she said sharply. "Your uncle and I don't *fight*. And if we did, he wouldn't hit me."

Cass went painfully red. "I'm sorry. I know he wouldn't. Don't tell him what I said, okay?"

Regretting her sharpness, Meg said, "Okay. What happened to me was that I ran into a gang of ski-masked hoodlums last Wednesday night." As Cass's red face went ashen, Meg added quickly, "But they just knocked me down and ran off."

"I'm sorry," said Cass again.

"So I went back to work today, and then stopped to see Charlotte Birdsong after school," Meg said, and sat down in one of the chairs.

After a moment Cass moved to the stove, to give her pot of whatever it was—something with chicken, Meg thought—a stir. "Checking up on me," she said over her shoulder. "You don't have any right to do that."

"Charlotte's my friend; I visit her frequently," said Meg. "But if I

was checking on you, it was because I hadn't seen you for a while. We've missed you."

Cass put the lid back on the pot. "I'm fine. I had a cold, see, and I didn't think a pregnant lady should be exposed to it." She gave an unproductive sniff. "And I meant to call, but I forgot. I think I'll quit those music lessons, anyway; they cost too much."

"Going to quit your work-study program, too?" asked Meg.

"No!" Cass glared and then wrapped her arms tight across her chest again, bending her head so that straight, shoulder-length brown hair swung to hide her face. "You can't cook in a restaurant with a cold, it's against the law or something. Besides, that's not a nice place. There's always some big, hairy truckdriver coming on to me."

Probably true. In addition to being pretty, Cass had an air of nervy vulnerability, something Meg counted a holdover from the hard, mean times of the girl's early adolescence. It was a quality that could attract the wrong kind of male attention.

"I'll offer one bit of advice only," said Meg. "Please go see your counselor and straighten things out with her."

"I will. I think I'll get a doctor's note and stay home for a while. I knew this girl who had a cold, she didn't take care of it, and pretty soon she had to go to the hospital with pneumonia. Walking pneumonia, she said."

"You're welcome to come stay with us, Cass. We're a healthy bunch; I don't think we'd catch your cold."

Cass fixed wide, unseeing gray eyes on Meg for one slow blink, then another. "I better not. Besides the cold, there's my dog. I don't think Grendel would like him."

"You have a dog?"

Cass gave her first real smile of the encounter and beckoned Meg to the glass-paned back door. In a chain-link dog run set against the original wooden fence, a small brown-and-white blur raced madly about, now and then slowing enough to fling itself against the wire walls.

"That's Tee—for TNT," said Cass. "The people at the Humane Society told me he's a pure-bred Jack Russell terrier. I have to keep him under control, though, because they said he might kill cats."

"I think you're quite right about Grendel," said Meg. "They'd be a

bad match. Speaking of which, have you and your mother worked things out?"

"Things? Oh, you mean about that dickhead—that jerk," she corrected herself quickly. "Len? Yeah, it's cool. I just told her no way he could stay in my house. I told her you wouldn't stand for it," she added with a brief flash of grin.

"You're right. I wouldn't." Meg, on her way to the door, put a hand on the girl's shoulder and then instead made a real hug of it. "You take care, and call me if you need backup."

Cass hugged back quickly and let go just as quickly. "Better watch out or you'll get my cold. I'm just going to stay home and be quiet for a while. Say hi to Uncle Vince for me and tell him I'll see him when I'm better."

Supper was Katy's work tonight, a concoction of hamburger, macaroni, garlicky chopped vegetables and canned tomatoes, topped finally with cheddar cheese and tasting much better than it looked. As cook, she was exempt from cleanup chores, so as soon as the meal was over she took herself and an apple tart off to her downstairs bedroom, leaving Meg and Gutierrez to their own devices.

Eyeing her husband's weary face, Meg poured him another glass of red wine and told him to stay where he was. When she had loaded the dishwasher and put the pans to soak, she topped off his glass, poured one for herself, and sat down. "So," she said. "Talk."

As usual, it took a few moments of hemming and hawing; but after spending most of his adult life living alone, Vince Gutierrez loved having someone at home to share with. And the sad puzzle of Esperanza Moreno kept nibbling at his mind like a toothy little terrier. He told Meg about Espy's "lost" baby.

"Oh, poor woman," said Meg.

"I'd wondered about a remark by Graciela Aguilar, one of her neighbors—that Rubén Moreno made Espy pregnant 'all the time.' Two kids didn't sound much like all the time to me."

"Depends on the kids and the circumstances," said Meg.

"Mrs. Gonzales, the older woman down at the Circle, said Espy wasn't happy about the pregnancy but would have been fine once she actually had the baby."

Meg took a slow sip of wine. "Same answer." At his questioning

look, she said, "The woman was pretty stretched trying to raise two healthy kids. How could she have managed a severely handicapped baby?" It occurred to her that Esperanza Moreno might have left town to arrange a late-term abortion, not an easy service to find and probably not an action she'd have admitted to. Also one likely to have angered her husband. After a moment's thought, she mentioned this possibility to Vince.

"Yeah, we're looking into that, but so far we haven't found any doctor who might have referred her.

"And damn it all, to make the whole thing more convoluted, Graciela Aguilar, this pregnant, if you can believe it, sixteen-year-old friend of Espy's, has gone missing. Her family was trying to make her marry the guy who got her pregnant, and she didn't want to, so she stole the family car and took off. Now she's out there somewhere on her own, with hardly any money and probably not a whole lot of sense, either. She'd have been better off to marry the guy."

"So she could end up like Esperanza?" snapped Meg.

Gutierrez lifted both hands palms-out in a shielding gesture. "Lady, I'm not looking for a fight, particularly not from a position I wouldn't touch in saner times. And along the same lines, let me tell you about a visitor I had today." He related the tale of the Jocelyn Ferrar biology lecture. "She acted as if I didn't know where babies come from."

"And clearly she told you much more than you wanted to know. Poor dear," Meg said in soothing tones, and then chuckled. "Vince. Suppose that, say, ten years from now, when Katy is twenty-four, she gets married, and gets pregnant."

"In that order, we can hope."

"Only hope. But then suppose she decides, as people sometimes do these days, to be very open about the whole business and share."

"Share?" he said suspiciously.

"You know, have a birthing party. Relatives and good friends all gathered around to watch the whole event."

"Not me! Absolutely not!"

"But it wouldn't be complete without the grandfather-to-be. Katy would be heartbroken."

"Meg, I cannot possibly..." He narrowed his eyes at her. "You're kidding. Aren't you?"

"Anticipating, love. By a good ten years, as I said, so let's not worry about it. Now I have some quiz questions to concoct; maybe you'd like to get to bed early for a change?" She drained her wineglass and rose to take it to the kitchen, where her gaze fell on a shelf of cookbooks.

"Vince," she began, and then wished she'd kept her mouth shut, he was already so beleaguered. But Cass was his niece.

"Hm?" He hadn't moved except to slouch a bit lower in his chair and stretch his legs out.

"I stopped in to see Cass this afternoon. She's at home with what she says is a cold. I know you're busy, but I think you should go talk to her."

"Goddamn," he said wearily, and pulled himself straight. "Has Mary Louise moved that guy in?"

"No, and I don't think she's going to," Meg said quickly. "But Cass is acting odd, all hunkered down and watchful. Wary."

He pushed his chair back and got to his feet. "Maybe I should go now."

"No. That will make her feel that we're ganging up. Just drop by to see her, maybe tomorrow or the next day."

"Chances are she's hiding out from some jerk of her own."

Meg rolled this possibility around in her mind. Cass's taste in boyfriends, formerly at least as awful as her mother's, had seemed to improve over the last year. But still… "You're probably right," Meg said. "So don't worry about it. Go to bed."

Chapter 12

GUTIERREZ REGISTERED the spindly red numerals of his bedside digital clock as he closed his eyes: 9:08. He fell asleep as if poleaxed; when the muted trill of the telephone jolted him awake, the same clock, still right in front of his face, showed 4:02. He caught the phone on its second ring and propped himself up on one elbow.

"Gutierrez."

"Chief. Johnny Hebert here. Thought you'd want to know there's been an assault on another woman, or really a girl. Not murder, but a beating, and what looks like multiple rape."

Katy! was his first thought. Immediately, and slightly more reasonably, Cass. He climbed out of bed and headed for the stairs, telephone in hand. "Do you know who she is?"

"Yeah, a high school senior named Debbie Finn. Her mother got home sometime after two A.M. and Debbie, who was supposed to be baby-sitting her little brothers, wasn't there. Around three, Mrs. Finn says she was just thinking about calling us when she heard a noise, and went outside to find the girl lying at the foot of the driveway, as if she'd been dumped there from a car."

Gutierrez, downstairs now, crossed the dining area to the glass doors, shoved one open, and padded naked and barefoot out onto the wet deck. By leaning over the rail, he could see the solid wooden door of Katy's room—what she called her "apartment"—and the west-facing window as well. Door closed tight, window-glass reflecting the light from the small bulb they left burning over the garage door.

"Has Debbie said who did it?"

"She's unconscious—or maybe half-conscious. Not responding to questions anyway. She's here at the hospital now, and her mother's here, too."

"I'll be right down," said Gutierrez, and pushed the "Off" button on the portable phone without waiting for a reply. Suddenly realizing he was cold, he turned back to the open door and bumped into Grendel. The big dog growled, not in threat but as an indication that he, too, was on edge and on guard. "Right," whispered Gutierrez, and rubbed the hard, square head as the two of them went inside.

Upstairs, the room was still dark. When he opened a drawer for fresh underwear, Meg turned over beneath the down comforter, mumbled something inaudible, and settled back into long, regular breathing. He collected trousers, shirt, and shoes and tiptoed out to dress in the downstairs bathroom. Then he scrawled a bland, husbandly note—"Problems out there, don't worry, talk to you later"—on the message board, grabbed his jacket, and checked locks before leaving. Grendel followed him, and Gutierrez decided to leave him outside; he could stay dry in the open garage, and keep an eye on the whole place. "Stay," he told the dog. "Watch."

A wet road gleamed under his headlights; rain had fallen as he slept and there would be more soon. He pictured the girl lying hurt and helpless in the cold rain, cursed aloud until he began repeating himself, and hoped that she, unlike Meg or the college girl earlier, had seen enough of her attackers to be able to identify them.

Gutierrez parked the Porsche near the hospital's emergency entrance next to a black-and-white. Inside, the brightly lighted admittance area was empty; but his hand had just touched the service bell when Johnny Hebert stepped from the doorway of a room down the hall, Officer Alvin Grebs trailing sore-footedly behind him.

"That was quick, you must have driven the red bomb," said Hebert. "Anyway, she looks like hell, but the doctor says all her vital signs are good and he doesn't think she's dangerously injured."

"Thanks for the call, Johnny." Gutierrez nodded a greeting at Grebs and stepped past Hebert into the room, where a nurse he didn't recognize and a doctor he knew stood beside a high bed. Dr. Eric Brodhaus had an arm around a tall woman whose bright-blond hair hung limp and wet to her shoulders. Under a black raincoat she

wore a nearly knee-length pink sweater, snug black pants or maybe tights, a pair of black pumps with circlets of mud on their high heels.

"Doctor," said Gutierrez with a nod. "And Mrs. Finn? Chief of Police Vince Gutierrez. I'm sorry for your troubles."

The woman looked briefly in his direction and then turned her gaze back to the still form on the bed. Under a blanket drawn to her shoulders, the girl lay on her right side in fetal position, head bent forward, eyes shut. Her breathing was broken by a shudder, like the remnant of a long bout of crying, then evened out again.

Looking her over without moving closer, Gutierrez guessed Debbie was thin and tall, like her mother. The long hair clinging wetly to her head looked black but was probably dark brown; it was hard to tell much about her face. The side visible to him appeared to have been pounded: eye blackened, jaw scraped raw, puffy flesh split over the cheekbone and across the lower lip.

"Hi, Vince," said the doctor, detaching himself from the woman and moving with Gutierrez toward the door.

"What can you tell me?" asked Gutierrez.

Dr. Brodhaus spoke in a low voice. "He—or they—punched the hell out of her face, almost as if the intent was to mark her good, where it showed. And she was definitely raped, looks like more than once, vaginally only."

Gutierrez made a sound deep in his throat and stood straighter, squaring his shoulders. In a flash-backward, he felt the satisfying weight of all the gear he'd worn on his belt when he was young and tough, baton and cuffs and bullets and speedloader and particularly his Colt Python, now locked up at home. Doing nobody any good.

Brodhaus was still talking. "Specifics will have to wait; we've got a nurse trained in rape exam and counseling on the way in. She'll do a very thorough exam and collect evidence, but it will take a while."

"Doctor!"

Gutierrez had more questions but held his silence as Mrs. Finn came toward them, clutching the lapels of her raincoat together over her breasts.

"Doctor, you've got to give her something!"

"Mrs. Finn, I don't want to sedate her until she's seen the nurse-counselor. She's had aspirin with codeine, for the pain and swelling."

"Fuck the pain!" snapped Mrs. Finn. "You give my daughter

something so she doesn't wind up pregnant from that bastard, who-
ever he is."

"We certainly will do that, since we have your consent," said
Brodhaus.

Turning quickly back toward the bed, Mrs. Finn teetered on her
high heels and would have fallen had Gutierrez not stepped close.

"Baby?" she said to the girl, the long-nailed fingers of her right
hand burying themselves in the leather of Gutierrez's jacket sleeve.
"See, you'll be all right, they're going to take care of you. Debbie,"
she wailed, "who did this to you? You tell me, baby, and I'll kill the
son of a bitch, I swear to God!"

Debbie shuddered, and the visible eyelid clenched tighter. "I
can't."

"What?"

"Tell you." A long pause. "Who they are."

"Can you tell us anything about them?" asked Gutierrez in a near-
whisper.

She shuddered again, then slowly straightened out her body, lifted
her head slightly, opened her eyes as fully as she could. Gutierrez was
standing right in her line of vision, and she peered up at his face
from under swollen lids. "Mexicans. They were all Mexicans."

At the rap on his office door, Gutierrez looked up, beckoned to the
hovering Johnny Hebert, and returned his attention to the telephone
receiver.

"Mr. Mayor, I am not saying that I do not believe Miss Finn...
nor that I do. I am saying I have no constitutional right to arrest ev-
ery dark-skinned, Spanish-speaking person in this town. Male per-
son, excuse me."

Hebert tiptoed heavily to a chair while Gutierrez glared into
space and held the receiver several inches away from his ear.

"Let me make *myself* clear, Lindblad," said Gutierrez evenly when
the instrument in his hand fell silent. "I have my captain in the hos-
pital, one lieutenant on extended leave. One lieutenant who wouldn't
touch this job with two ten-foot poles lashed together with hundred-
dollar bills. You push me much more, you get my resignation. Then
you and the city council can barricade yourselves in your downtown
offices and watch the vigilantes gather in the street."

After several moments, he grimaced but spoke in softer tones. "I am every bit as interested in finding that poor girl's assailants as you are. And I want my wife and daughter safe on the streets, too…along with all the other women in this town. I'll see that you're kept informed."

He hung up with exaggerated care and glared at Hebert. "I forgot, you're an acting lieutenant. You want to be police chief?"

"Not even in my dreams."

"I admire your good sense. What have you got there?" he asked suddenly, sniffing the air.

Hebert grinned and set a flat cardboard container on the desk. "I was going by Armino's, and took a chance that you might have missed breakfast."

"Bless the Arminos and their old-fashioned pre-cholesterol thinking," said Gutierrez fervently as he opened the container and peered inside. "Oh, God, a bacon-and-egg sandwich. Bless you, too. Aren't you having one?"

"I've eaten," said Hebert. "I'll just get some coffee and tell you what I've found out, not that it's much."

Gutierrez took a large bite, chewed for a moment with his eyes closed, then opened them and nodded at his subordinate. "Johnny, I appreciate your stepping in to deal with Mrs. Finn. The look she gave me after her daughter said 'Mexicans' would have melted glass."

Hebert stretched out in his chair and balanced his coffee mug on his belly. "Problem here is, I didn't learn much. Once we were under the bright lights of the cafeteria drinking coffee and she didn't have that poor battered kid right in front of her face, she cooled down and turned cagy. Mostly, I think, she was giving some thought to the mean realities of a rape investigation…too much time and trouble, lots of notoriety, like that.

"Anyway," he went on, as Gutierrez continued to eat, "she says Debbie is a good girl, quiet, works hard at school and makes okay grades. Goes to First Lutheran pretty much every Sunday, although Mrs. Finn admitted, when I asked, that she'd recently dropped out of the youth group there. She doesn't have a job, because she's responsible for her two little brothers, six and eight, when her mother is at work. Or out."

Gutierrez quirked an eyebrow at this, and Hebert shrugged. "Mrs.

Finn, first name Sandra, divorced the boys' father five years ago; she doesn't know where he is and gets no child support. She works daytimes as a clerk at Howard's Marine Supply down on the wharf, and some nights she tends bar out at the Ricochet. I got a strong sense that other nights she just hangs out there."

Gutierrez swallowed the last bit of sandwich and sighed. "What about rejected boyfriends? The girl's, I mean."

"Mrs. Finn says Debbie is shy and not very pretty, and so far as she knows has not had any boyfriends. Besides, she's too busy for a social life, seems to me. Mrs. Finn was already fretting about finding a replacement baby-sitter when she left the hospital."

"What about Sandra Finn herself?"

"Boyfriends of hers who might have decided to take advantage of the girl?" A more expansive shrug this time. "She says she absolutely doesn't bring men home. She says no one she knows would do something like this, and besides she wouldn't go out with Mexicans. I finally pried a couple of names out of her, men she's dated over the past few months. I'll have a look at them."

"Hm. Anyone get a story from Debbie yet?"

"She told Ruth Jensen, the nurse who examined her, that two guys came to her door and took her away in a car. They drove her to a 'shack in the woods,' beat her, raped her. Put her back in the car, drove her home, dumped her there."

"And how did she describe them?"

Hebert tugged at his curly beard. "Generic. Brown skin, black hair and eyes. White teeth. Dark clothes. They had knives, that's how they got her to go with them. Spoke Spanish only."

"She speaks Spanish?"

"I'd guess she barely speaks English." He gave his beard another tug and sighed. "Sorry. Debbie does not speak Spanish, but she's heard it on television and in movies and she's really sure that's what they were speaking. She's absolutely positive it was not English."

Gutierrez tipped his chair back and looked at the ceiling. "Johnny. What do you think about this? And I mean just between us."

"I think Debbie Finn opened her eyes in that hospital room and saw your face right there, and it gave her a way out. But out of what I do not know."

"That was my reading, too. But short of harassing a rape victim..."

"There is one thing that'll help," said Hebert. "I got the prelim report from the rape exam. Lots of semen, probably at least two guys—these were not your careful or considerate rapists who put on condoms. Not smart, either. Apparently they don't know that semen can be used for identification. But here's what's interesting: Several of the pubic hairs the nurse recovered were blond."

"Well, at least I've got something to harass her with," said Gutierrez with a grimace. "Maybe I should call our mayor and ask him to citizen-arrest the next blond Mexican he comes across."

Hebert set the empty coffee mug on the floor beside his chair and folded his hands beneath his bearded chin. "I've been wondering about that. Chief, what do you suppose got Mayor Lindblad on the case—on our case—so soon?"

"Could be he heard from someone on the hospital staff," said Gutierrez. "Alternatively, it could have been a politically aware police officer."

"Ah, of course," said Hebert. "I'd forgotten all about Alvin. He was the responding officer last night. And his black-and-white was still at the hospital when I left."

"No surprise. And…Jesus, I'm losing my grip," he muttered, reaching for the intercom on the corner of his desk. "Dispatch? Trudy, this is Vince Gutierrez. Get onto the watch commander, Sergeant Mendenhall, right away. Tell him to have patrol keep a close eye on the Winner's Circle Motel and anyplace else immigrant workers, particularly Hispanics, are known to stay. For the *immigrants'* protection, got that?"

"What is that clever saying, 'Better late than never'?" Gutierrez muttered, as he clicked the machine off and settled back into his chair. "Okay, many questions. Debbie is a quiet homebody-type who lives where?"

"Out in the county, just off Duboce Road."

"So. How did these nameless Mexican boys get to know her? To know where she lived? How did they know she'd be home alone?"

Hebert merely shook his head.

"And to my knowledge there've been no similar abduction rapes around here recently. On the other side of the question, if these rapists were our housebreaking vandals taking their violence to the next level, why would they break in someplace where there were people at

home and very little, I'd assume, to steal? Is Debbie Finn going home right away, or will she be at the hospital for a while?"

"The doctor wants to keep her for a day or two," said Hebert. "But as soon as the exam was over, he gave her a shot so she'd sleep. I got the one question in, asking for a description, and then I got chased out."

Gutierrez pondered this, rapping his knuckles rhythmically on his desk. "So. We need to have somebody down there in maybe four hours. And somebody should hustle out to the Finns' place; little boys have big ears and big eyes, and maybe Debbie's brothers woke up when things were happening last night. And there must be neighbors." Gutierrez paused and fixed his gaze on Hebert, catching him in the middle of a yawn.

"Johnny, how long since you've had any sleep? What were you doing at the hospital last night, anyway, after a full day on the job?"

Hebert rolled his heavy shoulders loose. "I got home, had supper, hit the computer to write my report on what I learned at the high school. Then I got on the Net, and lost track of time. So when I heard the call on my radio, I went to have a look.

"But I'm fine, I always get a second wind," he said. "And I should be the one to go to the Finns'. The mom and I got along well enough, and anyhow, people talk to me, even kids."

Gutierrez nodded acknowledgment of this. Even in uniform Johnny Hebert seemed untucked, unpolished, definitely nonthreatening. Whereas Gutierrez in sweats and running shoes could cause spines to stiffen and worriers to glance behind them.

"Okay. You catch the hospital follow-up and the Finns' neighborhood. But first, let's have a look at your results from the high school."

"Right there," said Hebert, pushing forward the manila folder he'd put on the desk when he arrived. "I had a nice chat with Burton Topp, the principal, who always has an ear to the wind and a finger in the ground—or possibly somewhere closer. Basically, he believes his school is under control but he has no objection to a police presence.

"So I talked to Jeremy Milstein, who vigorously objects to pigs on campus and says we don't see records on his counselees without a subpoena.

"Then I had coffee with the other counselor, Suze Shaw, who

cheerfully gave me two names. She says these guys are born trouble-makers who have been 'even pissier than usual' lately. She says she can tell me this without violating any confidence, because they never keep their counseling appointments.

"She also says," Hebert added, as Gutierrez scanned the contents of the folder, "that neither of them is smart enough to be running a burglary and fencing operation."

"What do you know, a Hamm," muttered Gutierrez. "Dwayne, age eighteen, senior but not likely to graduate. And Mike Lorenzini, seventeen-year-old junior. From the Lorenzini Nursery family? That's a surprise."

"According to Suze, he's as nasty as the Hamm kid but has better manners—which is probably why not everybody agrees with her opinion of him. I'd trust Suze on this."

"Fine. You've got plenty to do on the rape; I'll take care of follow-up at the high school. That should keep me safely out of the mayor's reach for a while."

Gutierrez twisted his breakfast leavings into a tight package, tossed it at his wastebasket, and followed Hebert out the door. "Alice?" he called, and the department secretary put her head out a doorway down the hall.

"I'm on my way to the high school pretty soon," he told her. "In fact, for anything other than a riot I've already left and can't be reached. Is Chang around?"

"In the captain's office," she told him, and he waved his thanks as he set off toward the other end of the hall.

"Aha!" he said with satisfaction as he pushed the unlatched door wider. Ray Chang was perched on the edge of Hank Svoboda's desk; Alma Linhares sat at the computer desk against the right wall with Val Kuisma looking over her shoulder.

"I looked in, Chief, but you were busy with Johnny," said Chang. "We heard about the rape last night."

"Hebert is dealing with that, for the moment," said Gutierrez. "Ray, have you heard anything on Graciela Aguilar?"

Chang shook his head. "The family hasn't had any word, and there's been no response to our bulletin. I talked with the Gonzales boys, but they say they didn't see her at all on Sunday and didn't see her leave."

"Did you believe them this time?"

Chang flushed slightly. "Yeah, I think they're okay. They knew Graciela to say hi to, but her family kept her pretty close, and the two of them are busy with school and getting ready to go out for baseball. They were surprised that she's only sixteen."

"Okay. Keep on this, Ray," he said, knowing the instruction was unnecessary and would have irritated anyone less straight-arrow than Ray Chang. "She's probably happily on her way to L.A., but our present run of luck on these things isn't great."

"Is it true the girl who got raped said it was Mexicans?" asked Kuisma.

"That's what she said."

"But you don't believe her," said Alma Linhares. She tapped a key on the computer, nodded with satisfaction as the adjacent printer hummed to life, and swung her chair around to join the group.

"Let's say I'm not completely comfortable with her story," said Gutierrez. "Val, Ray, you were both at the high school yesterday. Are there many Hispanics among the students?"

"I promised not to say who told me," said Chang, "but there are eighty-four Spanish-surname students at the high school. Less than half of them are actually Spanish-speaking recent arrivals."

"On a campus of around one thousand," said Val. "Just eyeballing, I'd say there are more southeast Asians at the school than Hispanics."

"Asians are quiet," said Chang a bit grimly.

"Right, you guys take it all out in t'ai chi," said Kuisma. "It's Latinos get in trouble from all that machismo. Makes me glad I'm Finnish."

"Bullshit, Kuisma," said Alma Linhares. "You're half Portagee, and if there ever was a bunch had trouble keeping their zipper up..." She looked at Gutierrez, and ducked her head. "Sorry, Chief. Kids at play."

"I skimmed Johnny's report on his talk with the counselors," Gutierrez said to Val Kuisma. "You have anything to add?"

"Not really. I wandered around and talked to kids, but nobody had much to say. There's four or maybe five kids I intend to see after school today, off campus. Kids who seemed less—not scared, but wary, I guess—than most."

"Have we got a major conspiracy here?" asked Gutierrez.

"Just kids, I think. Not to break the tribal rules. And the school is big enough," said Val with a shrug, "so that really straight-line kids wouldn't necessarily know about something like this gang even if it does involve other students."

"I'm headed for the school, to talk to a pair Johnny Hebert turned up yesterday. Val, you come along; we'll make this as official as possible."

"Wait, Chief," said Alma, lifting a sheet of paper from the printer. "I think you should see this."

Gutierrez took the page and read aloud from it. "Silk 'N Satin. In Mendocino. Identify the robe, gowns, panties as their merchandise, charged on three different dates to...goddamn! Dr. James Ferrar. The lying little bastard. Good work, Alma."

She grinned, then sobered. "Thanks. But I haven't hit with the banks yet. Nothing for Esperanza Moreno under that or any other combination of her names in Port Silva, Mendo, or Boonville. I'll go further out now—Cloverdale, Willits, Ukiah, maybe Santa Rosa."

"Maybe she didn't have an account," said Ray Chang. "Maybe any money she had was in a shoe box or something at home, and her husband took it when he took the kids."

"That's too damned likely," said Gutierrez, getting abruptly to his feet. "But go ahead with your inquiries, Alma. Val, we'll hold off on the school. I want to show this interesting report to my friend Jimmy and see what he has to say about..."

There was a rap on the doorjamb and Alice Murphy put her neat blond head in. "Chief? We just had a call from the high school, some sort of gang fight. Dispatch got Mendenhall out on that. And Dr. James Ferrar called to tell you, personally, that there's been vandalism at the fertility clinic, and his father is there with a shotgun."

Chapter 13

MEG, WHO HAD awakened very late, felt gritty-eyed and unkempt as she surveyed her classroom from behind the lectern. Given the fact that a good half of her first-period class had apparently not awakened at all, or at least had not bothered to come to school, maybe she should just dismiss the poor souls who had struggled in. And then go get the coffee she so badly needed.

Bad example. Bad psychology. She'd give them two of the three quiz questions, saving the third as a surprise for the missing. "Choose one question," she said over her shoulder, as she wrote quickly on the chalkboard. "Answer it in three to five paragraphs."

"Open book?"

Aaron, she knew without turning to look. "Open dictionary if you need it, Aaron. 'Heart of Darkness' stays closed."

She put question number two on the other chalkboard, and then turned, dusting off her hands. Some faces were creased in frowning consideration, one or two bright with inspiration, most of the rest bent over pens and papers. Two fidgeters, shifting uneasily in their chairs.

Meg, frowning in her turn, inspected her rollbook. DiMarco and Johanson were among the missing, as were the Costello boy, Greta Magnuson, Debbie Finn, Lisa Lockyer. What she had today, she realized, was the more civilized, or at least more civil, half of her class. With a few fringe kids. Strange. But pleasant, on a tired, wet morning.

By the half-hour point, only three heads were still bent. The other students, one by one, had brought their papers to Meg at her desk. As they returned to their seats, they exchanged low-voiced conversation with others who had finished; and now the formerly quiet

group was building a buzzy, heated edge.

Meg slapped her desk with the flat of her hand, and was rewarded with a startled silence. "Five minutes," she said, to those still toiling. "And the rest of you, please be quiet until everyone is finished."

As the third and last paper reached Meg's hands, the room was suddenly a-ring with voices, as if someone had opened the windows onto a passing parade.

"...I heard almost killed...a whole gang, like fifteen or twenty... but AIDS is what I'd really worry about...bunch of fuckin' damn aliens...I don't care, I don't think girls should..."

And Rachel's voice, clear and precise. "We're organizing a 'Take Back the Night' march, and every woman in town should come."

Meg slapped the desk again, and when this achieved no result, put two fingers in her mouth and produced her loudest dog-calling whistle.

Silence.

"Thank you," she said. "Would someone—some*one*—please tell me what's happened?"

Several indrawn breaths, but Rachel was quickest with words. "A girl from this class, Debbie Finn, got abducted from her own house she was *not* out on the street so there!" —this snapped at a girl in the seat next to hers— "and gang-raped last night."

"Debbie Finn?" Meg looked over the bobbing heads and saw in her memory's eye the skinny body hunched against unwelcome height, the long-nosed face with its mouthful of big, crooked teeth, the clothes that were too tight or too bright or both. Debbie Finn was a sad-eyed waif who wanted desperately to go away somewhere, anywhere, to college...more to escape and reinvent herself, Meg felt, than for intellectual or career ends. Meg had worked with the girl on her writing skills.

"That's dreadful. I'm very sorry," Meg said softly, surveying the familiar faces and remembering belatedly how often, just recently, Debbie's had been missing. Last semester she'd been hardworking, painfully eager, unfailing in attendance. This semester, however...

"The counselors are going to do an assembly sixth period," said Aaron Frankel, whose father was a psychiatrist and a professor at the university. "They'll bring in some people to talk to us."

As the buzz of voices began again, Meg looked at the clock. Five

minutes until the bell, which meant she could avoid this emotional minefield and leave it to the professionals. Coward that she was. "My assignment for you all, for tomorrow, is to attend that assembly," she told the group. "For anyone who would like to send a note or card to Debbie…" As wild notions of the proper Hallmark offering in the event of rape invaded her mind, Meg paused to draw a deep breath. "…please take it to Mrs. Shaw's office, and I'm sure she'll see that Debbie receives it. And I'll see you all tomorrow. You're excused."

She sat down at her desk and pointedly turned her attention to the quiz papers. After some shuffling and a muttered remark or two, the students gathered up their belongings and left quietly. The bell rang as the last of them trailed out the door.

Meg had no second-period class; and today no one had commandeered her free time. There would be coffee in the faculty lounge; there would also be faculty. She ran her mind over the list of teachers sharing her prep period, and decided there was none of that small group she'd trust for unbiased information. Any information at all. John and Lucy, her two good friends and the sanest people on the faculty, had classes. Counselor Suze Shaw would be very busy.

She pulled on her coat, slung her bag over her shoulder, and stepped outside her classroom, closing the door behind her and checking to be sure it was locked. Teachers were not encouraged to leave campus during prep periods, but as far as she knew no one had ever been shot or fired for doing so. If she walked downtown to Coffee Connection, instead of taking her car out of the gated lot, no one would even know she was gone.

Debbie Finn had changed over the past month or so, Meg acknowledged, as she pulled up the hood of her raincoat against a light mist. She'd stood a little straighter. She'd turned up once or twice in an outfit that was no more tasteful than her usual attire but a little more current. She'd trimmed the split ends off her lank hair, and cut bangs across her high forehead. Meg stared into the mist to see Debbie's recent face, and realized that it had sported eye makeup. None of this had achieved transformation; but in retrospect, the effort was what deserved notice.

From behind her she heard the bell signaling the start of second period. No running footsteps, though, no heavy hand falling on her shoulder. Freedom. She picked up her pace; even for her long legs,

this was a good fifteen-minute walk, and she had to be back in the classroom for third period.

Meg caught herself just short of a high curb, and was reminded of the days when she'd risked disaster by walking and reading at the same time. Junior high, that was, one of the times between sets of friends when books were more interesting than people. And Debbie had changed friends lately. Last semester Meg had seen her around campus with Marti Ledbetter from fifth period, and now and then with Cass.

Damn. Someone should tell Cass about Debbie. Nearer to downtown now, Meg found a telephone booth and called the Gutierrez house, but got no answer. She fished her coins from the return slot and wondered whether she could honorably leave this chore to Vince. Probably not.

At Coffee Connection, the line consisted of one elderly man, one young woman with a baby in a backpack, and two middle-aged women who were probably employees of the nearby hardware store, or maybe the stationery shop across the street.

"...the poor woman," the nearer one was saying. "Imagine how you'd feel if it was your daughter!"

"I don't have a daughter," said her companion, shifting her purse to reach inside for her wallet. "A decaf latte, dear," she called to the counter girl, "with non-fat milk and chocolate sprinkles. But if I did, and she got raped by a bunch of Mexicans, I know what I'd do. I'd round up my three boys, and my husband and his brothers, and we'd clean the illegal aliens out of this town in a hurry."

Meg bit her tongue almost hard enough to draw blood. For all she knew, maybe the rapists were Mexicans...or aliens, as she now remembered one of her students saying. She stood well back until the women, huffing and muttering but conveying no new information, had collected their drinks and left. "Latte," she said to the counter girl. "With lots of caffeine and whole milk. And a vented lid, please."

Paper cup in hand and twenty minutes remaining of her free time, she set off in the drizzle, trying to decide what she would do with her third-period sophomores. With any of her classes today. As she approached the back of the campus with cup empty and five minutes to spare, she heard what sounded like crowd noises and pushed her hood back to listen.

The campus was fenced here. Meg skirted baseball diamonds and running track and hurried past the long wall of the gym and through an open gate into full view of the so-called quad, the grassy area framed by the U-shaped two-story main building and the gym and bank of additional classrooms behind it.

What looked like most of the student body was milling around there, a mass loosely centered on a faster-moving group: a dozen or so youths, males, in the center facing off a larger, circling group, also males. A cacophony of voices, from shrill screams to hoarse shouts, bounced off surrounding buildings. As Meg tried to decide her own next move, twin streams of blue-uniformed people came trotting around either side of the building, batons drawn. In riot helmets with plastic face-shields down, they were featureless, anonymous; if her husband were among them, she couldn't pick him out.

Gutierrez whipped the car around the corner and jolted to a stop in front of the old hospital. In the moment between killing the siren and turning off the engine, he registered the scene: scattered figures along the outside of the fence, gate open, something odd about the grounds and the building. As he flung the door open and jumped out, a sudden blast of sound shook the leaves of the trees near the building and sent the fence-leaners flying for cover.

"Guns in the trunk!" he snapped at Alma Linhares, reaching back into the car to pop the lid. It wasn't sound waves that rattled those leaves, he noted grimly as he hit the flagstone walk running. The old man on the hospital steps braced himself and yelled something, and the shotgun he held high sent another load of shot loudly skyward to bring down a new shower of leaves and twigs.

"Doctor Gabe! Stop that!" shouted Gutierrez. As he reached the steps, the old man broke the gun and tossed spent shells aside. Gutierrez raced upward and snatched the weapon away. "Goddamn it! What's the matter with you!" he snarled at Will Ferrar, who stood to one side and well back.

Will blinked. "Hey, maybe you or God can stop Granddad from doing what he wants. Besides, he's got a right to be mad."

"Get away from my property, you sorry goddamned degenerates!" roared Dr. Gabe, grabbing for his shotgun with one hand as the other plucked a pair of fresh shells from a jacket pocket. "Or I'll blast

your vandalizing destructive butts, and sue you besides! That's mine, give it back!" he snapped at Gutierrez.

"Gabe, shut up," said Gutierrez through his teeth, handing the gun to Will. "Keep that thing away from him or I'll arrest both of you." With the threat of immediate slaughter eased, he half turned to scrutinize the rest of the scene. Merely unkempt previously, the spacious front yard was now a shambles of battered and uprooted bushes, grass churned and torn by tires. Worse yet was the building, its front smeared from foundation to six or seven feet up with orange paint: crude but recognizable simulated flames leaping as if to consume the whole structure.

"This mess is what we found when we came to work this morning." Dr. James Ferrar stood framed in the open doorway, two white-clad women hovering in the shadowy hall behind him. "So much for police protection."

The narrow face wore a look of tight distaste, as if the "mess"—or the mess-makers, or the police—had a bad smell. Staring at him, Gutierrez remembered his own original purpose here. To make this lying little bastard tell the truth about Esperanza Moreno.

"Chief Gutierrez!"

Christ, he'd forgotten all about the protesters, now streaming in through the gate in a shrunken version of yesterday's crowd, the perfect father and the three louts absent and Father Horvath without attendants today.

The man who'd called out—Ben Blakemore, owner of Prime-O Steakhouse—now marched up the walk with squared shoulders and thrust-out chin. "There will definitely be a lawsuit here. That old hooligan shot at us."

"If he'd shot at you, you'd be bleeding."

"But he can't..."

"He can be fined for discharging a firearm too close to an occupied building. You, and your friends, can be arrested for trespassing and destruction of property."

Blakemore's eyes widened to show white all around. "Chief Gutierrez...Vince...we agreed to meet here at ten A.M. in honest, law-abiding protest, outside the fence. We're not vandals, we had nothing to do with all this." He swept an arm wide to take in the scene of destruction.

"Bullshit!" snapped Dr. Gabe. "If you didn't actually use the paint-brushes or drive the cars, you made the place a target with your damned rabble-rousing!"

"It was done a while ago," said Alma Linhares, who'd been prowling the perimeter with the police shotgun cradled across her chest. "The paint is dry."

A black-and-white pulled up out front, reminding Gutierrez that there was a different riot in progress across town, one being observed —only observed, he hoped—by his wife. And his stepdaughter, and possibly his niece. "I want you to give your names to the officers who just arrived," he said, "and then go home. Save your law-abiding protests for another day."

"Creating human life in a dish is an immoral act," quavered Father Horvath, who should have looked ludicrous in a cassock clinging in mud-stained folds to his spindly shanks. "His Holiness has told us that."

"His Holiness should concentrate on people's souls and leave them to manage their own gonads," said Alma Linhares. Then she shook her head, tucked the shotgun under her right arm, and came to put her left across the old man's shoulders. "Father Horvath, you'll catch your death out here in the damp. You go home now, and have somebody fix you a nice cup of hot tea."

"All of you go home," repeated Gutierrez, and turned to climb the hospital steps again. Dr. Gabe had given up trying to regain his shotgun and now leaned wearily on his cane. Gutierrez put a hand on the old man's shoulder and was startled to feel its fragility, to sense a fine tremor there. So old, he should take him home, tuck him up into safety. Then go find Meg, make sure she was okay, feel her vitality under his hands.

That thought, and the quick image of Meg that accompanied it, brought him full circle again: Espy Moreno. "Gabe, I want you to let Will drive you home."

"Why don't you drive me home, young Vince? Even better, we can go by way of Armino's. Shooting always did make me hungry."

"Gabe, I'm sorry, but I can't," Gutierrez said, looking past him to the doorway where James still stood. "I have some business with Jimmy here. I'll come and see you later."

"And I'm sorry, but I can't spare Will," said James, with a mean-

ingful glance at his big wristwatch. "I'll need him at the hospital shortly."

Friend, you aren't going to be at the hospital shortly; Gutierrez flicked James with a glare that probably said as much. But he didn't want to involve the old man in this, not yet anyway. He looked around for ideas, and saw Alma.

"Alma. Dr. Gabe is willing to turn this mess over to us and go on home. But he needs a ride, preferably with a better-looking chauffeur than me."

Gutierrez held his breath; but Alma confined her retort to a single sharp glance at her boss, then smiled sweetly and took the old man's arm. He, for his part, straightened and puffed out his chest, gallantry overcoming anger and weariness for the moment.

Port Silva police force, specializing in taxi service for senior citizens. Deciding there could be worse uses of police power, Gutierrez waited until Alma had helped Dr. Gabe into the car before turning to the object of his own ire. "You lied to me, Jimmy," he said very softly. "Not a smart thing to do. You'll need to come down to the station now for an official truth session."

"I don't know what you're talking about," said James Ferrar, in equally soft tones. He took another look at his watch. "Now if you'll excuse me, I'm very busy, I have someone…"

"You knew Esperanza Moreno well enough to spend over five hundred dollars on fancy underwear for her," said Gutierrez. "Presumably so you could watch her take it off."

"I have nothing to say to you."

"Buddy, you'd better have. Lots. Beginning with where you were last Wednesday night and who can help you prove it. And since then there's another girl gone missing, a pretty, pregnant Mexican girl. Did you buy nice things for Graciela Aguilar, too?"

"Hey, this is crazy." Will Ferrar's voice was shrill, and he flailed his long arms as if to wave everyone away and clear the scene. "You can't talk to my dad like that!"

"Hush, Will. I'll deal with this. Sorry, I didn't mean that the way it sounded," James added quickly to Gutierrez. "Vince—Chief Gutierrez—I have a scheduled procedure at the hospital in an hour and a half, a procedure that can't be postponed without great distress to the patient.

"And I need time to prepare for it," he hurried on. "It's called GIFT, and it involves…"

"I know," said Gutierrez, remembering Jocelyn's lecture.

"Good. Vince, I swear I never harmed Espy. I have never, so far as I know, met this Graciela person. I was home alone last Wednesday night, not that I have any way to prove that. But I give you my word I'll come to the police station as soon as I've finished at the hospital." James spread his hands and shrugged. "If I wanted to run, where would I go? The little I own, the few people who care about me, are here."

Gutierrez blew out a long breath. "Okay, Jimmy, I'll accept your word. Just don't make me regret it. And eventually we'll need to see some of your records, starting with employment records."

"Access to my records will require a subpoena, Chief Gutierrez."

"I think I can manage that," said Gutierrez.

"Then if you'll excuse me, I'll go prepare for my patient. Will, please put my things in the car. Chief?"

Gutierrez raised an eyebrow, awaiting his assignment, and the smaller man wilted only slightly.

"I can't say exactly how long the procedure will take. I'll call you from the hospital as soon as I've finished."

"I'll be waiting."

Chapter 14

THE AFTERNOON sun was finally banishing mist and drizzle as Gutierrez pulled his borrowed black-and-white patrol car into the rear lot. He parked, climbed out, and was reaching wearily into his pocket for the key to the police station's back door when it opened.

"Hi, Chief," said Alma Linhares as she stepped aside to admit him. "I hear you got things cooled off at the high school."

"Not me, Mendenhall and about a dozen uniforms. And the weather; if the sun had come out an hour ago, we'd still be chasing kids. But I did one good thing," he added over his shoulder, as she followed him down the hall. "I went *mano a mano* with Burton Topp and convinced him that dismissing the whole school at noon might be professional suicide."

"Oh shit, can you imagine? A thousand seriously tweaked kids turned loose all at once, and no school buses for, what, two hours? The downtown merchants would've had to break out their Uzis. So what did he do with the kids?" she asked, as they reached his office door.

"The high school faculty and the Port Silva police force ushered everybody into the gym, where the chief of police spoke a few serious words. The counselors came in then, and a couple of psychiatrists, I think. By now they, the kids that is, are being released, in class groups or maybe alphabetical order. But gradually, very gradually."

He hung his raincoat on the coat tree and sat down behind his desk, reaching at once for the intercom. "Alice? I'm in my office. When Val Kuisma arrives with Dr. James Ferrar, send them both right in.

"So how many did Mendenhall collect?" he asked Alma. "And is there any coffee in the pot?"

"No coffee, but I will break the code of my NOW chapter and make some," she told him. "I don't know the numbers. We've got the Hispanics-only holding cell on one side, the Anglo holding cell across the way. Everybody's finally quieted down, I believe as a result of the remark some anonymous person in uniform made about fire hoses."

"We'll probably let most of them go. Mendenhall says it was such a crazy mess down there that nobody's sure who started things." Gutierrez leaned back in his chair and stretched his legs out. "He did recover a gun and several knives; the little bastards who brought their weapons to school will be charged. But the troops got there while it was still fists and curses."

"Thank you, Mother Mary," said Alma, and crossed herself before punching the coffeemaker's "On" button. "There, coffee on its way. Uh, Chief, did you get any lunch?"

He shook his head. "Coffee will have to do. I want to look over notes and get ready to question Jimmy Ferrar. But before that…" He looked at his watch.

"Right. At three o'clock, that's forty-five minutes from now, I want to see all of first and second watch in the briefing room. Organize that, Officer Linhares."

"Yes sir."

Gutierrez stood at the window end of the long room and surveyed a crowd of uniforms: two sergeants and twelve patrol and motorcycle officers. Two of the group were women. A couple of youngsters, three men in their fifties, the rest spread between. All whites except Officer Gil Ortega, who was Indian rather than Mexican, and Officer Lula Brown, the only African American on the Port Silva force.

"I'll be brief," Gutierrrez said. "All of you live in Port Silva or the county nearby; many of you were born here. Point is, this is your town, so keeping it peaceful is your personal as well as your professional responsibility.

"I believe you all know that Debbie Finn says the men who raped her last night were dark-skinned and Spanish-speaking. There's evidence she may have been mistaken about that. But whether she was or not," he said slowly and clearly, "understand me now. We will not roust every Spanish-speaking male in town; we will not permit

general harassment by civilians. If arrests are made for cause, they'll be accomplished by no more than necessary force. Anybody has trouble with that, see me and we'll talk about termination or early retirement."

A few feet shuffled and somebody snorted—Hub Hubbard, Gutierrez thought—but nobody said anything.

"Good. So here's the other thing. We have to identify the gang of young thugs who're having such a good time ripping up this community. Hear me: We are not working hard enough on this! Talk to your own kids, your nephews and nieces and cousins; somebody has to know somebody who's involved. We need to stop them before they kill somebody—and make serious, hard-time criminals out of themselves.

"Got all that? Good. Now let's see some results." With a nod, Gutierrez turned on his heel and marched out, shoulders back and belly pulled tight as befitted the uniform he'd changed into thirty minutes earlier. It was appropriate for addressing his officers, and for questioning a suspect as well.

"I told you I'd call," snapped James Ferrar, as Val Kuisma ushered him into Gutierrez's office. "It was not necessary to humiliate me by posting this uniformed policeman at my operating room door."

"Jimmy, you'll notice I don't tell you how to do your job." Gutierrez got to his feet and came around the desk. "Come along. Officer Kuisma, you, too."

Gutierrez led the way to a door near the end of the hall. The station's interrogation room was small, windowless, the walls as well as the floor covered with industrial-quality gray carpet. Gutierrez turned on the lights and gestured Ferrar to an upholstered chair centrally placed facing the desk. Val, notebook in hand, took a straight wooden chair against the side wall.

"Perhaps I should have my attorney here?" said Ferrar, and winced at the flat, echoless quality of his words in this space.

"Up to you," said Gutierrez. "This is not an arrest, you understand. We're merely asking you some questions. But if you want to call your lawyer and wait around for him..."

Ferrar drew his mouth tight, then shrugged and sat down in the chair, which was too large for him. His slacks and shirt were fresh,

Gutierrez noted, and his hair damp; apparently Val had allowed him time for a shower.

Gutierrez seated himself at the desk, took a tape recorder from a drawer, and set it between them. "Okay with you?" he asked.

"Have I a choice?" When Gutierrez simply waited, Ferrar shook his head. "Go ahead; what difference could it possibly make?"

"This is Chief of Police Vincent Gutierrez," he said into the machine, and went on to identify Ferrar and Val Kuisma, and to specify date, time, and place. "...in the matter of the apparent murder of Esperanza Moreno," he finished.

Ferrar grasped the arms of his chair and leaned forward. "I state now, unequivocally, that I had nothing to do with the death of Esperanza Moreno."

"We'll get to that," said Gutierrez. He opened the bottom drawer of the desk, took out a large paper bag, and upended it over the desk. Pale silken things slithered out and lay in a soft heap, glimmering under the fluorescent lights. "And what about these? Did you have anything to do with one robe..." he lifted it and let it fall "...and a nightgown, and another nightgown? And two pairs of panties, with plenty of lace? All of them found in the apartment rented by Mrs. Esperanza Moreno."

Ferrar sighed and sank back into his chair. "Obviously you've found the store, and they remembered me. If I'd been seriously interested in secrecy, wouldn't I have shopped farther away and paid in cash? But yes, I gave them to Espy. She loved things like that."

"Things like" pure silk underwear must have been very rare in Espy's life. "Did you give her money, too?"

He shook his head. "Never. She wouldn't take money. She said taking money would make her a whore."

"Jimmy. Tell me about Espy," said Gutierrez. He caught a look from Val indicating surprise at this meandering approach, and ignored it; haunted by the woman for a week now, he needed to know her.

"I did not kill her."

"But Jimmy, someone did. To find out who, I have to learn what it was about her that might have made her a victim."

"What are you, some kind of cop-*cum*-psychologist?" snapped Ferrar. "Either she was a random victim, in the wrong place at the

wrong time; or, more probably, her husband killed her. In either case, it has nothing to do with me." He caught Gutierrez's raised eyebrows and flushed. "At least, nothing *directly* to do with me."

"We're looking for her husband. We're looking at *all* possibilities. Jimmy, I've cleared my calendar. I can stay here all afternoon and all night, too, if necessary."

Ferrar squeezed his eyes tightly shut for a moment, then opened them, lashes wet, and focused on his own folded hands. "She seduced me," he said, and then, with a frown and a shake of his head, "No, that's not fair. We'd talked casually several times, as I told you the other day. Then one night, after a day in which absolutely everything had gone wrong, she stayed after her work was done and…comforted me. Espy was a very caring person."

"Did you know she was married?"

"She told me it was a bad marriage and she was separated from her husband. They'd come to Port Silva together and both found jobs; but after a while, when he got fired from one fishing boat and couldn't find a spot on another, he went back to Mexico. She liked her job and stayed."

Esperanza Moreno, Ferrar told the policeman, was the U.S.-born daughter of Mexican laborers who followed the crops legally but never became citizens, and ultimately returned to Mexico to live. The youngest child and only girl in a family of seven children, she attended school whenever she could and finally, reluctantly went back south with her family, marrying Rubén when she was seventeen.

"He was older than Espy, a friend of one of her brothers or something," said Ferrar. "I don't know why she married him, probably some kind of family pressure."

"Probably."

"At any rate, her parents are dead now. Rubén had promised he would live in the U.S. and become a citizen, but he backed down on that; he preferred Mexico."

"When was it you first had sex with Mrs. Esperanza Moreno?"

Ferrar's shoulders tightened, and his face went pink. "Ah, over a year ago. November, I think it was."

"And the acts took place at the clinic?"

"The first few times, yes." Ferrar's flush deepened. "Why do you have to know all this?"

Salacious curiosity, probably. Plus the need to know how Ferrar felt about the dead woman, at first and later. Maybe how he felt about Hispanic women in general. "And after that?"

Ferrar glared. "At my house. We could hardly meet at her little apartment; her children were there."

"And where were yours? Did Jocelyn or Will know about your affair?" And would they have been offended, he wondered, to learn that important, seemingly upright Daddy was banging a Mexican cleaning woman regularly and spending money on her?

"Jocelyn was living near campus with her boyfriend at the time. And Will has his own place, a house he's building on a piece of land out toward Comptche. I can't think how they'd have known."

"How long did this relationship go on?"

"Ah, a couple of months, I think."

"And then?"

"Her husband returned."

"And she took him back? Didn't it piss you off, Jimmy, that she'd just drop you for this Mexican fisherman who's been described to me as dumb and ugly?"

"No!" Another glare. "You're making this something different from what it was. My wife died thirteen—no, fourteen—years ago, and while I'm a normal man with the normal urges, my work is enormously demanding and I've never made friends easily. I didn't see Espy as an affair or a relationship, just as something wonderful that was happening to me. She made me feel—and act—about eighteen years old." A dreamy, reminiscent look lit Ferrar's face for a fleeting moment.

"I'm surprised her husband didn't come looking for you. For blood or maybe for money," Gutierrez added.

"He accused her of being unfaithful, but she denied it."

Gutierrez had a good idea of the way Rubén would have pursued his suspicions. "Then he went back to Mexico the second time. So what happened with you?"

"I saw Espy a few more times...."

"Had sex with her, you mean. At your house?"

"Yes. But it wasn't the same. She was very angry and she wanted to make a permanent, legal break with her husband."

Gutierrez eyed the other man for several long moments, until he

shifted uneasily in his chair, uncrossing and then recrossing his legs with the necessary attention to the crease in his trousers. "Well. I couldn't offer marriage, which is what she really wanted, to a woman thirty years younger than myself who already had a husband. And two small children."

"Right, Jimmy, same old problem. Just being kind, pretty, and a helluva fuck doesn't necessarily qualify a woman for elevation to wifehood. Particularly if she's uneducated and brown."

Ferrar lifted his chin and met Gutierrez's glare. "True. It doesn't. And Espy knew that perfectly well."

Gutierrez put his elbows on the desk and leaned forward. "Were you the father of her third child?"

There was a blow that missed its mark. "Obviously, Vince, you haven't followed my career in the press. On top of the spurious complaints that have to be dealt with regularly in my specialty, my former associate—Dr. DeWitt Blessingham—was accused of using his own sperm to impregnate clients; and the accusation spread to me."

"I think I remember hearing about it; he was convicted and you were exonerated. So what?"

"The reason that particular charge was easy to refute," said Ferrar, "was that I've been sterile for years."

"I see. Purposefully?"

Ferrar reddened. "Of course not. I contracted a disease not long after my wife died." When Gutierrez simply looked at him, Ferrar's flush deepened and he said, shortly, "Mumps. Jocelyn brought them home from school."

Gutierrez, who'd been thinking in terms of a protective tactic of the newly single or perhaps even a grotesque act of professional self-insurance, was chagrined for only a moment. "But Espy was pregnant?"

"Indeed."

"And you continued to have sex with her?"

"At the time, I wasn't aware of her pregnancy." As Gutierrez's eyebrows arched skeptically again, Ferrar produced a faint, tight smile. "I rarely see an observably pregnant belly. My work is usually over once the embryo or embryos have successfully implanted. Besides, Espy was...out of context, you might say."

"She still is. When did you finally stop with her?"

"Ah, maybe late April? The day she told me that during that last visit her husband had forced her to have unprotected sex with him; she asked me to terminate the resulting pregnancy. I refused. Don't look so offended, Gutierrez," he said sharply. "I told you earlier, I do not perform abortions. What I did was recommend a couple of clinics where she could be taken care of if she didn't put it off too long—one in Ukiah where Will sometimes works, and one in Eureka—and offered to help her with the expense."

"And?"

"That was it. She left, she never came back to ask for any kind of help. I suppose, as I think about it, her background must have prevented her from actually having an abortion."

"Was she angry with you?"

"I don't think so. I'd guess—resigned. To her life and her situation. For all her energy, Espy had a stoic streak."

A learned survival skill in a life like hers, thought Gutierrez, wondering if it had contributed to her death. "Did she suggest that there might be something wrong with the baby?"

"Of course not. If there were, she wouldn't have known."

"I thought there were tests," said Gutierrez.

Ferrar's small sigh—barely controlled tolerance of ignorance—made Gutierrez clench his teeth. "The usual tests are done later in a pregnancy, or more often not at all for a woman who is young and healthy and has borne healthy children. There's no reason Espy shouldn't have delivered another hearty ten-pounder right on schedule."

Except she apparently didn't. Gutierrez decided to keep this bit of information to himself for the moment. "And did you see her again?"

"Not to speak to. Maybe a time or two on the street, from a distance. And then I heard she'd left town."

"Heard how?"

"I don't know," said the other man with a grimace of irritation. "Perhaps from the cleaning service people."

"And when she returned again, healthy and flat-bellied and on her own?" Gutierrez asked.

James Ferrar shook his head, read Gutierrez's gesture toward the tape recorder, and said, "I didn't know she was back in town and if our paths crossed I didn't notice. I hadn't thought of her in months."

Bullshit, thought Gutierrez, recalling Ferrar's expression as he told of feeling eighteen again.

"And I had no reason to harm her," Ferrar went on. "She was not a threat to me in any way."

To whom, then, wondered Gutierrez, was a healthy, free-or-planning-to-be Esperanza Moreno a threat? Jocelyn or Will? Another woman? "What about other women?"

"I beg your pardon?"

"Have you had a 'relationship' with any other woman here in Port Silva?"

"I refuse to answer that. It's absolutely none of your business." James Ferrar closed his mouth tight and set his face in martyr's lines: bring on the cattle prods, the lighted cigarettes.

Gutierrez thought sourly that it would be very easy to make the little prick cough up his soul, and that he should be ashamed of himself for taking pleasure in the notion. He got to his feet, stretched, and sent Val to get coffee. When he and James each had a steaming mug in hand, he returned to his pursuit of information about Esperanza Moreno: her fears, her wishes, her friends. Her dreams for her children. Any plans she had mentioned. Any person other than her husband she'd been wary of.

This got him nothing useful. Dr. James Ferrar had enjoyed having a handsome, good-tempered woman available for his sexual pleasure. He'd bought her presents. Beyond that, he'd gone about his regular life and paid little attention to hers.

As to alibi, he had none. He'd gone home from work that Wednesday night at about seven, picking up some Chinese food on the way. He'd eaten while watching a video, drunk two or at most three glasses of wine, called no one that he could remember, been called by no one. Read for a while. Had gone to bed around eleven, waking promptly when his alarm went off at six-thirty the next morning.

"I thought that in the real world, an alibi was something of a contradiction," he said irritably to Gutierrez. "Something a person planning a crime would be sure to arrange."

"In fiction, Jimmy. Besides, in real life most murders aren't planned." Gutierrez caught Val Kuisma in a yawn and realized that his own stomach was stirring with hunger and threatening to rumble.

"Okay, we'll break this up in a few minutes, maybe talk some more tomorrow."

"I have been completely forthcoming here," said Ferrar. "If this is going to turn into steady police harassment of a busy and innocent man, I'll certainly get my lawyer to work."

"Good idea, Jimmy. Better give him a call as soon as you get home. But first, give me a rundown on some of those 'spurious complaints' you've had to deal with. What does your kind of doctor do to piss people off, anyway?"

"I don't see that it's any of your business," snapped Ferrar.

"Humor me, Jimmy." Aware that he was pursuing this line from frustration and a desire to irritate or even humiliate the other man, Gutierrez turned off the recorder and instead made a few notes. Nothing riveting turned up, and if Jimmy was humiliated, he bore up well. Snotty little prick.

"So. I guess we'll call it a day," he said, tucking his notebook into his pocket as he rose to usher the smaller man out. At the end of the hall, Ferrar opened the door to the outer office before turning to face Gutierrez. "Aren't you going to warn me not to leave town without your permission?"

"Just like television, sure. Don't leave town without my permission."

"Goddamn cops are fascists everywhere, even in small towns." Jocelyn Ferrar sprang up from the wooden bench against the wall and stalked toward them, eluding the grasp of her brother, Will, who'd been sitting beside her. "What the hell do you think you're doing with my father?"

"Jocelyn…"

"Will says you're practically pissing yourself because you found out my father used to have sex with some cleaning woman who just got killed." James made a wordless sound, almost a groan, and Jocelyn frowned at him. "And so what's the big deal if he did? His wife is dead, his kids are grown up, and the last I heard, fucking wasn't illegal between consenting adults."

"Jocelyn, could you just watch your mouth?" said her brother.

She ignored him. "Daddy, I called Harold Williamson, but he's in San Francisco trying a case. I didn't know who else you might want." She hugged her father and then wrapped both of her arms around

one of his as she swung around to face Gutierrez with a look so fierce he barely resisted taking a step backwards.

"Jocelyn, it's all right," said her father in soothing tones. "I'll talk with Harold's partner tonight. Or tomorrow. Come on, I'll take you and Will to dinner."

Ray Chang, who'd been a silent, interested observer to all this, stood very straight and watched the Ferrar family depart. "That's an awesome woman," he said softly. "I was afraid for a moment there she was going to leap on you and tear your throat out with her teeth."

"I bet she could," Gutierrrez agreed.

Chang followed his boss back down the hall, waiting to speak until they were inside Gutierrez's office. "So, Chief. Did that guy kill Esperanza?"

"He was her lover, or at least he had sex with her and bought her presents. He says he's the one who broke off the relationship, months ago, and hadn't seen her recently. And Jocelyn had a point; what he was doing wasn't illegal, and probably not immoral enough to cause him public trouble."

"She could have threatened to charge him with sexual harassment."

Gutierrez shook his head. "Not on her own, Ray. Not from her background."

Chang's grimace reflected his agreement with this. "He's probably too old, and not big enough, to have throttled her anyway. Our best bet is still the husband."

"True. We'll follow up on Ferrar, but carefully. Dr. James Ferrar is not some poor Mexican; Mayor Lindblad considers him a very important citizen."

"Terrific," muttered Chang. "Uh, Chief, there's this other thing. We found Luis Acuña's car, his old Dodge."

Gutierrez, pulling on his jacket, paused and frowned. "Acuña."

"The car Graciela Aguilar took off in."

"Ah." Gutierrez shoved his hands deep in his pockets and propped his rump on the edge of his desk. "Tell me."

"Nothing dire, not yet. It was down on the wharf, parked on the far edge of that big lot at the Dock restaurant."

"Any evidence of a struggle?"

"No evidence of anything." Chang hunched his shoulders high in

a slow shrug. "It was locked, with the windows up. Just the usual family garbage inside. Gearshift in park, brake on. I took Luis down to see it, and he said there was nothing out of the ordinary."

Gutierrez shuffled images in his head and considered a particular one: green-eyed girl tossing her hair back and striding off in the rain. He refused to amend that picture, to let it become battered or bloodied. "The wharf," he said. "And her boyfriend is a fisherman?"

"Right."

"So maybe she changed her mind about him and they've sailed away to get married."

Chang shrugged again. "We've started to check, talk to the boat owners and people who work down there. Nothing yet."

"Cross your fingers, Ray."

"Yes sir."

"And I'm going home. See you tomorrow."

Chapter 15

"THANK YOU for coming by, Chief Gutierrez." Mayor Lyle Lindblad had the spooked look of a man who hadn't noticed the falling tree until it thundered to the ground next to him. "Gives me a chance to express my gratitude to you in person."

"You asked to be kept informed," said Gutierrez stiffly. He had postponed home and dinner to take a quick look at his town, finding the high school campus empty and quiet, the fertility clinic free of demonstrators, the downtown streets a smooth flow of end-of-day traffic. As he caught sight of the LINDBLAD INSURANCE sign on Main Street, he'd remembered his reluctant promise to the mayor and pulled to the curb. The man was his boss, after all, chosen as Port Silva's top official by local voters. (A strong indication, in Gutierrez's personal opinion, that voters were as wrongheaded in Port Silva as in most other parts of the country.)

"Not that we've made much investigative progress," Gutierrez admitted now. "But we're working on all fronts."

"My daughter Leslie is a freshman at the high school," said Lindblad. "She got caught on the edge of that mess today, and she was terrified. She says she just about cried when she saw all those blue uniforms."

"By the time I arrived, Sergeant Mendenhall and his officers had things pretty much under control," said Gutierrez.

Lindblad wasn't listening. "And then I learned a television crew just happened to be passing by when the trouble started. If you hadn't controlled the scene, if the whole thing had gone up, Port Silva would have been on television all over the state. Maybe even the country!" he added, still wide-eyed. "That is definitely not the kind of publicity our business community is looking for."

Gutierrez didn't trust himself to go further in this discussion without blowing his cool and his sure-to-be-brief position of favor. "I'm glad your daughter is okay," he said. "I'll convey your appreciation to my men tomorrow."

Driving homeward in the gathering dark, he remembered that he had not heard from Johnny Hebert on the particular if not the only cause of today's mess at the high school: Debbie Finn's rape. Tomorrow, he thought, and fought to stay alert around a jawbreaker of a yawn that ended just before he reached his own driveway.

Twenty years ago—hell, ten years ago—he'd been like Hebert, able to work through weariness and pull a thirty-six or even a forty-eight-hour shift. Now he got tired too soon and pissed off too easily.

His nice little hillside house welcomed him with lights in kitchen and living room. There were lights in Katy's downstairs room, too; she must be at her homework early. He hadn't come across his stepdaughter at the school melee, but Meg had assured him she was okay. The white chief's car, delivered as he'd requested, was parked at the far edge of the driveway. Gutierrez tucked his elderly but much-loved Porsche in next to Meg's car, pulled the garage door shut, and trudged up the stairway along the side of the house to the brick terrace at the rear, rapping on the back door before entering.

Meg, stirring something at the stove, put down her spoon and went to the refrigerator to pull a square blue bottle from the freezer side. By the time Gutierrez had hung up his coat, she had filled a stubby glass with ice and poured gelid Bombay gin over it.

"Here you are, lord and master. According to an advice column I once read, I should be serving this clad only in a frilly apron and high heels, but I doubt you'd notice."

He accepted the glass, took a sip, sighed mightily, and had a second sip. "You never wear high heels."

"Is *that* my problem!"

"Meg, what are we talking about? And how come you're cooking? After a day like this, I thought we'd go out."

"Everybody is too tired to drive," she told him. "But this is not 'cooking.' This is heating up something called winter minestrone, from that new place downtown, Con Brio. They do takeout, bless their Italian hearts."

He sniffed the air. "I think I won't get drunk and pass out right away. I think I'll stay sober long enough to eat."

"You'd better stay sober long enough to talk to Johnny," she told him, nodding in the direction of the living room. As his gaze followed her nod, Johnny Hebert appeared in the doorway, a glass of red wine in his hand.

"Sorry to intrude, Chief. I missed you at the station, and I thought I'd come in person to tell you, um, what else I missed."

Gutierrez took in his subordinate's uncharacteristically humble demeanor, had another sip of gin, cast his mind back over a bad day apparently not finished yet. And groaned. "Debbie Finn. She's gone?"

Hebert nodded glumly and tossed a quick look in Meg's direction; Gutierrez shook his head. "Meg would hear all about it from me anyway. And Debbie Finn is a student of hers. Pull up a stool and talk, Johnny."

"She looked so awful, I couldn't believe she'd even think about leaving the hospital," said Hebert. "I was there around two P.M., and they said she was still asleep. I went back at four-thirty, and her mother had checked her out. So I hustled out to the Finns' house, but the whole family is gone. A neighbor says Mrs. Finn told her they were going to visit relatives for a few days."

"Did you get a chance to talk to the boys?"

Hebert brightened. "Oh yeah, earlier. They didn't go to school today, stayed with the neighbor instead. Mrs. Hill saw no reason I shouldn't talk to them; she supposed it might help in finding out who hurt poor Debbie."

Meg put a plate of mushroom-and-herb-topped focaccia on the counter in front of the men and joined the group with her drink.

"So?" said Gutierrez.

"So-so," said Hebert. "Recently—probably over the past couple of months but the boys weren't clear on that—Debbie's been going out nights, when she was supposed to be at home baby-sitting. She swore them to secrecy and brought them goodies. They went along, partly because they like her better than they like their mom; I get the feeling she's spent more time with them. Also they liked being left alone.

"But," he added with a sad face, "they never saw who she went with. Somebody would pull up at the bottom of the driveway and honk, and Debbie would leave."

"Didn't they ever sneak out for a look?" Gutierrez asked.

"They did. But it's a long driveway, and they didn't get close. What they saw, at least twice, was a pickup. Naturally. They both say it was dark, black or dark blue. Kevin, the eight-year-old, thinks it was an American model, full size. Neither of them got a good look at the driver, who didn't get out, and they were always asleep when Debbie got home."

"Anything last night?"

"Barry, the little guy, was asleep. Kevin says he was in bed and didn't get up, but he thought it was just the usual—Debbie got dressed up and somebody honked and she went out."

"Okay," said Gutierrez grimly. "Good. What did neighbors have to say?"

"About last night, nothing," said Hebert with a shrug. "There's a lot of coming and going at the Finn place. Sandra Finn said she doesn't bring men home, but apparently men come to pick her up, fairly often. Two neighbors didn't notice any difference recently. The closest one, Mrs. Hill, had a notion Debbie was sneaking out but thought she was entitled. Mrs. H. says Sandra Finn made a servant of her daughter and that's not right.

"After I found out they'd skipped, I did some checking on Sandra Finn," Hebert added. "I learned that she'd been arrested twice for soliciting. One conviction, got a fine and a suspended sentence. Notes on the case said she wasn't a real pro, just a woman who was both broke and lonely."

Gutierrez turned to Meg, who'd been listening quietly. "Have you seen Debbie with any particular guy or group recently?"

This she'd already thought about. "Not with a guy, but she's seemed close recently with another girl in my first-period class, Greta Magnuson."

Gutierrez and Hebert looked at each other. "Lots of Magnusons around," said Johnny.

"Some good, some not so good," said Gutierrez. "What about this Greta, Meg?"

"Sullen," said Meg promptly. "Skinny, blond, not bad-looking. Not very bright. When she was in one of my sophomore classes two years ago, she was a bit more cheerful; I think the logging company her father worked for has since folded. And I think I'd had her

brother the year before, but I don't remember much about him."

"Chief, are we going anywhere with this, now that the girl has left town and presumably won't pursue her complaint?"

"We'll continue the investigation, as for any assault case," said Gutierrez. "It's obviously more complicated than it looks, and I want to know what's behind it. Have a look at this particular Magnuson family tomorrow."

"Yessir," said Hebert. He set his empty wineglass to one side and got to his feet.

Meg rose, too, and went to stir the simmering pot. "Johnny, will you stay for dinner? There's plenty."

"Thanks, but no. Alma's got my car—hers is in for a ten-thousand-mile check—and she's picking me up here." He looked at his watch. "In five minutes. I'll go wait for her at the foot of the driveway."

Gutierrez blinked, then remembered. "Ah. You delivered the chief's car."

"Yessir. Thanks for the wine and focaccia," he said to Meg. "Chief, I'll see you tomorrow."

As the door closed on Hebert, Gutierrez got to his feet and drained his glass. "Meg, have I got time for a shower before supper?"

"Of course," she said absently. Her mind was on the possibilities of a romantic relationship between Johnny Hebert and Alma Linhares. Odd, but interesting. She was maybe a tiny bit envious.

On his way to the stairs, Gutierrez paused at the end of the sink counter to flick on the small television set, turning the volume low. "I think there might be something interesting on the local news."

Meg set the table and tossed the salad, wondering where normally ravenous Katy was. Upstairs, the pipes rattled as Vince turned off the shower. Meg looked at the clock, frowned, and picked up the kitchen telephone to dial the separate downstairs line that had been Katy's most-requested Christmas present. When her daughter answered, Meg said, "Better hustle, baby. Supper's on."

"I'm not hungry," said Katy.

"Really. Well, please join us anyway. We haven't seen you all day."

"It's raining."

"So it is. At your usual pace up the stairs, you'll get hit by about three drops."

"I'm tired. I think I'll just go to bed."

Meg, weary herself, was swept by a peppery flash of irritation. "Katy. Five minutes. Or else," she said, and hung up the phone.

Vince came down the spiral staircase moments later, looking very dark and male in a new suit of red sweats. As her bad temper faded, displaced by a warm little flicker of lust, Meg half wished she'd left Katy alone. Maybe later, if both of them could stay awake…

"Go ahead, sit down," she told him, dishing up a bowl of minestrone. "Help yourself to salad. Katy will be here in a minute."

She had just set a second bowl on the table when the front door was flung open and Katy burst in. She slammed the door behind her and struck a dramatic pose, chin high. Katy was all in black: tight black jeans, long black sweater, a black ribbon on her short dark (not quite black) hair. And what looked at first like two black eyes: black eyeliner and mascara (where did she get those? Meg wondered) applied by a demonstrably novice hand.

Vince eyed her in amazement. "Who died?"

"It's not your fault that nobody did!" she snapped. "I'm dressed in, um, in *solidarity*. With my *friends*. Who got arrested today and *beaten up* just for *defending* themselves."

Meg thought she had not heard so many italics in one paragraph in years. If ever. "I beg your pardon?" said Vince.

"Just because they're brown and speak Spanish, all you *gringo* cops think you can push them around. Jesús and Angel were *not* doing anything wrong, I know they weren't. And you threw them in *jail!*"

Meg looked at Vince, whose frozen face resembled more than ever an ancient Aztec mask. "Gringo?"

His eyes met hers, the mask shivered. By tacit mutual consent they broke that gaze, Meg biting down hard on her lower lip against laughter she knew would exact a price. "Katy…"

"And anyway I don't have time for supper because some of the kids are picking me up in a few minutes. I'm just going down to the road to wait for them. We're holding a candlelight vigil at the jail."

"No, you're not," said Meg.

"Mom, I have to do this! Anyway, you can't stop me."

"You want to bet?" Meg straightened to her full height; she topped her daughter now by little more than than an inch, but outweighed her by a good thirty pounds.

"You're going to *hit* me!"

Something she had never yet done, and it was a bit late to start. Meg sighed and relaxed her stance. "I think that would embarrass us both. But you are not going out."

"But I *need* to," she wailed, pounding one fist in the other palm. "Mom, you did this kind of stuff, when you were in college. About that war; I heard you talk about it."

"I was eighteen years old," said Meg weakly.

"People are older now," said Katy.

"Some of us certainly feel that way," replied her mother.

"So why...hey, I know! Why don't you come with us? You've got some black pants, and you can wear your black raincoat and put something over your hair...no, the gray will shine, that'll be neat. Come on, you always said it's important to stand up for what's right."

It made a clear picture in Meg's mind: the wife of the chief of police standing a vigil of protest at the police station, the gray in her hair mist-frizzed into a silver halo, folded hands cradling a candle. Jesus wept.

"Katy, no one is being held." Vince's voice had a tremor, whether from hard-suppressed laughter or pure disbelief Meg couldn't tell. "Only the people found to be carrying weapons were even charged; and they've been released by now."

"Well. Shoot," muttered Katy. She surveyed the table, and scooped up a piece of focaccia that she carried with her to the telephone. Her brief conversation was low-voiced, but Meg assumed it was to wave off whichever friends had planned to pick her up. Identities something to be checked on later. "Hey," Katy said, as she set the phone down. "Hey, look at the television."

The scene on the screen was the high school campus in a gray drizzle. On the ground of the quad were a few scattered belongings—books and sodden items of clothing and a broken umbrella. The camera moved up to focus on the backs of a crowd funneling into the double doors of the gym. The focus dissolved, and the next shot was of Vince Gutierrez, uniformed but hatless in the slight protection of a roof overhang; then the camera turned to the face of a sharp-featured blond woman wearing a glossy orange raincoat and lipstick of the same shade and shine.

"Chief Gutierrez, we've learned that there have been problems

here in town with undocumented aliens. Is that—are they—what's behind today's trouble?" She pushed the microphone at him.

The camera lingered on his lean brown face with its hooded eyes and deep cheek groves; he stood silent for a moment, as if to give everyone a good look. "The fighting we stopped here was between two groups of students. If any of them are undocumented, I have no knowledge of it. I do know that some of them are native-born U.S. citizens who happen to be Spanish-speaking."

"Yes, I understand," she said quickly. "But weren't today's fights, and the recent assault on a white girl, racially motivated?"

"Miss, my job is to protect and serve Port Silva's citizens and visitors in as fair and color-blind a manner as possible. That's what Mayor Lindblad and the members of the city council hired me to do. Beyond that, I can't comment on any case currently under investigation." His smile was a sharklike flash of white teeth.

"I see. Thank you, Chief Gutierrez."

Vince reached out to silence the set. "Do you suppose the mayor saw that?"

"Probably you should hope not," said Meg.

"Vince?" Katy had filled a bowl with minestrone. Now she brought it to the table and sat down. "It was the white guys that started it."

"I've heard that, but without any detail."

"I was there in the quad, at morning break," she said, spooning parmesan cheese into her soup. "This big ugly senior everybody hates climbed up on a bench and started yelling. He said that if the fucking—Mom, that's what he said, not me—Mexes wanted to kill each other it was okay with him, but when they started jumping white girls they were asking for it."

"Do you know this guy's name?" asked Gutierrez.

"Sure, Hamm. Dwayne Hamm."

"Ah. Thank you," said Vince.

Meg handed Katy a plate of salad. "Katy?"

"Good soup, Mom. What?"

"Don't you think you should apologize to your father?"

Katy blinked, turned to look at Gutierrez, turned back to her mother. "Huh?"

"For calling him a gringo."

"Oh. Sure, right. Vince, that was dumb and I'm sorry."

It occurred to Meg that this was the first time she had ever referred to Vince Gutierrez as Katy's father. From the look on his face, she thought it had occurred to him, too.

"Thank you, Katy. I don't know what I am, but gringo doesn't feel quite right." He picked up his soup spoon and propped both elbows on the table. "I've been thinking lately I should study Mexican history, take lessons in the language, something. Try to get in touch with my roots, like Mary Louise a few years back."

"With Mary Louise, it didn't take," Meg reminded him. And this reminded her of Cass, who had been friends with Debbie and still, probably, did not know of the rape. But this was not a burden she was going to lay on her husband's weary shoulders tonight.

"No," she told him, "just stay a mongrel, like Katy and me. If you don't have any roots, maybe you're free."

They finished their meal quietly, and Meg absolved Katy from any cleanup chores, sending her off to her bedroom with a hug and a jar of eye-makeup remover pads. Then Meg and Gutierrez took coffee and biscotti into the living room, where the Beethoven Sixth Symphony was whispering from the music system. "How did your...interview with Dr. James Ferrar go?" she asked. "Is he a serious suspect?"

"Serious asshole," muttered Gutierrez. He dipped the hard cookie into his coffee, swooped the dripping result to his mouth, and settled back to relate to Meg the salient points of his session with Jimmy Ferrar.

"So, a cold-blooded little prick, excuse the language. But not necessarily a murderer. He's sorry about Esperanza Moreno's death, but he's a lot more upset about the demonstrations at his clinic. He says he's had nothing but bad luck and bad publicity ever since he and his former associate, a doctor named DeWitt Blessingham, were accused of misconduct. Blessingham was ultimately convicted of using his own sperm to impregnate clients."

"I remember that," Meg said slowly. "It hit the news about six months after Dan was killed."

Meg's first husband, math professor Daniel Halloran, had been run off the road by a drunk driver in the mountains of Arizona. Gutierrez had seen pictures of him, and knew that Dan's features and

coloring, particularly his electric-blue eyes, lived on in his daughter.

"The clinic was in San Diego," said Gutierrez. "How come it was a big story in Tucson?"

Meg settled lower into the soft couch, propping her coffee mug on her knees. "When Katy was, oh, six I think, Danny and I decided it would be nice to have another baby. But nothing happened. Turned out things were just minimally wrong: Dan had a lower-than-normal sperm count, my uterus was slightly misshapen. So what had occurred naturally when I was twenty-nine didn't happen again at thirty-five.

"Anyway, after a couple of years of mild treatment and all the stuff you do—temperature-taking, ovulation charts, mucus tests, sex by timetable—my doctor said maybe we should think about in vitro. And Danny being Danny, he set about reading everything he could find on infertility treatment and clinics. The Blessingham clinic claimed the highest success rate on the west coast—in fact, so much higher than any others whose records were available that Danny got suspicious."

"Like any good mathematician."

"Right, and any good husband. He was also troubled by what he saw as lack of federal oversight of fertility treatments. Many countries—England, Germany, Australia, others—have rules and extensive record-keeping; but all that clinics have to do in the U.S. is to report their success rates."

"In this big, messy country," said Gutierrez slowly, "it's tricky to make laws about something as basic as reproduction without offending half the population. Congress tends to stay well back from stuff like that. Besides, they probably don't want to take on the A.M.A., which I believe generally prefers to regulate itself."

Meg permitted herself a brief grin. "Right. Wasn't it a California politician who said that any doctor licensed in this state is free to practice brain surgery if he chooses?

"Anyway," she went on more soberly, "infertile people here have many options. They can pay a donor for semen. They can hire a woman to donate eggs, or to be a surrogate and gestate an embryo. They can pay a clinic to prepare embryos to order for them. They can buy one couple's unused embryos from a clinic, if the first couple agrees."

Gutierrez could feel himself sliding once more toward Dr. Gabe's point of view on all this. "I guess you didn't pursue the in vitro option."

"Dan and I were still tossing the idea around when he was killed. Afterwards I spent quite a long time moping around the house drinking gallons of coffee and lots of other stuff besides, and reading newspapers and watching television. When I saw the story about Dr. Blessingham, I remember thinking I was lucky I hadn't gone to his clinic. Last thing I needed right then was a baby, especially some other man's."

Gutierrez put an arm across her shoulders and pulled her closer. "Sorry."

"It's okay. Long time ago."

"Funny thing," he said after a moment. "Jimmy says that he practices very conservative medicine. But he still gets threatened periodically with lawsuits by disgruntled clients."

"On what kinds of charges?"

He tipped his head back against the cushions and thought about his notes. "That he discriminated against a biracial couple. He said he rejected them solely because the woman was forty-five years old, which was past his stated cut-off age of forty-two, and the husband even older. In another instance, a woman he had rejected for treatment because of a history of drug abuse picketed his home with signs.

"Then, let's see," he said, and lifted his head for a sip of coffee. "There was a couple who got upset and threatened suit when he refused further treatment after they'd been through four cycles without success. And last year there was a woman who insisted she had asked to have surplus embryos frozen rather than discarded. He had a signed contract with her disproving her claim, but it made good newsprint."

"I think I'm not sufficiently evolved to appreciate the world of modern science," said Meg. "I think I was very, very lucky to have a baby the old-fashioned way. And at the moment I'm quite sure one was enough."

"Meg, Katy is wonderful."

"Right, and her currently most wonderful quality is that she's downstairs and we're here. Let's go to bed. And if anybody calls you tonight, he'll be lucky to live to regret it."

Chapter 16

WHEN THE DARK silence of the bedroom was invaded by the telephone's muted little trill, Gutierrez's sleeping mind registered the sound and named it dream, mental echo of the night before. He sighed, and sank deeper into sleep.

Meg, on the telephone side of the bed tonight, heard it as well and reached out blindly with no thought but to silence it. When she found the instrument in her hand, and realized it was still producing sound but of a different sort, she eased herself out from under the comforter and Gutierrez's outflung arm and crept across the room to the bathroom, where she closed the door and turned on the light.

"I don't care what it is," she snarled, softly, to whoever was at the other end of the line. "I'm not going to wake him up."

"Ma'am, Chief Ziegler asked me to call Chief Gutierrez. To tell him the old hospital is burning."

Old hospital. The fertility clinic. Dr. Gabe's place. "Is anyone hurt?" she asked.

"Ma'am, we don't know that yet. Crew's just started working it. I gotta go," the male voice added, and with a click the line resumed its open tone.

Meg looked at herself in the mirror. Heavy eyes, rumpled hair, mouth soft and slightly swollen, she looked like a lady who'd had a big night. And so she, they, had, and she was not by God going to wake Vince from the first decent sleep he'd had in weeks.

She turned out the light and waited for a moment as her eyes adjusted. She made it safely, silently, across the room, and paused beside the bed to replace the telephone in its base. Dr. Gabe's hospital. Maybe after all...

As she settled carefully onto the bed, Vince groaned and snorted.

"Um," he said, and then, "Ah," as he rolled over and reached for her, pulling her down with one arm and sliding his other hand inside the V-neck of her nightgown.

Meg sighed and pressed his hand against her breast for a moment before pulling free. "Sorry, love, but I think you'd better wake up. Someone just called to say the old hospital is on fire."

The Porsche was in the garage. Gutierrez flung himself into the nearest vehicle, the white city sedan, slapped a portable magnetic light on the roof, and made a gravel-spewing turn to aim himself down the drive. The rain had stopped for the moment but the sky was low and heavy with more to come, this night a replay of the one before and something he seemed doomed to repeat eternally.

At 4:40 on a Wednesday morning, traffic on the Coast Highway was sparse. Gutierrez, jaw as tight as his grip on the wheel, resisted the urge to use his siren. No need here, no reason to wake the sleeping north end of town when he got that far.

Probably those vandals, moving up from painted flames to the more exciting kind. Probably he should have posted a man at the clinic instead of ordering patrol to increase again the frequency of drive-bys in that area. But there was Winner's Circle to watch, too, and other places like it where vulnerable people were sleeping or trying to.

At Madrone, the first east–west street within the town limits, he swung a quick left and then, five blocks up, a right, onto Jefferson. Dr. Gabe's shingled cottage was dark and silent; the Cadillac was not on the street but the garage door was closed. If the old man was at home and asleep, there was no point in disturbing him.

Gutierrez hit the accelerator and bounced into a right turn. Before he reached Main Street, he heard sirens; as he turned onto Main, he saw a light that mimicked a rising sun, against the western sky.

The front yard of the old hospital was a writhing maze of hoses being pulled about by running, shouting men in yellow-edged black rubber gear. Gutierrez left his car at the curb behind a fire engine and ran to the gate in the iron fence, where he made himself stop; he had nothing to add to the crazy but ordered activity there and would only get in somebody's way.

"Art!" he shouted, as he caught sight of a tall man, rubber-suited

but bareheaded, standing inside the fence well back from the activity.

Art Ziegler, Port Silva's fire chief, looked over his shoulder and raised a hand in greeting. "Hey, Vince. I knew you'd been having trouble here, so I told 'em to call you," he said, as Gutierrez approached. "Good thing we've had months of practically nonstop rain. Otherwise an old wooden building like this would have gone up in a flash. As it is, we got here kind of late, because the fire started in the rear and wasn't noticed until it had a pretty good hold."

"Is anybody inside?"

"Don't think so," said Ziegler. "The doctor who runs the place—we called him and he should be here any minute—he says they're strictly outpatient, no overnight beds; and nobody's working at night right now. But there's always the possibility that the asshole who set this trapped himself in there, so we've got a couple of guys in breathing gear going in for a look."

"So it was arson?"

"Guys who got here first said you could really smell the gasoline." He'd been dangling an electric bullhorn from his right hand. Now he raised it to his mouth and shouted something at his men; there was a scurrying response from hose carriers, and two streams of water shifted direction.

"Who's in charge here?" demanded a familiar voice. Gutierrez and Ziegler turned to see Dr. James Ferrar stepping from the passenger door of a big, light-colored Mercedes sedan. As he slammed the door of the car, a uniformed officer motioned the driver on, pointing to the end of the block.

"So much for the office and file room. And the computers," said Ferrar grimly as he reached the pair. "What about the rear buildings?"

"Those two little stucco structures?" asked Ziegler. "We wet 'em down as a precaution, but they should be safe—they're well back, tile roofs, no encroaching shrubbery or trees. I wouldn't bet on the power supply, though."

"There's an emergency generator system. I should probably be grateful the troglodytes didn't know that's where the freezers and incubators are."

As he pulled his coat tighter around his shoulders and set off at a near-trot toward the rear buildings, Gutierrez registered with a jolt

what he'd meant. Back there, in an incubator or for all he knew maybe a freezer, were microscopic future Hegartys. And who, except James, knew who else besides?

He forced his attention back to the main building, a high, dark shape eerily backlighted by flames shooting from ground-floor windows at the right rear, smoke billowing from the upper level. Men on the ground shouted to one another; streams of water shifted.

Lower flames billowed again, and the watching men heard a heavier sound, a rolling rumble and a series of sharp cracks. "Ceiling in the ground-floor rooms getting ready to go," said Zeigler. He pulled a walkie-talkie from a pocket and spoke into it.

"Jesus, Chief, did the old man get out?" Swung around by a hard grip on his shoulder, Gutierrez found himself facing a wild-eyed Officer Ralph Hawley. On the street behind Hawley, bar-light still flashing and driver's door open, was Hawley's patrol car.

"What old man?" demanded Gutierrez.

"He was here when I checked at one A.M., said I didn't have to worry, he'd be keeping an eye on his…"

"Daddy!" Anguish rang in that single word as Jocelyn Ferrar ran in through the gate. She spotted Gutierrez, stopped, wailed, "The Cadillac is parked down that side street!" Then, as her father appeared, "Granddad must be in the building!"

"Dr. Gabe? Shit," said Ziegler. He moved closer to the building, walkie-talkie at his lips. "Ziegler to rescue. We have word that Dr. Gabe Ferrar may be in there."

"That ridiculous old fool," whispered James Ferrar. "He *threatened* to do something like this, and I didn't listen."

"Jimmy, shut up!" said Gutierrez through clenched teeth. He set off, in Ziegler's wake, across the muck and hoses toward the building. Before they reached the steps, the front doors opened and the two firemen emerged, carrying a long form between them.

"Wait," said Ziegler, his hand on Gutierrez's shoulder. The pair came down the steps and several feet along the flagstone walk before stopping to lower their burden gently to the ground.

The firemen stepped back and removed their helmets, and the nearest looked at Ziegler with a shake of his head. "Didn't stop to feel for a pulse, but I think he's a goner. He'd crawled out of the burning room into the hall, but the air was bad there, too."

Dr. James dropped to his knees beside his father. "He's alive, but barely," was his pronouncement as the fire department paramedics raced up with stretcher and breathing apparatus. Gutierrez got what experience and an ache in his chest told him was likely to be his final look at the old man before they swept him off to the ambulance: face blackened from smoke, hair singed to the skull, trouser legs wet black shreds of fabric. If Gabriel Ferrar was alive, it was probably to his own sorrow.

James conferred briefly with the paramedics before taking his daughter's arm and hurrying off with her to their car.

As to the scene at hand, the fire was under control or nearly, the sense of urgency giving way to methodical teamwork. "Art, you do good work," Gutierrez told Zeigler. "Let me know what you discover when you can get inside, okay?"

"Sure. Be a while, though."

"You know where to find me." Gutierrez nodded and headed for his own car. He could go to the hospital, where he would be useless and probably resented by the younger Ferrars. He could go get some breakfast; with the world he stood in reeking of smoke, and a stench in his nostrils, real or imagined, of burned flesh, the thought of food brought bile to his throat and queasiness to his stomach.

Or he could emulate Art Ziegler and go to work.

At fifteen minutes past seven A.M., first watch was being briefed by Sgt. Mendenhall, and third watch had checked in, cleared out, and gone home—except for Ralph Hawley, the distraught patrol officer from the fire scene, and Dave Figueiredo, a cousin of Alma Linhares and a young man impelled by a sharp mind and equally sharp curiosity.

"Ralph, don't beat yourself up about it. It was his property, he had a right to be there, you couldn't have stopped him, short of arresting him. Dave, thanks for your information. I may need to talk to you again later." Gutierrez waved the two of them out and reached for his telephone.

The clerk or nurse or whoever she was at Good Samaritan Hospital was a by-the-book sort. "Dr. Gabriel Ferrar was admitted to Good Samaritan earlier this morning, but information about his condition is available only to members of his family."

"This is Chief of Police Vincent Gutierrez," said Gutierrez in his most authoritative voice. "Besides being a good friend of Dr. Ferrar, I am investigating the fire that caused his injuries. What is his condition?"

"Oh. Chief Gutierrez. I, um...I believe Dr. Ferrar's condition is extremely critical; would you like me to have his doctor call you? That would be Dr. James Ferrar."

He'd thought treating one's own family members was not normal medical procedure. Not considered sensible or quite ethical either. "Please ask him to call me as soon as he's free. To pursue the investigation, I need information on the nature and extent of Dr. Gabe's injuries." Gutierrez gave her his office number. Then, fairly sure of the answer, he asked, "Will visitors be permitted?"

"Oh my, no. Only immediate family."

Gutierrez thanked the woman and put the phone down. Jimmy would probably try to stop him, but he could get in if he pushed hard enough. Question was, how much did he need to see his oldest friend on what was surely his deathbed? And what good would his presence be?

What he could and would do was catch the son of a bitch who'd torched that hospital. What had happened was painfully obvious to Gutierrez, who knew he was going to pay a big price in guilt for having ignored the possibility. Dr. Gabe had mounted guard over his property as he'd threatened to do, and he'd either stumbled on the fire-setters or spotted them and charged into confrontation. And then...what? Been struck down and left to burn to death?

Gutierrez took a deep breath against a tightness in his chest and a ringing in his ears: undirected anger was a waste of energy. He gathered papers scattered across his desk into an orderly handful and went looking for troops to marshal. As he stepped into the hall, the back door opened and Johnny Hebert ambled in.

"Hebert! In here," he said with a sharp nod, and Johnny followed him into his office.

"Grab a cup of coffee," Gutierrez said. "You hear about Dr. Gabe and the fire?"

He had not, so Gutierrez filled him in on what he knew and what he suspected. "Ralph Hawley was the patrol on the north end of Main last night, with instructions to keep an eye on the clinic. He

checked the doors at midnight, all locked, drove by half an hour later, nothing. At one o'clock he saw a light in the rear, found Dr. Gabe there 'making rounds' with a flash. Gabe told him he was staying the night, napping and watching."

Gutierrez sighed. "Hawley says from then on he drove by about every half hour, except for an assist at Fisherman's Rest around one-thirty A.M. and another at the marina that started at three. He says he doesn't *think* he slacked off because of knowing there was an owner on the site."

"Any report on Dr. Gabe's condition?"

"Extremely critical," said Gutierrez through his teeth. "At his age, probably terminal." He took a deep breath and expelled it in a gusty sigh.

"So. In effect, we'll put the Debbie Finn matter on hold for the moment," he told Hebert. "In actual fact, this may be related, because I'm not convinced we've got *two* roving criminal gangs in this one little town. Anyway, here's where we are so far."

He handed Hebert a sheet of paper. "The names of the protesters who were on-site at the clinic yesterday. They said they had nothing to do with the damage the night before; and most of them are what you'd call responsible citizens. But we'll need to talk to every one of them.

"Here are the names of the three young jerks who got physical at the clinic on Monday," he said, offering another sheet.

"Oops. Arnie Grebs."

"Right," said Gutierrez. "And Dave Figueiredo, who was on patrol last night and keeping a particular eye on the Winner's Circle, saw Arnie Grebs, and Dwayne Hamm, he thinks it was, in Arnie's pick-up last night about two A.M. He thought at the time they might be heading for the Circle but changed their minds when they spotted his black-and-white. They drove off to the north.

"And one more possibly pertinent thing," he said, offering the last sheet of paper. "Yesterday, at the high school, a kid named Bobby Hooper was found to have a pistol in his possession, a snub-nosed .38. Which was listed in the items stolen from one of the vandalized houses last week."

"Hooper?" said Hebert, and shook his head.

"Sixteen-year-old from a sheep-farming family out in the county.

He said somebody gave it to him. Then he changed his mind; said no, that was wrong, he found it on the ground during the action at the school."

Hebert put the sheets in order, folded them double, and put them in his inside jacket pocket.

"Make copies," said Gutierrez. "And get Kuisma on this with you, and Chang, too, unless he's got something working on Graciela Aguilar's disappearance."

"I'd say arson and murder take first place," said Hebert, and then flinched visibly. "Sorry, Chief."

"So am I. And somebody else is going to be, too."

When Hebert had departed, Gutierrez stared at his own reflection in the glass front of his antique lawyer's bookcase, a gift last year from Meg, and acknowledged that he was going to pursue the area of this investigation he should above all leave to somebody else. But the only other person he'd trust for it was Hank Svoboda, who was unavailable except for consultation. Afterwards.

Although food was still not an appealing idea, he feared for his self-control unless he put something, anything, in his stomach. At his usual haunts, like Eddie's or Armino's, he'd run into people who'd want to question him or even commiserate with him. He settled for McDonald's, where he consumed an Egg McMuffin with bacon and an enormous container of milk in the solitude of his nearly anonymous white car.

At nine-thirty Gutierrez pulled into the parking lot at Good Samaritan Hospital. "I asked Dr. James to call me, but he hasn't," he said to his passenger. Reluctantly aware that he needed backup on this, he'd opted for Alma Linhares, who had the deep awareness of human possibilities found only in people from very large families. Besides, Alma was smart and tough, with hardly a gram of sentimentality in her whole being.

They checked at the desk, to learn that Dr. Gabe was on the second floor in the intensive care ward, and Dr. James was there as well. They took the elevator up, and Gutierrez was about to approach a nurse and ask her to find Dr. James when the man himself emerged from a nearby room and started down the hall away from them.

"Jimmy."

Ferrar turned around. "Gutierrez, I haven't called you because there's nothing definite yet."

"What's definite is that I need to talk with you, and with Jocelyn, and with Will," said Gutierrez. "Preferably in my office, which offers privacy."

"Don't be ridiculous!" snapped Ferrar. "We have nothing to tell you."

"If you'd prefer to remain available to your father, we can probably commandeer an office here," said Gutierrez. "This is Officer Linhares, who can take notes. Are Will and Jocelyn in the building?"

Ferrar's face was set in what looked more like irritation than sorrow. "Will is in the lounge; Jocelyn is in an office making some telephone calls for me. All right, my father is stabilized with pain medication for the moment. I can give you one hour; then I have my own work to prepare for, with Mrs. Hegarty. Good Sam," he said with a grimace, "has reluctantly agreed to let me perform the embryo transfer here. So come along and let's get this over with."

Gutierrez's snap decision was to talk with all three at once. The small office Jocelyn had been using had a desk, an office chair, a visitor's chair, and a wooden stool. While a huffy Jocelyn went off to collect her brother, Alma Linhares pulled two molded plastic chairs in from the hallway.

Gutierrez took the desk. Will, who was red-eyed and moved as if the air around him were water dragging on his limbs, lowered his long body into the visitor's chair. James and Jocelyn took the plastic chairs, and Alma set the stool against a wall and perched on it, hooking a boot heel over a lower rung and opening a notebook on her knee.

"What is your father's condition?" Gutierrez asked James.

"He has second- and third-degree burns over his legs and lower body, less serious burns to his upper body and face; his lungs were seared, and his heart is weakening."

Other than that he's fine: was the follow-up James's tone suggested. Gutierrez unlocked his jaw and swallowed hard. "Is there any injury that might be unrelated to the fire?"

"He has a deep gash on the side of his head. I'd suppose it was caused by falling and hitting a desk or a shelf."

"Or by someone hitting him."

"Well. Possibly."

Gutierrez eyed the trio grimly. "Did any of you know anything, did he say anything to any of you after the shotgun business yesterday, about further plans he might have?"

None of them remembered anything of the sort.

"Did any of you see Dr. Gabe last night?"

James shook his head. Jocelyn said, "No," softly. Will, hands gripping the arms of his chair so tightly that his knuckles whitened, said, "I had supper with him, and he said he was tired as hell and was going right to bed. It was about nine o'clock when I left to go home."

"And where were you all last night? Jimmy?"

"I was at home, as usual."

"Really?" said Gutierrez. "Then who was it my patrolman saw driving your Mercedes about one A.M.?"

"I—perhaps Jocelyn…"

"I'd been studying late so I went for a drive.…" Jocelyn's voice trailed off in its turn, and her face went pink. "Uh, no. That was some other night."

"All right," said James. "I remember now, I'd been doing some heavy reading and I wasn't sleepy, so I decided to go for a drive. I parked out on the headlands for a while and listened to the ocean."

"Did you go to your clinic?"

"I drove by before heading home for bed. Everything looked quiet and I didn't stop. Other than that, I spent the evening at home alone until the call about the fire."

"Jocelyn? Don't you live with your father?"

"Ms. Ferrar!" she snapped, and then reddened further. "I have the little in-law apartment at the back of the house."

"And were you at home last night?"

She glared at him and spoke through tight lips. "I had a late lab at school. Then I grabbed some supper downtown. Went back to the library and studied until around ten. From then on I've got one hell of an alibi; I spent the rest of the evening, until about one-thirty, with a cop."

If it was only until one-thirty, it isn't an alibi, thought Gutierrez. "Anybody I know?" he asked mildly.

"Ray Chang."

At another time he'd find this interesting. Gutierrez probed

further, and found that James had not observed his daughter's comings or goings; and since the Merc was always parked in the garage, which had an electronic door-opener, Jocelyn couldn't say for sure if it was there when she came home.

Gutierrez turned his attention to Will, who occupied his chair like one of the Egyptian pharaoh figures: arms right-angled at elbow, legs the same at the knees, feet flat in front of him. "Will, where were you last night?" While James's Mercedes stood out, Will Ferrar blended right into the local scene by driving a Dodge pickup truck with a shell over its bed. If Will were out and about last night, no official had noticed him.

"At home, I was at home. But I can't prove it, I live alone and there aren't any neighbors close. Goddamn it!" he said in a half sob, "if I'd just stayed in town with Granddad this would never have happened." Tears spilled from his reddened eyes and he made no effort to wipe them away.

Dr. James Ferrar had had enough. "Gutierrez, if my father didn't set that fire himself and then get trapped by it—and I insist that's the likeliest possibility—then he was a victim of the idiots who've been making my life hell. You have absolutely no right to be harassing us. What kind of family do you think we are?"

"Murders happen in families all the time," Gutierrez said. "Families can get fed up with irascible, uncooperative old people—especially old people who have lots of assets."

Will closed his eyes and shook his head; James and Jocelyn broke into furious speech, Jocelyn's voice the stronger. "Don't be ridiculous! He was the hero of my life, my grandfather. And if I'm not crying and beating my breast like Will, it's just because I don't, ever!"

James tried again, and once again she overrode him. "And my father helps people make life, he wouldn't take life away." Then, in contradiction of her previous claim, she broke into tears.

James seemed faintly embarrassed by this display. "I make a very decent living, Gutierrez. And in spite of our differences, my father has not yet evicted me."

"No, but as recently as Monday he talked to Mal Johns of Coast Real Estate about selling the hospital," said Gutierrez.

"But I didn't know that," said James firmly. "Besides, I probably had nothing to gain from his death; I doubt he has enough regard for

me to have made me his heir. He's probably leaving everything to his medical school, or the county Land Trust. Or to Will; he's said often enough that Will would make better use of the money than I would."

"Oh, stop all this!" shouted Jocelyn, leaping to her feet. "Gabriel Ferrar is the most traditional man on earth! Whatever he might tease or threaten, there's no way he'd destroy his own past or leave his estate to anyone but his son." She snatched her handbag from the desk and headed for the door.

"And he's not dead yet!" she shouted, and fled.

Chapter 17

"CHIEF, MY BOY'S rights is being violated here." Officer Alvin Grebs spoke in a tone near pleading, but his stiff stance revealed how much he hated what he was doing. "Bob Englund was way out of line on this."

Grebs's son Arnie was presently being questioned, along with Dwayne Hamm, about last night's arson. Gutierrez, working at his desk, now gestured the senior Grebs into the office, but did not ask him to sit. "Arnie made an illegal U-turn, apparently because he'd spotted the black-and-white coming in his direction. Officer Englund stopped him, found his registration was out of date, and detected the smell of alcohol."

"So Arnie had a beer someplace. That don't mean it's legal to search his truck."

Gutierrez wished he'd thought to get this all on tape, in preparation for a firing for incompetence. "That's exactly what it does mean, Grebs, especially since Arnie is below legal drinking age. And what Officer Englund found in the truck's utility box was a can that had contained orange paint, with a couple of dirty brushes. And two five-gallon gas cans, one of them empty."

"Nobody drives around the back roads in this county without a spare can of gasoline. I got one myself."

"And the orange paint?"

"Nothin' illegal about orange paint, either, far as I know."

"If it matches the orange paint on the Family Fertility Clinic, then it's illegal," snapped Gutierrez. "And one act of vandalism could be presumed to lead to another."

"Chief Gutierrez, there's no way on God's earth my boy would've set a fire."

Gutierrez thought that Arnie Grebs, and his many brothers as well, had probably been playing with matches since before they learned to tie their shoes. If they had ever mastered that difficult skill. "Alvin, you'd better talk to your son and explain the facts of life to him and his friend. Maybe you'd better get him a lawyer."

"Shit, I can't afford no lawyer. I guess the Police Officers' Fund can help, I've contributed enough over the years."

"You can apply," said Gutierrez. "But an arson charge, and murder if it comes to that, will incur a lot of legal time and expense."

"Shit," muttered Grebs. "I better go talk to Arnie."

"Good luck," said Gutierrez. Johnny Hebert, who had joined in the questioning of the two suspected vandals, thought they were guilty of the painting incident but probably not the fire. Englund, who'd made the arrest, figured they were good for both.

And Gutierrez would leave them to their work. He had—in twenty minutes—an appointment with the mayor. After that, if he were still breathing and still chief of police, he'd go talk to Art Ziegler.

On his way out the door he spotted Ray Chang coming from the men's room. This morning, Chang had teamed with Duane Mendenhall in questioning the high school pistol-toter, Bobby Hooper. "Ray?" Gutierrez called.

"Good afternoon, Chief," said Chang. "Oh, I meant to tell you. We—the fishermen, actually, on their radio net—located the guy who's the father of Graciela Aguilar's baby. He's on a boat out of Crescent City, and he says he hasn't seen her. He's really upset, and told the guy who talked to him he's coming back down here as soon as he can."

Gutierrez nodded wearily. "Has her family heard anything?"

"Nope. Her sister is pretty much coming apart."

"Ray, alert the Coast Guard on this if you haven't already. The guy who threw Esperanza Moreno's body in the water was unlucky with rocks and tides. Could be he's learned better."

Chang made a face. "Yes sir, I'll do that. I'll keep on the whole thing."

"Good. Now, what about the Hooper boy?"

Chang shook his head. "He found the gun right there on the ground, and wiped it off with his shirt because it was wet. That's what he says, that's all he says. He's scared of somebody, but it's not me."

"His family?"

"Scared of them? I don't think so. 'Bobby's the youngest, he's a good boy, he's always home nights, he wouldn't lie,'" intoned Chang. "His mother cleans his room regularly, and she's never seen that .38 or anything else from any of the robberies.

"They're covering for him, sure," added Chang, shaking his hair back. "But I'd say they pretty much believe him and think we're picking on him. He's no experienced lawbreaker, and neither are his parents."

Gutierrez glanced down the hall, where a lumpy figure was slouched in a chair outside the interrrogation room. "We're holding Hooper?"

"We have to charge him or let him go. Actually, I think he'd be happy to spend some time in juvie in Ukiah. He'd be fairly safe there."

"The kid is sixteen, not six!" snapped Gutierrez. "Old enough to bear some responsibility for his actions and his choice of friends. Go ahead and charge him," he instructed, "with possession of stolen property and possession of a firearm on the school grounds. And release him to his parents. But on your way to do that, walk him slowly past young Hamm there by the interrogation room."

Chang followed Gutierrez's glance, and grinned. "In a cheerful, friendly way, you mean?"

"Right, best buddies. And I'll see you tomorrow, probably."

Mayor Lindblad was unhappy, and wanted answers to questions like, "Why aren't you returning my calls? What's the matter with your people? How could you let something like this happen?" Gutierrez, unsurprised by the speed with which his stock had fallen, kept his expression attentive and nodded or shook his head at what he hoped were appropriate intervals.

"...disgrace that one of our most prominent citizens is killed trying to protect his own property! Something, I might add, that our police should have been doing for him."

Dr. Gabe was not dead. Gutierrez saw no need to point this fact out, since he was miserably sure it would soon change. And what was he doing here, a grown man letting a fool yell at him?

He bit back the anger that had become his constant, untrust-

worthy companion. He could not afford to resign or to get himself fired, not until he'd settled with Dr. Gabe's killer. Espy's killer. Graciela's killer? "Mayor Lindblad, I have an appointment with Art Ziegler, to find out what he's learned about the fire."

"Oh. Well, keep me informed."

"I'll do that. And I hope you and the city council will cut us some slack on our overtime budget."

"Ah, well, we'll have to see. I'll talk to the others. And let you know."

Up yours, said Gutierrez silently as he got to his feet.

Art Ziegler had gone home for the day, but he'd left a photocopy of his report with his secretary. Gutierrez scanned the printed pages before putting them in his jacket pocket. "Art said you could call him at home if you have questions," said the secretary, a young woman whose name Gutierrez didn't remember.

"Thanks. I'll probably be in touch tomorrow."

Next stop the hospital, for a conference with Svoboda. He parked in the too-familiar lot, drew a few deep breaths as he was locking his car, and set off for the big front doors.

The woman behind the desk saw first his uniform, and then his face. "Oh, Chief Gutierrez. Can I help you?"

"Has there been any change in Dr. Gabe's condition?"

She didn't have to look at her clipboard. "No, not that we've been told of. I believe Dr. James is in the building. Would you like me to page him?"

"No, thanks, I'll have a quick look around upstairs. And then I'll be in Hank Svoboda's room for a while."

The upper hall was quiet, the nurses' station empty for the moment. Gutierrez went to peer through the glass panel of room 226, but there was nothing human visible there. The high, narrow bed was tented, and bordered by machines with dials and tubes.

"He's still alive," said a quiet voice, and Gutierrez spun around to find James Ferrar close behind him. "His heart is stronger than it seemed at first, which is a shame," James went on, "because his lungs are very badly damaged."

"Has he regained consciousness?"

James frowned and shook his head. "He's receiving a heavy dose of morphine, for what would otherwise be excruciating pain. Anyone

except Gabriel Douglas Ferrar would give up and die. Stubborn old fool."

Gutierrez relaxed his clenched fists and did the deep-breaths routine again. "Has he any chance of recovery?"

"Miracles have been known, but I think not this time." He stepped away from the door, and Gutierrez, after one last glance inside, followed. "And what about the arson? Have you arrested anyone?"

"No," said Gutierrez flatly. "How did it go with the Hegartys?"

James raised an eyebrow at the question. "Well enough. The emergency system at the clinic did its job; the embryos, pre-embryos is the more proper term, were brought here in a portable incubator; we made the transfer without further incident. Mrs. Hegarty will probably stay in town overnight and go back to Santa Rosa tomorrow."

"That's good," said Gutierrez. "You know, the old hospital won't be usable for some time, if ever. Where will you work?"

James shrugged. "The timing could have been a lot worse for me. With the Hegartys, I've finished this round of scheduled procedures and would normally give the staff a week or so off anyway. I myself will go on with some initial interviews with prospective clients or those who want to repeat—nothing I can't do in a rented office while I look around for a permanent site. And while I have someone re-establish my records from backup; that will take a while."

"What luck," said Gutierrez.

"Are you still looking at me as a, what, arsonist and parricide? Gutierrez, I wouldn't have had the nerve," James said. "I've been terrified of that man all my life and I still am. And would I have been stupid enough to torch my clinic the night after it had been vandalized and was supposedly being watched?"

"What better time?" asked Gutierrez. "If you did have the nerve. I'll be in touch, Jimmy."

Gutierrez's first glance into room B15 gave him a view of two empty beds and a feeling like a blow just over his heart; a moment later, a toilet flushed and Hank Svoboda appeared in the doorway of the bathroom. Still pale, still gaunt, he moved slowly but without assistance.

"Hey, Vince! By God, it's about time you showed up here." Svoboda headed not for his bed, but for a big recliner chair nearby. "My

daughter the doctor brought me my chair. You can park your butt in one of those plastic jobs and tell me what's happening."

He settled himself gingerly into the recliner and looked hard at Gutierrez, reaching out a hand. "I heard about Dr. Gabe, and I'm real sorry. Hospital rumor is pretty sure he's not going to make it."

"That's basically what Jimmy told me just now." Gutierrez clasped Svoboda's hand briefly, then pulled up a chair and sat, leaning back and stretching his legs out.

"I'm sorry," said Svoboda again. "What did Art Ziegler say about the fire?"

"Definitely arson, definitely amateur. Somebody splashed gasoline all around two rear ground-floor rooms and then tossed in a few matches. No sign of forced entry. Dr. Gabe had apparently set up there for the night as watchman; they found a blanket and his coat on a bed in another room. Jimmy thinks his father did it himself and then couldn't get out, but I don't believe it."

"Who, then?"

"Maybe the same people who vandalized the place the night before. We've picked up Arnie Grebs and Doug Hamm's son, Dwayne, as strong possibles on the vandalism. Or maybe the people who've been protesting at the fertility clinic. The fire was started in the office and file room where all the records and the computers were, which could mean the intention was to screw up business.

"Of course," he added with a shrug, "as Art Ziegler says, that's where all the best fuel was, too—lots of paper. Anyway, we're talking to twenty-some people known to have been involved at one time or another in the protests—including Father Horvath."

"Yeah, my daughter tells me the Catholics are down on anything but purely homemade babies," said Svoboda. "But if Father Horvath *had* managed to stagger in there carrying a gas can, he'd have been the one got trapped and burned."

Gutierrez got up and wandered over to the window, which looked out on a lot of wet greenery. "I had a talk with Dr. Gabe's attorney," he said after a moment. "And I found out that he'll leave a sizable estate: not only the old hospital or whatever it's insured for, the land it's on, and his house, but quite a few investments. And Jimmy inherits. All of it. He said, or implied, he didn't expect to, but there's no reason to believe him."

"He'd have got it eventually anyhow," said Svoboda.

Gutierrez turned from the window and began to measure the room with his paces. "Right. But he said the other day that his father could live to be a hundred."

"And he needs money now?"

"He's fifty-three years old; if he wants to expand his clinic, as he says he does, and work and make real money, he needs to get at it. He has a house with a big mortgage that looks to me to need a new roof and some foundation work, a Mercedes that has to be twelve years old. He wanted Gabe to give him the hospital building, but Gabe was reluctant, for several reasons."

He paused in his pacing to look at Svoboda, who was frowning. "And you think I'm the last person who should be judging Jimmy Ferrar."

"The notion did cross my mind," Svoboda admitted.

Gutierrez was pacing again, eyes fixed on nothing in particular. "Listen. His daughter, whom he seems to come as close to loving as Jimmy can manage, needs a lot more money to finish her education, especially if she decides on medical school. His son—I don't know how he feels about Will, but he clearly finds him a useful employee —has a big mortgage of his own, on forty acres of old sheep ranch and tanbark scrub where he's trying to build himself a house."

"You suppose it was maybe a family plot?"

Gutierrez turned and focused on his friend, who spread his hands and shrugged his bony shoulders. "Just a suggestion."

"Goddamn it, Hank, don't you jerk me around." He dropped into his chair and tipped his head back, blinking hard at the ceiling. "Goddamn it, I love that old man and he's dying."

"I know you do. That's why you should go home and grieve instead of thrashing around trying to do…whatever it is you're trying to do."

Gutierrez blew out a long breath. "Right."

"But maybe you could tell me, first, whether you've got anything on the rape?"

"How did you…? Oh, sure, she was here in the hospital," Gutierrez said. "But not for long." He told Svoboda Debbie Finn's tale, and its aftermath. "One good thing, there haven't been any more housebreakings."

"None of the local bad guys turned up sticky on those?"

"Nope. But we had one stolen item surface: a pistol. First solid lead we've turned up." He was about to go on with that story when he glanced at the other man and was jolted by the suddenly pale face and flickering eyelids. "Hank!"

"Sorry," said Hank. "I still wear out fast, but it's improving. I'm going home Friday, and then the doctor says a month at home. I say two weeks."

"Take the advice you pay for, buddy," said Gutierrez, making a mental note to corner one or more of Hank's daughters on the topic. "Come on, let me help you back to bed."

"Listen, Vince," said Hank, as he settled against his pillows and pulled the covers up. "Don't go jumping off any cliffs."

Or to any conclusions, thought Gutierrez.

"And come to see me tomorrow."

"Right. Take care, Hank."

He drove slowly homeward under a sky that was once again leaking soft rain like slow tears. Hank was absolutely right: no cop was worth his job if he couldn't be objective. What he should do was leave this investigation totally to Johnny Hebert, who had lived in Port Silva only a few years and was probably free of emotional involvement with the Ferrar clan. He himself could concentrate on the housebreakers. Or the rape. Or the murder and the disappearance, except the first, anyway, ran back into the Ferrar connection and...

Christ, what was happening to his town? He couldn't remember a time when there'd been such a deluge of serious crimes here.

He was still considering this anomaly when the back door of the house opened before he could touch the knob, to reveal Meg standing in the doorway. She didn't say anything, but the look on her face brought his heart to his throat.

"Meg, what's happened? You...Where's Katy?"

She pulled him inside. "I'm fine. Katy's fine. The hospital called two minutes ago to say Dr. Gabe had died."

He stood flat-footed, absorbing the fact.

"Vince? If you want to go see him, I'll drive you."

His leather jacket seemed stiff and awkward, and he concentrated on the laborious task of getting it off. "No. No, I don't want to see him. What I want to do is get very, very drunk."

Chapter 18

GUTIERREZ NOTED sourly that everyone at the station was giving him a wide, wary berth this morning. Some of them, he was sure, knew of his friendship with Dr. Gabe, and others were simply reacting to the way he looked.

His secretary, one of the former group, appeared at his office door as he was hanging up his jacket. "Chief, I was real sorry to hear about Dr. Gabe. I made your coffee."

"Thanks, Alice. I appreciate it. Any of the detectives in yet?"

"Ray Chang was, but he went out again. Alma is getting something to eat; she was here early to catch up on her paperwork."

"I want to see all of them as soon as they turn up."

Alice gave him a nod and left, closing the door. Gutierrez poured himself a mug of coffee and carried it to his desk, where a haphazard-looking collection of notes and reports and folders awaited his attention.

After looking over Alma Linhares's notes from yesterday's Good Sam interview with the Ferrars, he slid them into the folder labeled "Fertility Clinic/Ferrar" and slapped on a scrawled Post-it note: "Talk w/clinic employees."

He scanned Chang's most recent report on the search for Graciela Aguilar, and Ray's added note that nothing had been heard from any agency, U.S. or Mexican, about Esperanza Moreno's husband and children. The report went into the "Winner's Circle—Moreno, Aguilar" folder, right on top of the transcript of his interrogation of Dr. James Ferrar about Espy. That event seemed years ago; what struck Gutierrez as immediate and permanent was the presence of Jimmy Ferrar around his neck like some bloody albatross. After a moment's thought he added a Post-it to the second folder: "Check clinic employees."

He burned his mouth on a too-large mouthful of coffee, barely managing to swallow the hot liquid instead of spewing it all over his papers. Last night's attempt at alcoholic oblivion had been a dismal failure, a waste of good gin; what strong black coffee was now going to do to his abused and still-empty stomach, he didn't care to think about.

A fatter, expansion-type folder on the right edge of his desk proclaimed itself, via somebody else's Post-it, "Local Crooks fm. J. Hebert." Gutierrez cleared desk space and spread out the contents of this folder.

He was looking at three sets of mug shots and criminal records. Doug Hamm was on top, his face as round and pasty as that of his son, his hair as spiky-sparse and short-clipped, but mostly gray rather than black. At age forty, Hamm had an arrest record going back more than twenty years, with convictions that ran from auto theft through assault and spousal abuse to armed robbery. According to Hebert, Hamm was currently wifeless, living in squalor with his two sons and supporting his Budweiser habit by working sporadically at rough construction.

Hebert had noted that the older boy, Dwayne, had a minor juvenile record: fighting, shoplifting, petty vandalism, and harassment of a neighbor. The younger son had so far stayed clear of the law's notice.

Ev Olson had a gray-blond pompadour, a horsey face with a high forehead and prominent, crooked teeth, and reportedly a frozen left knee. Olson's record started with petty thievery and intimidation and slid into drug dealing and acting as enforcer for larger dealers. Presently he was staying at home with two small children and bringing a little money in by cutting and selling oak firewood. His wife, Kirsten, was a waitress at Hungry Wheels and a favorite with both the manager and the truckers who came there to eat.

Kirsten. Gutierrez had seen her a few times, tall and white-blond, with broad, square shoulders and pale, mascara-fringed eyes. He wondered whether she was local or somebody Ev had picked up in his druggie biker days. He found the pad of Post-its, wrote "Local girl?" on one, and stuck it on the page next to Kirsten's name.

And Bo Tetter. Gutierrez looked at the face of the man Hank Svoboda had once beaten up, and decided that many others had

followed Hank's example. Tetter had dropped out of high school, served briefly and dishonorably in the army, had local arrests for assault and for rape and a conviction for involuntary manslaughter after a bar fight in which his opponent died. He now lived with his mother, who said he was a good boy who'd suffered from the lack of a father. He had no apparent income.

There was a rap at the door, and then Johnny Hebert put his head in. "You wanted to see me, Chief?"

"Come in, sit down. Johnny, do you have any personal connection with the Ferrars? Like sleeping with Jocelyn or going duck-hunting with Will?"

"Nope. I've never met Jocelyn and I don't hunt." Hebert had his thermos bottle with him this morning; he poured a cup of tea into its cap and sat down. "I've talked with Dr. Gabe a time or two, just around town. I think he'll be missed."

"He will. I want you to take over the arson investigation, which is now arson and murder." He nudged the "Fertility Clinic/Ferrar" folder across the desk. "Here's what's been done so far. The only thing I'd add is something Hank Svoboda said yesterday, and I took at first as a joke: Could be it's a family plot."

Hebert's sleepy-looking eyes brightened. "Families are weird enough for anything, I've noticed."

"True. The mayor is hot on this; I'll try to keep him off your back. And I'm authorizing overtime, so get what uniformed help you need."

As Hebert picked up the folder, there was another rap on the door, and Val Kuisma came in, followed by Alma Linhares. Val said, in formal tones, "I'm sorry about your friend, Chief." Alma, no respecter of protocol, came around the desk to put an arm across Gutierrez's shoulders and press her cheek briefly against his. "I'm really sorry, boss."

"Thanks. Me, too." He picked up his coffee mug and found it empty. "Would you get me some coffee, please?"

"Boy, give a man an inch," she muttered as she took the mug.

"We're doing some realignment here," he told them. "Johnny will follow up on the fertility clinic arson-murder. Val, you keep on with the burglaries; Ray can fill you in on the Hooper boy, the kid who had the stolen gun and our sole serious lead right now. I still think

we've got a Fagin in this someplace, an older, experienced person planning and keeping discipline." He handed the "Local Crooks" folder to Kuisma.

"Chief, what about me?" Alma Linhares's aggrieved expression lightened as Ray Chang came in. "Hey, Raymond! Does your mama know you're messin' with a round-eyes these nights? Especially a round-eyes with eyes that don't match?"

A flush painted Chang's pale cheeks pink. "Jocelyn Ferrar is…interesting. But she's not crazy about the police right now, including me."

Too bad, thought Gutierrez. "Ray, is there anything from the Coast Guard, or the fishermen?"

"No, sir."

"Then maybe you, and Alma, should get down to the Winner's Circle and push people harder."

"That's something I wanted to talk to you about," said Chang. "I think Dolores Acuña knows more than she's saying. Partly she's frightened of her husband, but another problem is, she doesn't like me. One of the other women there told me Dolores thinks white gringos are bad enough, but yellow gringos with squinty eyes are over the line. And I'm convinced she knows more English than she lets on."

Gutierrez considered for a moment. If he took part in this, he'd still be at least peripherally involved with Jimmy. But not with Jimmy and Dr. Gabe. And outside was better than in, moving better than sitting.

"Okay," he said, getting to his feet. "Alma, you're my backup again. Ray, for the moment you work with Val."

"Goddamn rain," muttered Alma Linhares as they made their way across the parking lot. Gutierrez had become so accustomed to moving around in the wet that he'd hardly noticed today's light drizzle. "Want me to drive, Chief?" Alma asked, as they reached the white sedan.

Gutierrez figured his head was clear by now, but he was less sure about his reflexes. "Sure."

At nearly ten A.M., traffic was light. Alma flashed her lights at a black-and-white as they neared the motel; apparently patrol was following orders and keeping an eye. The place looked dismal, as if it

might melt away in the endless rain. There were two old cars in the forecourt, no children in sight; all doors were closed.

"Luis Acuña got his car back, I believe," said Alma. "An old blue Dodge, and it's not here. So he must be at work. Ray says Dolores is staying home from work right now, because Mrs. Gonzales's back is giving her trouble and she can't baby-sit. So I'd guess Dolores must be getting stir-crazy about now, cooped up in two rooms with three little kids."

"Good," said Gutierrez. He stepped out into the rain, locked his door, and waited for Alma to join him. "Dolores knows you?"

"She's met me."

"Lead off," he said, and fell into step behind her across the muddy ground of the forecourt. She rapped hard on the door, waited a slow ten-count, rapped again. "Mrs. Acuña? Officer Linhares here, with Chief Gutierrez."

Dolores Acuña was small and weary-looking; if she'd ever possessed Graciela's verve, it was long worn away. Standing protectively in the narrow door opening, she bobbed her head at Alma and then looked past her and up at him. The lines in her forehead eased, and as her sister had earlier, she loosed a flood of Spanish, of which he caught only the odd word.

"Mrs. Acuña, may we come in? I think you know my assistant, Officer Alma Linhares." Dolores retreated before his advance, and he and Alma were inside in a moment, Alma closing the door firmly behind them.

Gutierrez took off his jacket, glad he'd put on slacks and shirt this morning instead of a uniform. "Hi there, Juanito," he said to the speedy-footed toddler of his first visit. "And…?"

"Teresa," said Dolores, nodding at a little girl who was five or six years old. "Y Ugo." This last was a round brown baby who sat on his diapered bottom on the floor, fat legs straight out before him.

"We want you to know that we're working hard to find your sister, Graciela." Gutierrez spoke slowly and clearly as he pulled a chair out from the table and sat down, gesturing Dolores to the opposite chair. "And we need to ask you some more questions. And then have another look at Graciela's belongings."

"Por favor, en español? No hablo inglés."

"Officer Chang, who speaks *español*, couldn't come today," he told

her. "But I know you've lived in this country for several years, Do-
lores. And you work here, hold a job. A smart woman like you would
surely learn a little *inglés*—more than you think, even."

She put a hand to her mouth and shook her head.

"Usually Luis speaks for you," said Gutierrez. "Today, he's not
here. You can speak for yourself."

"I can talk." This was from Teresa, who had come to lean against
her mother's side. "Mama, I help."

A little more of this, and the dam was broken. Dolores had little
grammar but many English words. She was, Gutierrez and Alma
learned, desperately worried about Graciela and very angry with her.
Very angry with Luis as well, for driving Graciela away.

With Teresa's help, Dolores told them that Graciela was very
smart. Also very pretty, which is how she got into trouble. It was her,
Dolores's, fault for not watching better over her sister. And Luis's
fault, Frank Higuera was a friend of Luis. Not a bad man, she added
quickly. But older than Graciela, more serious.

Alma got up like a good girl and made coffee while Dolores
talked and wept. Graciela spent too much time with Esperanza
Moreno, who was older and did not love her husband. They talked
together all the time, giggled and shared clothes.

With a cup of coffee in her hands, Dolores took a deep breath
and then a deep drink. Esperanza, she said, had told Graciela she
talked with a *curandero*, about her baby. And then she had no baby.

"*Curandero?*" said Gutierrez. Dolores looked confused. Teresa said,
"Is doctor."

"*Sí, doctor,*" said Dolores. Graciela had a baby in her, and did not
want it. Esperanza knew of this *doctor* and told Graciela. Then Espe-
ranza was dead. Now Graciela was dead, maybe. After wailing some-
thing brief but clearly heartfelt in Spanish, Dolores put her coffee
cup down carefully before bursting into tears.

"Graciela goes to Hell!" said Teresa, wide-eyed.

"I'm supposed to be at basketball practice!" stormed Katy. "You can't
lock me up like some prisoner! It's a violation of my civil rights!"

"Civil rights implies some grasp of civility," Meg snapped. "And if
you keep behaving like a hoodlum, I won't have to lock you up; oth-
er authorities will do that for me."

"Mo-om!" Katy wailed. "I didn't *start* any fights. Somebody shoved me and I shoved back and it just—went from there."

"Katy, sit down. Sit down!" When her daughter had perched herself sullenly on one of the kitchen stools, wrapping her long legs around its wooden ones, Meg sighed and picked up her cup of tea.

"Katy, this is a dangerous time at school. Some people have been found carrying knives."

"That's not my fault! Besides, maybe some people need to be able to defend themselves."

"You think maybe everybody should keep a .38 in his backpack, just in case anybody shoves him? Or insults him?"

"Oh, don't be stu—silly."

"What's stupid is letting other people provoke you into bad behavior. If that's what happened."

Katy, head down, mumbled something inaudible.

"Katy, we've been having this discussion since you were three years old. I know that turning the other cheek is not your favorite posture. Or mine, for that matter. But sometimes, for the general welfare as they say, we have to do it."

"Bullshit," said Katy. "In my opinion." She unwound herself from the stool and headed for the living room. What she probably intended as a haughty stalk looked from Meg's viewpoint more like a flounce. Thus does the female reveal itself, even in a five-foot-nine-inch girl jock. Poor baby.

"And I don't see why I can't have a TV in my room," called Katy, over the noise of whatever it was she'd turned on.

"Right, and a refrigerator, too," said Meg. "Then we'd never see you."

The telephone rang, obscuring what was probably an indictable reply.

"Hello?" said Meg, and took a sip of lukewarm tea.

"This is Mary Louise," said a familiar voice. Meg eyed her own reflection in the kitchen window and twisted her face into a dragon-like grimace.

"What can I do for you, Mary Louise?"

"What you can do is give Cass a message from me."

"What makes you think Cass is here?" snapped Meg.

"Look," said Mary Louise on a long sigh, "I know you think I'm

stupid. But where else would she go? I mean, she took her car, most of her clothes, her cookbooks, even that stupid dog. I just hope that monster dog of *yours* eats the little rat. Tee, I mean, not Cass."

A not unlikely scenario, thought Meg. "Mary Louise, the fact is…"

"Look, I'm not mad or anything. And I'm not telling her she has to come home," Mary Louise went on quickly. "Things are fine here, and if she's happier with you, so be it."

"Mary Louise…"

"What I want you to do is tell her to tell her friends to stop calling here. She's had some weird messages on her telephone, and they're starting to make me nervous."

Meg's window-face now wore a plain ordinary frown. "What kinds of calls, Mary Louise?"

"Oh, a guy saying her name, and then laughing. One that said, 'Cass, be careful.' A couple of times just heavy breathing. A girl saying she should come back to work, but that's probably okay except she hung right up, too—no name, no number to call back.

"Listen, I better get back to work here. Not everybody has a job that's over at three in the afternoon. Just tell Cass about these calls, and tell her I'm turning off her machine."

Meg had her mouth ready, actually opening, to say Cass was not there. But she couldn't quite get the words out.

"And give her my love, okay?"

Meg put the telephone carefully back in its holder. She emptied the cold tea from her cup, took the cozy off the teapot, and poured the cup full of warm tea. She picked up one of the lemon slices she'd cut earlier and squeezed it into the tea, watching her hands perform this simple, useful task.

When the cup was once again empty, she set it on the drainboard. Her reflected face was somber now, and thoughtful. She rinsed her fingers under the tap, then ran smoothing palms over her bound but wisping hair.

"Katy?"

"Yeah?"

"The rain has stopped for the moment. Will you take Grendel out for a short run, please? I'm going to see Charlotte."

Finn Park was dankly wet, an expanse of boggy grass no one would

play on. Charlotte's house, however, with no trees overhanging it, was enjoying a patch of late-afternoon sunlight, its roof giving off little trails of steam.

Meg paused on the front porch and listened, but heard no piano notes, no sounds of instruction. She rang the bell, and was rewarded by an alerting bark and then, in a moment, the appearance of Charlotte's son, Petey.

"Hi, Meg." He spoke around a mouthful of brownie, the other half of which he held in one hand. "Come on in," he said. "Mom's in the kitchen."

"Hi, Pete. Thanks." Meg stepped past him, the only boy in the freshman class who topped Katy in height. He was one of Meg's favorite people, and ordinarily she would have stopped to chat; today she merely gave him a vague smile and hurried by.

"Charlotte!"

Charlotte was at a breadboard slicing thin dough into narrow strips; wooden racks of drying noodles lined her sink counter. She looked up quickly, then dusted her hands off on her apron. "For a minute there I thought you might be bleeding again."

"Same as, almost. Why don't you get one of those pasta machines?"

"Because I like doing it this way. Wine?"

"Absolutely. But for a change I've brought a contribution." Meg reached into her big shoulder bag for the bottle of chardonnay. "It's chilled," she added, "because our wine rack is in the garage."

"Husch," noted Charlotte, examining the label. "Lovely. I'll open it."

Meg dropped heavily into the rocker. "Charlotte, have you heard from Cass this week?"

"No." Charlotte handed Meg a glass of wine, then poured one for herself and came to sit in the wicker chair. "What's happened?"

Meg took one sip and then told of the telephone call from Mary Louise. "I haven't talked to Cass since Monday, and she hasn't been near me, or Vince either, or he'd have mentioned it. I think," she added.

"I know she and her mother are never going to be really comfortable together. And maybe there's been more trouble over Mary Louise's current boyfriend. So I suppose Cass could have gotten fed

up and gone off with a friend, or a boyfriend of her own. But from the way she's been behaving, I'm more inclined to think she's frightened of something or someone, and has gone to earth."

"I agree," said Charlotte. Her usually sunny face had darkened.

"Charlotte, has she talked to you about particular friends?"

"Not really. It seems to me that Cass is in a kind of social limbo," Charlotte said slowly. "The 'nice' kids in town seem silly to her, I think. I keep expecting her to pat my sweet, serious Petey on the head and say, 'Good boy.' But she has to avoid falling in with the other kind, because she's not going to be called trash ever again."

Meg spent a brief moment silently cursing Mary Louise.

"If she has a confidante," Charlotte went on, "a best friend, I haven't heard of it. I'd be surprised."

"What surprises me is that she hasn't come to you, or to me, about whatever she's frightened of. We're different in some ways, you and I, but I'd have said she trusted both of us."

"Well," said Charlotte, "there's one way in which we're very much alike. We're both married to policemen."

Meg stared at her. "Damn, who could expect me to notice a little thing like that?" She took a reflective sip of wine, and then another. "Okay. Let's assume for the moment that Cass is not herself doing anything illegal or blatantly immoral."

"She wouldn't take the risk," agreed Charlotte.

"But she knows something. She somehow knows somebody who is…"

"Involved in activities at least antisocial and probably against the law," Charlotte finished for her.

"And being Cass, her first and only thought is to protect herself."

"That's awfully harsh, Meg."

"You're too kind, Charlotte. But Cass is what she was made. Let's see, she was holed up at home on Monday, clearly wary about something; but there was no sign she was planning to go anywhere.

"Then Monday night," Meg said, slapping the arm of the rocker, "Debbie Finn was raped and beaten. And Cass had been friendly with Debbie until quite recently."

Charlotte was frowning. "I'm not following."

"I bet Val has been keeping his pregnant little wife out of the loop, as they say. But Vince is miserable and he talks to me about it.

He thinks there's a connection between the vandalizing housebreakers and the rape. But he can't be sure, because Debbie Finn has disappeared."

"Like Cass."

"Ugh. Let's hope not quite." Meg slumped back in her chair and stared into space, cradling her wineglass in both hands. After several moments of silence, she got to her feet. "Charlotte, I have an idea. Okay if I once again use your phone?"

"My phone is your phone."

Meg fished a small address book from her bag, then propped her hip against the counter and punched out a series of numbers. "Long distance," she said to Charlotte, "but not very. Hello, Ben. This is Meg Halloran, Vince Gutierrez's wife. I'm glad to see you're still at the sheriff's substation there." Silence for a moment. "No, Vince can't get away right now, poor guy. But I've been thinking I should run up and have a look at the place, make sure it hasn't burned down or something."

Meg fell silent, listening intently, and Charlotte sat forward as if by doing so she could hear what Meg was hearing.

"How odd. Well, probably he jumped out of a passing car; chances are his people will come back for him. How's the weather?"

When she hung up a few moments later, Charlotte said, "Well?"

"The Gutierrez property is in Trinity County, right on the edge of the Trinity Alps in the Shasta–Trinity National Forest. The deputies from the sheriff's substation drive around a lot, just keeping a general eye out.

"Anyway, Ben says somebody who'd been hiking near our place yesterday came to the substation and said they'd seen this little dog they thought might be lost. Yappy little guy, brown and white; they couldn't catch him, but they were worried that something else would, like a mountain lion. Asked the deputies to watch for him. Cass recently got this little Jack Russell terrier, and Mary Louise says she took him with her when she left."

"Isn't that camp extremely isolated?" asked Charlotte.

"Well, fairly. But we finished the cabin off and winterized it last year. It's not an area for heavy snow, and there's none on the ground now. And Cass has been there several times; she knows how to chop wood, build a fire, start the generator."

While Charlotte digested this information, Meg finished her wine and then refilled her glass with water from the tap, to drink it dry again. "Charlotte, I cannot, I *can not* tell Vince about this."

"He needs to know."

"He needs to know what Cass knows. But she won't tell him. He won't be able to make himself push her hard enough." But she, Meg, would cheerfully string Cass up by her ears and toast her over a slow fire if that would produce information about the local thugs. Especially about the tall, pale one who had hurt, and worse, humiliated Meg.

Charlotte sighed and took another slow sip of her wine. "Sometimes one glass of wine seems inadequate. Meg, would you like me to come with you?"

"Thanks, but no thanks. It's a good two hundred miles, and I'll drive my van, which is no luxury ride for a pregnant lady."

"When will you go?"

"Oh, I'll wait until tomorrow. Cass is quite safe, no one here could possibly know she's up there."

"What will you tell the people at school?"

Meg grinned. "Because of recent problems, tomorrow has been declared a cooling-off period. No school. See, it's meant."

"You don't believe things are 'meant'."

"True," said Meg, "but such a coincidence gives a nice simplistic frame to what might otherwise look like pure impulse."

"I still think you should tell Vince," Charlotte said.

"No. He's emotionally overloaded already and I'm perfectly capable of handling this. And don't you... Sorry."

"You're forgiven. Good luck."

Chapter 19

MEG SURVEYED her husband from behind her coffee mug and decided he looked physically more rested this morning, but still emotionally exhausted. She knew, from what he'd said the night before, that his earnest attempt to keep some professional distance between himself and James Ferrar appeared doomed. In some fashion—he'd not made clear just how—the disappearance of a young woman from the Winner's Circle had a possible connection with the fertility clinic.

Graciela Aguilar was very pretty, and really just a girl; in the color snapshot her sister had given Vince, her hands-on-hips seductive pose was mocked by her laughing face. Another woman for Vince to worry over, in a town where being female seemed to have turned even more dangerous than usual.

And all the more reason for Meg to hold her tongue about Cass, at least until she found out what was up. And to keep her fingers crossed that Mary Louise didn't decide for some reason to call Vince about her wandering daughter.

Vince pushed away the plate from which he'd been absently shoveling in scrambled eggs, and looked across the table at Meg as if surprised to find her there, still in her robe and slippers. Meg saw enlightenment dawn on his face.

"Oh, right. You have a day off. What do you plan to do?"

Not a usual inquiry from one of them to the other, two adults as accustomed to living separately as together. "I need a change of scene," said Meg. "I think I'll drive up to Trinity County and have a look at the camp. Make sure that nothing has blown away, nothing is leaking."

"Good God, Meg, that's a four-hour drive!"

"Exactly what I need, love. A chance to get out of town and on the road. I'll take Grendel along for company, and I'll plan to stay the night, come back tomorrow or even Sunday."

"But suppose the roof did leak and the cabin is flooded? Or all the firewood is wet?"

"Guess what? I have a perfectly good sleeping bag and I've slept many a night in my van. Or, if it's too cold or feels too lonely, I'm sure I can find lodging in Weaverville this time of year."

She leaned across the table and squeezed his hand. "You can work the weekend, as I'm sure you plan to do anyway, without worrying about entertaining me. Without worrying about me at all."

As he knit his brow over this, the front door opened and Katy came in on a burst of chilly wind; behind her, until she got the heavy door shut, was a sky showing a lot of blue around its cloudy patches.

"Hi, Mom. Look, sunshine! Hey, is that real food I smell?"

Meg, who was putting in another morning on good domestic behavior, gestured to the counter where covered dishes were keeping warm on a hot-tray. "Scrambled eggs and Canadian bacon. And I think there's some toast left, in the oven."

"Yum. Mom, how tall was my father? Oh, I mean my first father," she added, and loped around the table to put an arm around Vince's shoulders and plant a kiss on his cheek. "Hi, Vince. Did you make the eggs?"

Meg's heart gave a little leap, as it always did when Katy's essentially loving and thoughtful nature peeked out from behind its cloak of adolescent storming and posturing.

"Good morning, Katy. No, your mother cooked this morning."

"Danny was six-feet-four," said Meg, as Katy filled a plate. "Why?"

"I was thinking, if I keep growing I could save us a lot of money by winning a basketball scholarship to Stanford. Maybe even go on to one of the women's pro leagues. *That* would be a neat way to make a living."

"Probably a better option these days than being a forest ranger," said Vince. He got up from the table and went to the coat closet for his jacket. "Oh, wait, Meg. What about Katy?"

"Kimmie's. Or Charlotte's. I'll leave you a note," she told him. "Hang in there, love, and lock up all the bad guys."

"Yeah," he said absently, his mind already somewhere else. "See you tonight," he added, and gave her a perfunctory kiss on his way to the door.

Meg, about to correct him, closed her mouth. She'd make it a very specific note.

Katy, whose head had come up at Vince's question, was silently watchful during this exchange. When Meg returned to the table and her mug of coffee, Katy put down her fork.

"Okay, Mother. What's happening?"

"I beg your pardon?"

"How come the cooking and cute stuff at eight A.M. on a free day, when you're normally pretending to be a deaf hermit in a cave? And where are you going, that you need to farm me out?"

Ah, the too-speedy return of the gimlet-eyed teenager. "Katy, I don't care for your tone."

Katy rolled her eyes but said, "Sorry. Mom, please tell me where you're going."

"I'm going to drive up to Trinity County for a winter check of the camp. And I thought you'd enjoy spending the day, and the night, too, if you like, with Kimmie. Or the day at least with Petey."

"I'd rather go with you."

"Katy, it's a long trip. And no normal fourteen-year-old wants to spend two whole days with her mother."

"So who ever said I was normal," said Katy with a shrug. "We haven't been anywhere together, just you and me, since last summer. And whatever you're really going up there for, I bet I can help."

Meg did a quick mental run-through of circumstances. In her present mood, Katy left to her own devices might get into—God knew what. Race or political warfare, perhaps. Driving the seldom-used van instead of the Toyota, they were unlikely to be spotted by any harasser. And in dealing with Cass, Katy might be a real asset.

"Maybe we can work something out," she said. "Let me get more coffee, and I'll tell you what the story is."

No houses broken into, or at least no reports of such. No rapes, no unexplained deaths. No fires, suspicious or otherwise. A scatter of traffic mishaps, a few DUIs, a bar fight involving only fists; two do-mestic disturbances easily handled with nobody bloodied. Gutierrez

stared morosely at the report of the night's events, wondering at his own lack of satisfaction. After all, if this pattern held for a few days, maybe they could straighten out the real crimes. Lock up the bad guys, as Meg had instructed.

"Anything from the Hooper kid?" he asked Ray Chang.

Ray shook his head. "His mother says he's telling the truth about finding the gun, and she's thinking about suing us for harassing him. She says he's so scared he'll hardly come out of his room...scared of us is what she thinks."

"Did she have anything to say about who he's been hanging out with?"

"She didn't, but his sister did." Val Kuisma, with a lean, easy-moving, outdoorsman's body, rumpled black curls and earnest green eyes, could readily pass for twenty instead of his actual thirty-some-thing. Girls always had time for Val.

"Wendy is nineteen, the only other one of the six Hooper kids still at home. She says Bobby has been running with a bunch of kids who have transportation, which Bobby doesn't. The two she's seen picking him up are Mike Lorenzini and Frankie Beaubien. They're both juniors at the high school; Bobby is a sophomore."

Lorenzini. Ms. Shaw-the-counselor's choice, somebody Gutierrez himself had intended to check out several days ago. "And?"

"Ray and I figured the odds were against being able to get a search warrant for those two, and the search at Bobby's didn't turn anything up anyway. So we just went out and talked to 'em. Lorenzini had a good time telling us to go fuck ourselves. Beaubien was jumpy, extra polite, and didn't know anything about any housebreakings, no way."

"They're good for it, I'm sure," said Ray Chang, grim-faced.

"At least they're pinned down for a while," Val added. "Gives us time to locate some of the others, and to sweat Bobby Hooper. And to check more pawn shops and flea markets for the loot."

"Good. Johnny, how about the arson and murder investigation?"

"Art Ziegler hasn't found anything on the site he didn't expect, except that it appears possible the gasoline might have come from a storage shed on the hospital grounds. The shed was sometimes locked, sometimes not, and nobody was able to tell Art's people how many cans were there or how empty, or full. Art says the most

obvious answer to the fire is that Dr. Gabe did it himself—and he has no trouble with the obvious."

"But I have," said Gutierrez.

"Right," said Hebert. "But so far I can report lots of talking, no results. I had Bob Englund and Dave Figueiredo question all the people known to have been involved in the protests at the fertility clinic. There weren't many serious alibis for three or four o'clock in the morning; but there wasn't anybody who came across as a fire-starter, either."

"Young Grebs and Hamm?" asked Gutierrez.

Hebert shrugged. "They admit to the trashing and paint job the night before, but swear they didn't start the fire or hit Dr. Gabe or anybody else. There's no evidence against them, and it's hard to see what they had to gain.

"Then I got onto the non-Ferrars working at the fertility clinic," Hebert went on. "They seem to be a law-abiding bunch. No crimes beyond the occasional traffic violation, none of them with immediate family members known to be troublesome. They all work hard for respectable wages, like their jobs, and want to keep them.

"And I didn't uncover any grudges, against the Ferrars or each other. Marilyn Wu, the embryologist, seems to feel the old man didn't appreciate his son's professional skill, but…" Hebert shrugged again, an expressive lifting of his heavy shoulders. "Ms. Wu is divorced from a physician, could work in her profession anywhere but likes it here, lives with her ten-year-old daughter, and was at home with her from five P.M. on the night of the fire.

"Then the two nurses. One of them was at home in bed with her husband, the other was at her boyfriend's house in bed with him. All night. They're sorry about Dr. Gabe, and both of them see the clinic fire as an extension of the vandalism, the old man's death as accident.

"Only bit of gossip I came across—and it wasn't mean-spirited—is that the younger nurse, Trish, thinks Dr. Wu is sleeping with Dr. James Ferrar."

"Before or after Esperanza Moreno?" asked Gutierrez.

Hebert shook his head. "I didn't want to cloud the arson issue, so I didn't mention Mrs. Moreno. Oh, I spoke with one more person, a therapist who works for the clinic but on retainer and in her own office, which is downtown. She has her own separate clients uncon-

nected with the clinic, and her own private life. Has no personal opinions about the clinic personnel, and was home alone the night of the fire."

"Um. Okay, we'll get on to the Ferrars in a minute." As Gutierrez got up to refill his coffee mug and Kuisma followed suit, Ray Chang took advantage of the lull. "Chief, did you learn anything from Dolores Acuña yesterday?"

"Dolores thinks her baby sister had an abortion and is now on her way straight to hell," said Alma Linhares.

"Here?" asked Chang. "Dr. Ferrar?"

"Probably no, to both," said Gutierrez. "I spent yesterday afternoon talking with people at the U.C. campus hospital, at the Women's Wellness Group, at local doctors' offices. They won't identify their patients by name; but everybody says there's no doctor in town who'd do a late-second-trimester abortion on a sixteen-year-old. Not only is it more complicated both medically and ethically, but there's a law on the California books, pre–*Roe v. Wade* but not clearly superseded, prohibiting abortion after week twenty.

"Now, Dr. James Ferrar says categorically that he does not perform abortions; but his connection with Esperanza Moreno, and Mrs. Acuña's suspicion that Graciela and Espy had some doctor in common, can't be ignored. So we've got a blurring of case lines here. Johnny, what did you find out about the Ferrars?"

"Okay," said Hebert, settling himself lower in his chair. "I've got inquiries working on the finances of all three, but bank records, as you know, will take subpoenas. Which we wouldn't get, not yet.

"Dr. James Ferrar's history of complaints successfully defended you know about. Will Ferrar has been pretty much on his own since he was seventeen, and there are some big gaps in his C.V., because he likes to get away from civilization—usually heads for Mexico or Central America. When he works, he works lots—for the fertility clinic, for the campus health service, as vacation fill-in at Good Sam. Has, as you know, a big mortgage on his land, and a hefty debt for building material he's bought on credit. Never been married. Lost his California driver's license once for too many moving violations."

"Drugs?" asked Gutierrez.

"Apparently not. I get the impression that Willie is big on health and on taking care of his body. No smoking, no drinking, no snorting.

"Now Jocelyn," he went on, "was arrested and charged with growing marijuana while she was in school at Berkeley. Charges dropped, insufficient evidence. And she was charged right here in Port Silva last November with assault and property distruction. Seems she came home one day and found her live-in boyfriend in bed with another woman. She laid them both out and broke up some furniture as well. This was dropped, too."

"Oops," said Alma. "Better be careful, Ray."

Gutierrez, who was getting to his feet, shot her a look of irritation, and she ducked her head.

"Okay," he said. "Everybody has plenty to do. I plan to keep digging for—Jesus, I mean *looking* for—Graciela. The clinic people are all on leave from work right now. Officer Linhares and I are going to drop in on them at their homes with Graciela's picture."

Nancy Ahearn, R.N., was a sturdily built, middle-aged Port Silva native with three grown children. She enjoyed her work, admired Dr. James enormously and his kind-natured son nearly as much, thought Jocelyn a snip with a smart mouth a mother would have controlled. She'd considered Dr. Gabe a local treasure and an absolute love, and was sure his family, like the town, would miss him greatly.

Mrs. Ahearn knew of Esperanza Morales's cleaning-team connection with the clinic; everyone had talked about it after the discovery of her body. But she'd not known the woman beyond nodding to her in the hall, and had not seen her for months. As for Mrs. Moreno's friend, Graciela... "No, sir, never seen her to notice her," she said with a sigh, handing the photo back. "She's real pretty, reminds me of my youngest when she was in high school. And five months pregnant, you say?"

"About that," said Gutierrez.

"Oh, my. Soon as you two leave I'm going to get right down on my knees, ask God to take care of her and her baby."

"Good idea," said Alma.

Trish Potter, R.N., was a twenty-seven-year-old nurse-technician who'd moved to Port Silva from Redding following her divorce eighteen months earlier. She loved her work, thought Dr. James Ferrar a fine doctor but personally a dry stick—"anal retentive, or what I really

mean is tight-assed." Dr. Gabe had been too much the old-fashioned male chauvinist for her taste. Jocelyn she considered smart and tough—"a real modern woman."

"Will is strange, though," she said thoughtfully. "Real good-looking, and terrific with the patients, but I think he's not all that interested in women, you know, sexually. Certainly never gives me a glance." With her hands in the back pockets of narrow black jeans, Trish's shrug gave a nice jiggle to prominent breasts. "Of course, maybe it's just, he's had to peer up too many twats; kind of an occupational hazard in this business, you might say. I think, when he's not helping people, what he really likes is to be alone, with his horse. He's got this horse he's crazy about."

Trish had, of course, heard of Esperanza Moreno's death, and vaguely remembered her working at the clinic. "But I was fairly new here myself, learning the routines and getting settled. I didn't pay much attention to cleaning ladies. Oh, is that the girl you wanted to ask about?" She scrutinized the picture, then handed it back. "Nope, sorry. If she's ever been to the clinic, I've sure never seen her."

"Thanks," said Gutierrez.

"No prob. Any time."

Marilyn Wu, thirty-five-year-old embryologist and single mother, was probably five-feet-four, with black hair knotted smoothly behind her head, a pale complexion, black eyes that made no pretense of docility; her body was narrow but not fragile. Standing in her uncluttered living room where she had offered no one a chair, she took the photo from Gutierrez and examined it. "No," she said finally, and handed it back. "To my knowledge I have never seen her, certainly not at the clinic. She was never a patient, and I'd say she's too young to have been on the cleaning crew."

"She was a good friend of Esperanza Moreno. She's sixteen and pregnant—and missing," said Gutierrez. "Did you know Mrs. Moreno?"

"I saw her and knew who she was. But that was some time ago. And you're quite wrong if you think James moved that girl into his bed as a replacement for Mrs. Moreno."

"What do you...?"

"James enjoys a good uncomplicated fuck as much as any man, and Mrs. Moreno was attractive and appropriately awestruck."

"But…" Gutierrez shut his mouth, aware that he was sputtering. Ms. Wu eyed him with what might have been disdain.

"But he would not have risked his professional reputation by fooling around with a child, which this one obviously is. In fact, I'd say his close call with Mrs. Moreno—he was quite worried about her husband—has cooled his lust considerably, reduced it to a more manageable level."

Her smile made clear whose management she had in mind. On the whole, Gutierrez thought James would have been better off with Espy. "It's been suggested," he said slowly, "that she was looking for someone to terminate her pregnancy."

Marilyn Wu's face flamed and her eyes narrowed to black slits. "You must be out of your mind! Under no circumstances would James have done that!"

"What about the rest of the staff?"

"Absolutely not!" Wu blinked hard, took a deep breath. "James has no moral objection to abortion, but he won't personally perform the procedure because he feels it would conflict with the clinic's purpose, and he certainly wouldn't let anyone on his staff do so. Nancy Ahearn has deep religious objections to abortion. Trish wouldn't get her hands or her reputation dirty. Nor would I."

"What about Will, or Jocelyn?" asked Gutierrez.

She twisted her lips in distaste, but decided to answer. "In my opinion, and that's all it is, Will hates the very idea, and Jocelyn, who is of course vigorously prochoice, wouldn't know how."

As the moment of silence was about to become awkward, Alma asked the question that should have been Gutierrez's. "What about Dr. Gabe?"

"A definite possibility!" she snapped. "That old man always did whatever he wanted, with absolutely no consideration for the law or his son's reputation! And that's all I have to say on this matter. Except this: although I'm probably strong enough to strangle someone, I was in San Francisco the night Mrs. Moreno was killed—at a fiftieth-anniversary party for my former in-laws."

"Names?" said Alma.

Ms. Wu gave them, Alma wrote them down.

"James may not have a winning personality," Ms. Wu said, as she showed them to the door, "but he's an honest man and a very good doctor. And he's not a killer, of the born or the unborn. I think you people should stop bothering him and let him get on with mourning his father."

"Jesus, Mary, and Joseph," muttered Alma Linhares as they headed back to the car. "Chief?" she said softly after a moment to the still-silent Gutierrez. "What do you think?"

"Nothing." He was blindly placing one foot ahead of the other as he remembered Dr. Gabriel Ferrar's list of those he believed most in need of birth control information and abortion: the young, the poor, and the stupid. Espy's qualifications there were iffy, Graciela's more clear-cut.

Would his contribution to his old friend's memory be the branding of him as an illegal abortionist? And if Dr. Gabe had dealt with Graciela, where was she now?

"Chief?"

"Leave it for now, Linhares! We have four more people to see." He took a deep breath, let it out slowly. "Let's take Dr. Bethany Martinson next. She's the therapist retained by the fertility clinic to counsel clients and potential clients."

"And she won't tell us squat," said Alma. "Not if she's a therapist. Those people all think they're priests or something."

But Dr. Martinson was unavailable—in San Francisco for the day at a symposium at the U.C. Medical Center, said the notice taped to her office door. Gutierrez scribbled a note on the back of a business card and pushed the card through her mail slot. "So that leaves the Ferrars," he said to Alma. "Let's drive by the old hospital. Jimmy might be there looking things over."

"Yessir."

James Ferrar's Mercedes was parked on the street just to the north of the old hospital, which was wrapped in endless loops of yellow tape marked DANGER! and an invisible miasma of wet burnt wood. The building itself seemed a lifeless shell, a weary old person ready to lie down for the last time.

"Probably in the back," said Gutierrez, picking his way along the side of the main building. As they reached the badly burned rear, the

door of the ash-marked but intact stucco building before them opened, and James Ferrar came out.

"James," said Gutierrez, with the briefest of nods.

"Vince," said Ferrar, lifting his head as if a smell worse than that of burnt wood had just met his nostrils.

"Will there be a memorial service for your father?"

"I'm sure there will. We haven't had time to think about it yet."

"Be sure to let me know when you do."

"There will certainly be a public announcement."

Fuck you, thought Gutierrez. He pulled the photo from his jacket pocket and held it out. "We're still looking for the young woman I mentioned to you Tuesday. Graciela Aguilar lives at the Winner's Circle and was a friend of Esperanza Moreno. Do you know her, or have you seen her?"

James took the photo, turned it to the light, and pulled a pair of half glasses from his shirt pocket. "No. And no, so far as I can say." He handed the photo back, removed his glasses, and returned them to his pocket.

"I've had the same answer from the rest of your staff, except for Will. Is he here?"

James's mouth tightened, in annoyance at someone other than Gutierrez. "No. Will has been unable to deal with his grandfather's death. So far as I know, he's out at that place he's building, probably talking to his horse. I haven't seen him since Wednesday night."

"I understand he has no telephone there?"

"You understand correctly. Is there anything else, or may I get back to work?"

Alma, who'd been holding her silence, took a deep breath and Gutierrez put a quelling hand on her arm. "Where is your daughter?"

"She's here helping me, but she can't know anything about some...Hispanic girl who's wandered off."

Alma moved away from Gutierrez's side, past James, to the open door of the stucco building. "Miss Ferrar? We need to talk to you."

Jocelyn came to the door at once, nodded politely enough at Alma, and frowned at Gutierrez. "More harassment?"

"Depends on your definition," said Alma. "Or degree of guilt. We need to show you a picture."

"I can hardly wait," said Jocelyn. She dusted her hands together as

she came forward, the honest laborer interrupted by minions of bureaucracy. "Let me see."

"This is Graciela Aguilar. She lives at the Winner's Circle Motel and was good friends with Esperanza Moreno, the woman who was found dead last week. Graciela disappeared Sunday night, and her family is very worried. She's sixteen years old, and five months pregnant." Only when he had finished his spiel did Gutierrez put the photo in her outstretched hand. "Do you know her, or have you seen her?"

Jocelyn tilted the shiny rectangle so its surface would catch the light properly, and looked at it. "Nope, sorry. She's pretty. Looks happy." She handed the photo back. "I hope you find her."

He tucked it away carefully in his inner jacket pocket. "I hope so, too. Her sister Dolores believes that Graciela, who was unhappy about her pregnancy, went to see a doctor Esperanza Moreno had told her about. Dolores believes that even if Graciela doesn't wind up dead, like Esperanza, she'll go to hell for getting rid of her baby."

James Ferrar's face had gone white and rigid; he moved his mouth with obvious difficulty as he spoke. "Gutierrez, if you accuse me publicly of performing abortions on either of these women, I'll bring a lawsuit that will bankrupt you and the whole town of Port Silva well into the next century."

"I'm not accusing, not yet. Did you perhaps give advice to this girl, as you did to Esperanza Moreno, about where she might have her pregnancy terminated?"

"Absolutely not. I never saw the girl. And neither of the clinics I recommended would deal with a five-month pregnancy, especially in a minor—not without extraordinary circumstances."

"But this doctor Esperanza talked of—can you suggest who else she might have meant?"

"Absolutely not! And your continuing to question me is something my attorney…"

"He's wondering about Granddad," said Jocelyn, who had been listening in silence. Now she mimicked Gutierrez's stance, legs wide and hands in pockets. "Aren't you?"

"I am looking for information," he said.

"He didn't do it. I don't suppose the law would have stopped him," she went on, "but his own ethics would have. His eyesight was

failing and he had tremors in his hands. It wasn't the broken hip that caused him to give up practicing; he simply refused to put his patients at risk."

"Well. Okay, that makes sense," said Gutierrez. He controlled an embarrassing urge to grin by turning his gaze on Alma Linhares, who was scribbing in a small notebook. "Got all that, Officer Linhares? Then we'd better move on."

Chapter 20

MEG AND KATY were driving the westernmost route—Coast Highway One north and east to Leggett where they would join Highway 101, which winds its way north as the Redwood Highway. At Arcata they would swing eastward on the squiggly red line named 299, marked along its map-route with the evenly spaced black dots proclaiming it scenic—and slow.

"When Vince says four hours, he's thinking of his Porsche," said Meg. "But we're in no hurry. We've got ocean, forests, river, and mountains all in one day. Hardly any towns, hardly any people. Peace."

"And it's not raining, that's the beauty part. It's *too bad* you didn't ask Vince for the Porsche, Mom," Katy added with a dramatic sigh. "But it really feels good to me to be loose and rolling and…away."

"That's genetic," said Meg. "From your grandfather Evans. And me." She was ashamed to admit even to her daughter how much she enjoyed being out here, away from any immediate responsibility except keeping her van on the road. Away from classrooms, students, even husbands.

In recent months Meg had willingly reined in her own prickly, combative nature and worked hard at being warm and supportive to Vince, whom she loved. It wasn't even a sacrifice on her part, because she had happened into one of those emotional good patches, with energy and attention to spare; and such balance, after all, was what made marriage valuable, even possible.

But this last blow, Dr. Gabe's death, had put Vince beyond her reach somehow, as if an invisible wall separated them. She hoped—she was sure—the distance was temporary, and the best thing she could do right now for him was to deal with his wandering and difficult niece. The fact that this task took her out in the world, out

on the road, was a nice little bonus for which gratitude was surely the proper response.

"What if we get to the camp, and Cass isn't there?" Katy asked.

"Then we'll have had a nice trip and a chance to relax and we'll go back home tomorrow. Or the next day if we feel like it."

"We sure have enough food," said Katy, tossing a glance at the big cooler in the rear of the van.

"If Cass is there, she's probably staying close to the camp, and she could be getting short on food after, what will it be, four days."

"Actually, I'm feeling kind of short myself. Okay if I get an orange or something?"

"Absolutely."

Two hours later, Katy pressed the "Off" button on her portable tape player, took off her earphones, and stretched. "I changed my mind again. I am definitely going to be a forester, and protect all these red-wood trees."

"Good for you," said her mother. Adding to herself, If there are any left by the time you grow up. In Meg's more pessimistic moods, she foresaw the demise of all but enough redwoods to satisfy tourists driving north—maybe a mile-wide band of the giant trees on either side of the highway.

"Mom, how are you going to make Cass tell you…whatever it is you think she knows?"

"I hope we can convince her. I'm hoping, too, that you can help me with that. You probably know her better than I do—or at least differently."

"Cass likes me, but she doesn't really *like* to like anybody. So she sometimes says mean things, to push me into not liking her."

"And what do you do then?"

Katy grinned. "Oh, I usually just leave her alone. Then she gets lonesome and talks to me again. I bet there's a word for not wanting to do what you really *do* want to do."

"Ambivalence. Ambivalent as an adjective."

"Neat," said Katy. "Cass is a very ambivalent person."

"What we're going to have to do," said Meg a bit grimly, "is get her to make a decision and take a stand."

"Lots of luck to us, then. Hey, we're almost in Eureka. Can we

stop for lunch? Like maybe fish and chips before we head into the woods?"

"I know just the place," said Meg.

Half an hour later, under a sky still briskly blue, Meg let Grendel out of the van, fed him the piece of cod she'd saved, and trotted him quickly around the block. There were two hours or more of driving ahead: eighty-plus miles mostly east from sea level here up and down along the gorge of the Trinity River to Junction City, then ten or so north on gravel roads to the camp at some twenty-two hundred feet. Two hours to think about what she was going to do. If Cass was there.

Katy slept. Meg worried. What if Cass was there, but *with* somebody? Somebody with all the class and good sense Cass's former boyfriends had exhibited. In which case she, Meg, could find herself knee-deep in shit and Katy along with her.

Or what if some other kind of squatter, a more dangerous kind, had stumbled onto the camp and set up housekeeping? Kind of thing that happened all the time. Except probably not here and now; after all, the sheriff's deputies hadn't seen anything amiss.

But those kinds of people knew how to lie low and avoid notice, at least until they were ready to leave, when they might elect to ransack or burn down their borrowed quarters.

She knew this was all, or mostly, nonsense. But hovering on the black edges of her mind was a seriously troubling thought: Harm to her and Katy would probably be more than her worn and worried husband could handle. Caution, Margaret.

Katy woke groggily as they began the gravel-road stretch. "Where are we? Oh, I know. Not far now. Hey, look, the redbud's out! Must be spring, Mom."

"Keep an eye peeled, Katy."

"For what?"

"For anything."

But they saw nothing except a few offshoots of the road, none of which looked recently used. Meg, who had put on her down vest after the lunch stop, rolled her window down now, to listen. The air smelled piney and cold, but there were no patches of snow at road level, no water standing in the roadside ditches, and their passage

raised a thin plume of dust. Must not have had rain for some days. Maybe, she thought, as she mentally crossed her fingers, the little creek would be low.

She came to the last turn, their own offshoot-road. Bushes crowding the narrow way from either side had clean, shiny leaves; obviously there'd been little if any traffic here since the last rain.

"Hey!" said Katy. "Look at that, the bridge boards are gone! Some creep took them!"

Meg braked the van at the edge of the creek, which had no real banks here, simply a gentle slope down to the water that gurgled gently over a broad rocky bed. "It doesn't matter, Katy. I can see it's shallow enough to ford."

They drove slowly down into the water, bumped across the rocks, climbed the opposite slope, and eased onto what was now only a two-wheel trail marked at its start by a sign that said PRIVATE ROAD. The Gutierrez property, some forty acres, was posted with PRIVATE —NO TRESPASSING signs but not fenced; Emily Gutierrez had believed that fences kept out only the seriously law-abiding and so were not worth spending money on. The camp, and the cabin, were ahead just a short distance; Meg negotiated a curve and thought she caught the shine of a tin roof through the screen of scraggly fir and pine.

"Mom, when we— Watch out!"

Meg braked the van hard, bringing it to a stop virtually nose-against a barricade of logs and boards that effectively closed off the narrow roadway. She blew out a long breath and turned off the engine. "Well. Now we know what became of the bridge boards. Katy, are you okay?"

"Yeah," said Katy, rubbing the back of her head. "But Cass isn't gonna be."

"First things first," Meg suggested, opening her door. "If Cass put that there, you and I can move it."

Meg handed Katy her leather-palmed driving gloves and reached under her seat for the gauntlets she kept there for such things as wood-gathering; she pulled these on and she and Katy quickly shifted the boards and then the logs to the sides of the road. They had just climbed back into the van when Grendel, in the back, sat up quickly and growled.

"Mom, it's a dog! Look, isn't he *sweet!*" Katy was out again in a

flash, bending and clapping her hands at the yapping little brown-and-white dog. "Come here, you cute thing! Here, boy."

"Katy, be careful!"

"Go away!" The high-pitched cry came from ahead, from the camp. "This is private property! Go away or I'll shoot!" The blast of noise—shotgun, Meg thought—was so loud it seemed visible in the air and almost obscured a yowl that followed, a cry of pain.

But not from Katy. Meg had leapt from the van and dragged Katy and her armful of dog behind the vehicle before realizing that her daughter was unhurt. She herself was unhurt. The obstruction in her breathing, the weakness in her knees, disappeared in a searing wave of rage.

"Cass! This is Meg Halloran! You come out here this minute! Without the gun! Or I'm going to feed this miserable little dog to Grendel!"

Katy clutched her squirming bundle closer and stared first at her mother, then at the figure slowly approaching. Cass wore jeans, sweatshirt, hiking boots, and a too-large khaki down vest. Her right arm dangled loosely at her side, her left hand was tucked under the vest front against her right shoulder. Her mouth was tight-pressed, corners drawn down, her eyes red and wet-lashed. Glad that the girl hadn't shot herself in the foot or elsewhere, Meg couldn't work up any sympathy for what had to be a very sore shoulder.

"You've got no right to come here and bother me. Put my dog down."

"Bullshit!" snapped Katy. "Who gave you the right to put that crap we almost hit across the road? Who gave you the right to *shoot* at us?" Katy set the Jack Russell on the ground, and he immediately streaked for the van and ran around and around it, barking wildly.

"Boy, that dog has got a serious case of the stupids," Katy remarked. "Just like you."

"Katy, time out," said Meg. "I'm going up to the cabin with Cass. You can bring the van up once we're out of the way." She took a gentle but firm grip on Cass's left elbow, turned her around, and kept her hold as they moved up the trail. "Come on, Tee," she said to the terrier, who gave a last yip and then darted past them to lead the way.

The camp was set in a clearing surrounded by Douglas fir, lodgepole pine, digger pine, and some presently naked trees whose name

Meg had never known. There was a big fire ring, an open-faced shed big enough for three cars and now home to Cass's little Subaru, a medium-sized storage shed with a door and a padlock, and the main building, a board-and-batten wooden structure set on a concrete-block foundation.

The shotgun lay on the steps, double-barreled and medium-bore, and definitely not something that had been left here at the camp. Either Cass had bought it, or, more likely, she'd found it in some corner of the old Gutierrez house in Port Silva, in Emily's lifelong hoard of useful objects. Meg picked it up, broke it, and leaned it against the cabin wall.

Inside, the Gutierrez "cabin" was one large room with a fireplace at one end and kitchen equipment—stove, sink, refrigerator, bench-rimmed redwood table—at the other. A couch and a scatter of chairs and small tables were ranged before the fireplace; several folded cots and a single open one lined the rear wall, the latter draped with a sleeping bag.

A skillet and a teakettle were on the stove, and the fridge hummed gently; clearly Cass had managed to turn on the propane. The remains of a small fire were evident in the fireplace, but the room was cold.

Cass saw Meg's glance and shrugged, then winced. "I didn't want to waste the wood. I don't mind the cold."

Right. You were afraid somebody would see the smoke. "I do," said Meg. "I'm going to make a big fire. Then I'll fix an ice pack for your shoulder."

"I don't like ice, and besides, my shoulder will be okay. I wish you'd just go home. Come here, Tee." Patting her lap in a gesture that her little dog obeyed at once, Cass arranged herself in one of the upholstered chairs. Her small face in its obstinacy was such a replica of Mary Louise's that Meg had to quell twin urges, to laugh at that face and to slap it.

"You won't be able to use that shoulder in a few hours if we don't ice it," Meg said. "And if you're going to take up shooting, the police department runs a firearms use and safety class you should enroll in." She found newspapers and kindling in a box beside the fireplace, small to medium logs in a cubbyhole built into the wall. "Katy," she said when the door opened, "put a kettle on for tea."

In the lean-to that housed toilet and shower, Meg dug around in a big cupboard and finally unearthed the ice bag she remembered. She filled it sparingly from the refrigerator's small freezer compartment, wrapped a towel around it, and showed Cass how to hold it in place. "For about twenty minutes," Meg told her. "Then you let it rest for a while and apply it for another twenty minutes."

Katy had put the kettle on, and had found the teapot and a box of tea bags. Waiting for the kettle to sing, she said over her shoulder, idly, "So what made you decide to come way up here, Cass?"

"I wanted to get away by myself for a while. I was tired of school and people and...everything. And I thought this was a family camp; no reason I couldn't come if I wanted to."

The kettle began to hiss and then gave its piercing whistle; Katy turned off the flame, removed the whistle-top, and poured the steaming water into the teapot. "It's not a family camp now, it's Vince's camp. And ours, because we're married to him. We'd probably have let you come, if you'd asked us."

She turned to face Cass and crossed her arms over her chest. "But Vince is going to be seriously pissed when he finds out you shot at Mom and me."

"I didn't shoot at you!" Cass's face paled. "I just pointed the gun up and it went off. I don't see why you have to tell him about it."

"I don't either, Cass," said Meg in soothing tones. "Is the ice pack working?"

"Uh, I guess. Yeah. Thanks."

Katy looked at her mother with raised brows. Meg looked silently, blandly back; and after a moment Katy gave a small shrug.

"How come you're not in school today, anyway?" asked Cass suddenly. "Both of you."

"We had a free day, because of some trouble on campus."

"Yeah," said Katy, "there were fights. Because this girl got raped and said it was Mexicans. Which hardly anybody believes. Debbie Finn, her name was. Didn't you know her?"

Cass shivered visibly, and pulled the ice bag away from her body. "I'm too cold. That was long enough. I knew Debbie just sort of, mostly last year; we weren't really friends. I'm sorry about what happened to her; it must have been after I left. I didn't think she knew any Mexicans," she added softly.

"Who did she know?" Meg asked as she collected the ice bag.

"Oh, just—kids. Like I said, we weren't really friends. And I was busy." Her face had regained its normal color, and her voice was steady.

"Katy, let's go bring in the cooler," said Meg. "We're going to be hungry before long."

Cass perked up when they lugged the chest in, her interest in food both real and a diversion. "I just bought whatever caught my eye," said Meg. "Probably we can find something to cook."

Cass was sure they could. The little deli ham didn't interest her, and the chicken breasts were still mostly frozen. But the package of pork chops...and apples, onions... "Is there some white wine?" she demanded.

Cass, sore of shoulder, could not trim and chop; but she could direct, firmly. Katy could trim and chop. "Cut all the fat off the edges, and use a little bit of it to grease the hot pan," Cass told her new servant. "Then salt and pepper the chops and brown them. Slowly."

Some sizzling minutes later she said, "Okay. Now take the chops out and put in the onions you sliced, and stir them around. *Gently*, to pick up the brown bits," she said sharply. "Then put the lid on for a few minutes."

Katy sighed but obeyed. Unpeeled sliced apples came next, then the browned chops. Then a generous slosh of wine, and a bit of water. "Now put the lid on and turn the fire really low. And check it every now and then," instructed the by-now-imperious cook.

"That's lovely, Cass," said Meg, who had read the lift in Katy's chin: enough role-playing. "I can hardly wait. Did you learn that recipe at Hungry Wheels?"

"No! It was this other place I worked, more of a café," Cass replied shortly. "It's good with mashed potatoes, but I think we'll have to make rice."

"Your mother says someone called you from Hungry Wheels. About coming back to work. But she didn't leave a name. Do you suppose it was Debbie? Did she work there, too?"

"No. I need to go to the bathroom." Cass got to her feet abruptly, and the dog she'd been cradling and stroking tumbled to the floor, righted himself, and sighted an enemy.

"Tee!" Cass yelled.

"Grendel!" snapped Meg.

Ten pounds of terrier charged one hundred ten pounds of komondor, yapping challenge. Grendel stood motionless for a moment, secure in the ropy coat that was protection against wolves; then with a sweep of his head he broke the little dog's grip and sent him flying. He lunged after Tee, planted a big paw on the writhing body, and looked up at Meg as if to ask, "What should we do with this nuisance?"

"Your dog is a whole lot braver than you are," commented Katy. She scooped up the terrier and handed him to Cass.

Not quite fair, thought Meg.

"I think you're scared of somebody," said Katy, head high and blue eyes hard. "Or you wouldn't be hiding out here with guns and barricades. Like maybe whoever it was that raped this Debbie. And it wasn't Mexicans."

"I don't know anything."

"If you do know something, you have to tell Vince. Otherwise, when somebody else gets hurt like that, it will be partly your fault."

"Katy," began Meg.

"Vince is your uncle and he watches out for you, helped you buy a car, like that. He's trying to get the bad guys off the streets, and if you can help and don't, then you're a rotten person."

"I can't!" wailed Cass, clutching her dog so tightly that he yelped. "They'll hurt me the way they did Debbie. She—this person—will tell them to, and they will!"

Meg put a hand on Cass's good shoulder. "There's no reason for them to learn that the information came from you. And even if they do, Vince won't let them hurt you."

"You can't stop them," said Cass wearily. "They do what they want."

"Bullshit!" said Katy. "How do you think Vince is going to feel about you when he finds out all this?"

"He'll hate me. But I can't help it."

"Or," said Katy, slowly, "how about this she-person and whoever else it is? How will they feel about you when somebody at school, maybe, starts a story about this policeman's relative who knows a lot of stuff and is telling? Pretty mad, I bet."

"You're, like, my cousin! You wouldn't do that!"

Katy met Meg's look and then, slowly, shrugged.

"*Maybe* I wouldn't. But I'd like to. It would be fair."

Her daughter's go-for-the-jugular instincts would be wasted in the forest service, Meg decided. Law school, maybe, if pro basketball didn't materialize. "Cass, I think you have to trust us, and your uncle."

"Vince, I *was* careful. I also thought I was being useful, exploring what was only a possibility but one you couldn't have taken time for. And it's getting cold here and I'm at an outdoor phone booth at a gas station, so you'd better listen."

"Sorry. And I appreciate the help. But I wish you'd told me." He waited for a a reply, and when there was none, sighed loudly. "Okay, done deed. So what is Cass's story?"

"Cass goes through life like a cat, close to the wall and on the watch for trouble. While she was working at Hungry Wheels, she noticed that the waitress and assistant manager, Kirsten Olson, had some kind of connection with some kids Cass knew, or knew of."

"Connection," muttered Gutierrez.

"Kirsten drives a motor home to work, an old slab-sided Winnebago. Sometimes, most often when Cass worked a late shift—which she was not supposed to do but she got better money—she saw these kids arrive and get into the motor home, as if they had keys."

"What kids were they?"

"She saw Dwayne Hamm, and Mike Lorenzini; she doesn't know them personally, but she knows who's who and what kind among the local teenagers, because, as I said, she watches. There was a girl named Maddy who is Kirsten's younger sister; she comes into the restaurant on her own now and then. Apparently she dropped out of school in San Francisco and the family shipped her up here.

"Then there was a boy named Ron Magnuson, who I bet is the older brother of the Magnuson girl in my class. Cass knew him because she'd seen him with Debbie Finn, who bragged about him; he was her exciting new boyfriend.

"And here's a bonus," she added softly. "Cass says he is blond, with pale blue eyes, and very tall. If he's the same kid I had in class three years ago, only now of course much taller—he's probably the guy who hit me and then slashed my tire. Because he thought I'd recognized him."

"We'll check on Ron Magnuson," said Gutierrez in grim tones.

"Meg, what did Cass think these kids were up to in the Winnebago? The obvious?"

"Right; sex, maybe drugs, too. She says when they did come into the restaurant, which didn't happen often, they were very polite to Kirsten. As if she were doing them a big favor. But then one day, she saw Kirsten giving Hamm and Magnuson money."

"She's sure of that?"

"At the moment she is. She says she was clearing tables and happened to look toward the counter, which has a mirror behind it. She saw Kirsten hand Dwayne Hamm what looked like 'a bunch' of bills. Very quickly. And then the boys left. And she thinks it happened another time."

"So, since she herself ran with a bunch of thieving vandals in the past, she figured out what was happening: that contraband of some sort was being paid for," said Gutierrez. "Would have been nice if she'd told her uncle, the chief of police, about all this."

"I'm sure she would have, eventually," said Meg, who wasn't sure at all. "But the attack on Debbie Finn sent her into orbit, I think because she's all too familiar with the…the ground rules. For this kind of thing. Her take is that Debbie was involved in the housebreakings, and got scared and wanted out. And then the others had a really good time showing her why she should keep her mouth shut." Meg zipped her down vest higher and tucked her chin into the collar. "The bastards."

"Listen, Meg, I want you to call the sheriff's substation and ask for protection."

"Love, I came up here in my van. I told no one I was coming except you and Charlotte, and I'm sure no one followed me. We have Grendel with us, as well as that hyper terrier of Cass's, who goes off at the drop of a pine needle. And we have a shotgun." She would not, she decided, tell him about Cass's use of the shotgun.

"Okay, figure you're safe for the night. Then I want you all to come home tomorrow."

"I can do that, and I don't think Katy will object. But Cass… Vince, she's terrified."

"I'm sure she is. But there are some questions I need to ask her."

"She and Katy are in the van. I think she'll talk with you, now that I've paved the way. Hold on."

"Cass?" Meg called, and beckoned. Cass slid from the van and came across the gas-station tarmac, head down and body huddled into the too-large vest as if against the wind, or prying eyes, or just life. Meg handed her the phone and moved out of earshot but stayed within the girl's line of sight, standing tall and square-shouldered. If she was a poor hand at soothing and consoling, she could at least, by God, be a fierce protector.

Many chilly minutes later, Cass laid the telephone down on its shelf and came toward Meg, her chin up and her cheeks faintly pink. "Uncle Vince just needed me to tell him some things. He's not mad at me at all. Oh, he wants to talk to you again."

Fierce protector feeling a bit snappish, Meg picked up the phone. "Vince? Was that helpful?"

"It was. But she doesn't want to come home. How did you find things there? Got a sound roof and plenty of dry firewood?"

"Everything's fine."

"Then how would you feel about staying another day? If I call the substation and ask the deputies to keep an eye out in your direction, you'll probably be safer there than here."

"I…don't mind, actually. It's a long drive."

"Okay, let's do it that way. Call me, uh, Sunday morning, early. We'll see what's happened here, and if Cass is still reluctant, we'll find someplace else for her to go."

Meg spent only a moment balancing his need for, or at least comfort in, her company with his wish to have all his women stowed safely out of harm's way. "Fine."

"And…Meg, goddamn it, you be careful!"

"Yes sir, I surely will. You stop worrying about me and go blow that Winnebago away. Kill those fuckers! I really wish you could. Wish I could."

He made a sound somewhere between a chuckle and a groan. "I love you."

"I love you, too. Take care."

She hung up the phone and then had an immediate urge to pick it up again. Forget I said that about blowing them away, Vince! she told him silently.

Chapter 21

"YOU'RE LOOKING good," said Gutierrez, his surprise at this fact showing in his voice.

"Yeah, instead of one step short of satin pillows and folded hands," said Hank Svoboda, who was reclining today in his big green chair in his own living room. "You look tired, and pissed. Been working hard, I guess."

"Right." Gutierrez tossed his leather jacket at a nearby chair. "Schmoozing and conferencing and politicking and telephoning. When I'd rather have been breaking heads. Would you happen to have any gin in the house?"

"Uh, nope, don't think so. Got some really fine Scotch, though...at least Patience says it's fine. Single malt, whatever that means. Or there's beer—two, three different kinds."

"Beer sounds right," said Gutierrez, and headed for the kitchen and the refrigerator. Patience was Patience Mackellar, a widow whose comfortable gray-haired appearance belied her quick wit and private investigator's license. If frugal Svoboda was keeping single-malt Scotch on hand for Patience, she had probably been upgraded from friend to lady-friend, or whatever term Hank found appropriate. "Are you ready?" he called, as he fished a bottle of Red Tail Ale from the food-laden fridge.

"No, I'm fine. Had my quota until maybe a snort of brandy at bedtime. Vince, get your ass in here and tell me what's happening in our crime wave."

"Remember it's your boss you're talking to, old buddy," said Gutierrez. He tipped the bottle for several swallows before dropping into an overstuffed chair, where he propped his feet on the matching ottoman and frowned at them. "Okay. Our original number-one

problem, the housebreakers, we're making progress on. But it's a long story." He told Hank in some detail of the revelations Meg had wrung from Cass.

Svoboda pulled the lever that brought his chair up a notch. "So did you search Olson's place? Or his wife's Winnebago? Except…no, those folks are pros and they gotta know you've been talking to some of their troops."

Gutierrez grimaced. "We kicked it around and decided just that. The last burglary was a week and a half ago, and the owner of Hungry Wheels says Kirsten Olson has had a couple of days off since then. It's not likely there's any of the loot still lying around. And even if Cass weren't too scared to talk, what she thinks she saw isn't enough."

He shook his head and then tilted his beer bottle again. "Ah. Anyway, Kirsten Olson, born Kay Kebler, has convictions in San Francisco for robbery and assault, and a couple of arrests for soliciting. She served two years on the assault and is no longer on parole. No charges since then. My friend in the San Francisco district attorney's office says she is dirty, mean, and tough."

"Matches her up real good with Ev Olson," said Svoboda. "Except I guess he's not so tough anymore. So you're gonna watch the restaurant?"

"The restaurant, which will be easy, and the Olson place, which won't. Meanwhile, we need to look harder for Debbie Finn. Cass is absolutely convinced her rape was connected, and that makes sense to me. Maybe we can get her to testify. Her boyfriend, Ron Magnuson," he added, his voice deepening to a growl, "doesn't seem to be around at the moment. Nobody in his family has any notion where he might be."

"Vince, I know Debbie's mother, Sandra Belinski she was. Grew up out in the county in a family that never had anything, and then she had real bad luck picking men. You find her, let me be the one to talk to her."

"When we find her, you're on," said Gutierrez. "Look, are you okay? Getting hungry? Because I can fix you something."

Svoboda shook his head. "Jeannie came by an hour ago, heated up supper, and watched to make sure I ate it. My daughter may be a hardworking M.D., but she still cooks, at least for her poor old dad."

"I thought maybe your friend Patience put together all that stuff in your refrigerator."

"Patience will hold your hand, listen to your troubles, open the beers, fetch stuff from the deli or the fish-and-chip place. What she won't do is cook. So tell me what's happening on the dead woman. You turn up her husband?"

Gutierrez was tempted to try a smile, but his face felt out of the habit. "We're getting there. I think. Alma Linhares and I were going through a box of snapshots taken by Esperanza Moreno's young friend, Graciela Aguilar, and we found one of Rubén Moreno and the two kids—and his car."

"Hot damn," said Svoboda quietly.

"It's an old green Chevy Malibu with a Mexican license plate we could read once the photo was enlarged. We've sent the photo and the number down the network. But the way things are going around here, he'll have a perfect alibi, and Espy was killed by some forever-nameless druggie who wound up with about ten dollars for his trouble." He looked at the bottle in his hand, seemed surprised to find it empty, and got to his feet. "Probably I should get going."

Svoboda peered up at him. "Meg's not home, you said?"

"True. But it's getting late, and you must be tired."

"Vince. You can manage one more beer and still drive. Get me one, too. Then we'll talk about Dr. Gabe."

"I don't… Yeah. Okay."

Gutierrez took his time opening two beers, came slowly back to the living room, handed Svoboda one brown bottle and sat down again in the overstuffed chair but straighter this time, with his feet flat on the floor.

"Hank, I am so fuckin' confused about this, I don't trust myself."

"Did Zeigler decide it was arson, there at the clinic?"

"Oh, yeah. And the pathologist who did the postmortem says the wound on the back of Gabe's head was consistent with a fall, particularly in an old man who was frightened. By the fire he'd started, is what everybody seems to think."

Svoboda had stretched out in his chair again, resting the beer bottle in the faint hollow where his belly used to be. "But you don't."

"I don't know what I think. The Gabriel Ferrar I knew most of my life would not have burned down his old hospital, not for the

insurance he didn't need, and not because he was mad at…his son. The town. Old age."

"So it was the protesters, or that gang of vandals. And Gabe walked in on them as they were torching the place, and started swinging," said Svoboda. "Just what he'd have done."

"True. So we're looking for one or several bastards who'd knock an old man down and let him burn to death."

"Here's something I know, Vince: Fire is a terrible thing. Being caught in one can liquify a man's bowels and turn his brain to mush. Not that I'm making excuses, you understand."

Gutierrez rubbed a hand over his face. "No. Okay, we've talked to all the protesters anyone can remember, none of them looking like arsonists or murderers. We've put out radio and television requests for information from anybody who was on the street that night. We've spent hours with the two local boys, Arnie Grebs and Dwayne Hamm, who admitted vandalizing the hospital and grounds Monday night."

He paused for a drink of beer, rolling it around in his mouth. "They have alibis of a sort, probably not good enough to hold up. There is no evidence. They swear they didn't return the next night to torch the place. And they're beginning to convince me."

"And then there's the missing pregnant sixteen-year-old we haven't been able to find, either." Gutierrez considered and quickly decided against mentioning his theory about late-term abortions. In spite of the gruesome dreams he'd had last night—all variations on a toothily grinning Dr. Gabe with a huge knife in one hand while the other held a bloody child aloft by its heels—he sided with Jocelyn Ferrar on this. At most, Dr. Gabe might have given Espy, Graciela, who knew who else, information about where to find a doctor. Not illegal. But enough to drive someone else to strike the old man down?

This notion had not occurred to Gutierrez before.

"Vince?"

He jumped, blinked. "Sorry. Hank, you'd better get well in a hurry and take over this job, because it's too much for me. I think I'll retire, take my savings, and move up to Trinity County and build a big wall around the camp."

"Yup, with moats and gun turrets and razor wire. Stuff like that is

real popular these days, I hear. Meg and Katy might not enjoy it, though. How long since you had a meal, Vince?"

Gutierrez looked at his watch, which told him it was after eight. "Uh, I ate breakfast this morning."

"As you noticed a while back, there's stuff in my icebox to feed an army. Go out and heat something up, the microwave's right there on the counter. In fact, if you don't want to go home to a cold, empty house, my guest room is made up, I think."

Gutierrez had gratefully accepted a meal—two big bowls of home-made chicken soup with noodles and two chunks of cornbread—and helped Svoboda to bed, but declined the invitation to stay the night. At nine-thirty he climbed into his white sedan, which seemed to decide for itself to head not north toward home, but back into town. Chief of police prowls deceptively peaceful town, hoping for...luck? Mayhem? Justice?

It was full dark now, with no rain but a misty fog that haloed the streetlights and made the street surfaces shiny-slick. Not a very active Friday night so far, most people probably at home in front of their fireplaces; two or three hours to go before the bars began to spill brawling patrons out into their parking lots.

He drove past the clinic, where the yellow-taped main building was just a black hulk but the rear buildings squatted in the glare of half a dozen big lights mounted on temporary poles. Saw a passing black-and-white pause and turn to circle that particular block; good.

Gutierrez cruised the north-end neighborhood, very little traffic here, and Dr. Gabe's house as dark as the clinic. Back to Main Street, past closed shops and lighted restaurants and the occasional bar. Movie theater, curbs there and nearby lined with cars. Video shop open and busy, a black-and-white moving through its parking lot. Good.

Group on the sidewalk jostling and calling out: Gutierrez thought, *Trouble*, and then registered the shop-front as a pizza place, the noisy group as students, the sounds cheerful not threatening. Good. Drove on; lights blinked at him and he blinked his own back, Johnny Hebert's hand waving from the open window of his stately Volvo sedan as it passed.

Up some side streets also quiet, a few people walking, raincoated

and hatted. A bicycle with no light, but it turned a corner and disappeared, and Gutierrez elected not to give chase. This street ended at a wooded park, no sign of occupants there but it was probably damp and drippy under the trees.

Back on Main Street, a couple of cars fender-to-fender in the middle of an intersection but it looked like minor damage, no one shouting, and a uniform was there, black-and-white parked nearby.

He thought about stopping at Coffee Connection but a glance up the block showed a line outside, short, but he didn't feel up to social contact—more like, what was his mother's phrase? A bear with a sore paw. Or a sore head. There was another coffee place, less popular, at the other end of town.

His radio was muttering along, nothing much. The fender bender. Somebody going on meal break. At the Safeway on the other side of the street, the big parking lot was well-lighted but not very busy. If the homeless couple were still camped there by the Dumpster, he couldn't see them, wasn't looking very hard. On to the southern end of the commercial district, and there was Java Hut and a familiar vehicle at the curb. He pulled in behind Alma Linhares's midnight-blue Ford Explorer. All his troops were out and probably edgy tonight; if he continued his cruise he'd come across Ray Chang, maybe Val Kuisma, although he hoped Val was at home with his pregnant wife.

Gutierrez left his motor running as he got out of the sedan and stood in the angle of its open door. Here came Alma, by herself, tall Java Hut cup in hand. Just another cop with no Friday night date. She spotted him and he lifted a hand.

"Chief? Something up?"

"No, unfortunately. Hang on a minute, while I go get a cup of that stuff." He was reaching into the car to turn off the engine when a siren sounded nearby and the police radio crackled with new urgency.

"Winnebago, white, license (unintelligible). Weaving, changing lanes for two blocks." Static. "…light and siren but didn't respond, pulled into Safeway lot from Main…"

Gutierrez dropped into his seat as Alma yanked open the passenger door and flung herself in. He slapped the magnetic light onto the car roof, hit the siren, and swung from the curb in a tire-squealing U-turn.

The big store building was three blocks ahead; Gutierrez saw a flashing bar-light coming down Main from the other direction, stepped on the gas and turned off a block before the store and left at the next corner, and slammed his car over the curb to block the back entrance to the lot.

The high white motor home lumbered across the lot, grazed a bumper or something, and rocked, hesitated, aimed itself toward the back exit and hesitated again. Two bar-lights came from behind it and then in tight around it, patrol cars pincering the big machine to a halt; two uniformed officers hit the ground running. By the time Gutierrez and Alma reached the vehicle, one officer was inside and the other stood at the open passenger door, hand on his still-holstered weapon.

"Shut the thing off!" called Gutierrez. "Coats, you're good, stay there," he said to the outside officer, and pulled himself up into the doorway. A dark-haired male shouted and gestured from the high-backed chair that served as driver's seat. The figure in the passenger seat was stretched out, blond head back, also shouting but with laughter. Officer Dave Figueiredo stood between and behind the two, barking commands that only added to the din. As Gutierrez climbed in, he spotted another figure in the rear of the vehicle, standing but motionless and silent.

"You're under arrest on suspicion of driving under the influence of alcohol," declaimed Figueiredo. "And of having open containers of alcohol in your vehicle," he added, gesturing at two sixteen-ounce cans of Budweiser in the holder in the center console.

The driver yelled, "Go fuck yourself, dickhead," and flung himself at his door, managing to get it open but not before Figueiredo got a good grip on the back of his shirt.

"Stay where you are. Sir!" he added, and in movements almost too swift to follow, cuffed the driver's wrist to the steering wheel. Barely a man, more a boy, Gutierrez noted. And the laughing passenger was female, also young.

"Linhares, get in here," Gutierrez snapped, and as Alma lurched against his shoulder, the girl swiveled her seat around and swept an arm across the console, tipping both cans into a frothing tumble.

"Hey, empty cans," she said, and giggled. "Big deal, we had a beer each. Couple hours ago."

"Coats, get the Breathalyzer," called Gutierrez. "And Officer Figueiredo, as soon as we've tested these people I want you to put them in the squad car and then take this vehicle apart."

"Hey," said the girl, glaring at him from pale eyes. "You can't do that."

"We can. In search of further alcohol or other controlled substances," added Gutierrez with a tooth-baring grin.

The girl's eyes widened, and she was gathering herself to stand when Figueiredo produced his second set of cuffs and tethered her, too, to the wheel. She jerked at her left arm like an animal fighting a trap, looked wildly around, and then raised her right hand swiftly toward her mouth.

"No you don't," sang Alma Linhares, leaping to pinion that arm. As the girl squealed and thrashed her long body about, Alma gripped the now-clenched right hand and slammed it against the dash. "Spread it out. Do it!"

This was a big girl—Maddy Kebler, Gutierrez would bet, Kirsten Olson's sister—and her hands were large. Gleaming on the little finger was a narrow circlet of diamonds set in gold. Karen Ederle's list of objects stolen from her house described just such a ring; it had been her mother's wedding ring.

Gutierrez reached past Alma to pin the hand more firmly in place; Alma pulled the ring off and dropped it into her pocket. "Miss Maddy Kebler," he began, "I am Chief of Police Vincent Gutierrez, and I'm placing you under arrest for—" He caught movement in the rear of the motor home, and turned in time to see a rear door swing open, lights from the parking lot outlining a tall figure in the opening.

"Alma, take over," he snapped, and launched himself out the forward door. The escaper, very tall, was just getting his long legs into function when Officer Coats, returning with the Breathalyzer, came around the back of the motor home. The boy yelped, skidded, tried to reverse his direction, and found himself facing Gutierrez.

Fair hair curling to the collar, wide eyes so pale they were practically colorless: Gutierrez thought he could feel his own adrenaline like little jolts of electricity as he saw what Meg had seen and felt not terror but anticipation. Glee. "Ron Magnuson?"

Head forward, eyes rimmed with white, long arms half-spread,

the boy gulped a deep breath. Not really a boy, Gutierrez reminded himself. Ron Magnuson was nineteen years old. "Uh. Uh. Yeah."

"Vince Gutierrez. Chief of police. Where's your ski mask tonight, Ronnie?"

Magnuson tossed his head high and threw a look over his shoulder to see Coats standing there with his hand on his holster. "Oh, shit," he whispered and lunged forward, something that looked like a tire iron high in one hand.

Gutierrez could feel the cold air on his teeth as he stepped under the swinging arm and rammed a fist deep into Magnuson's belly. The iron clattered to the ground, the long body jackknifed, Gutierrez jerked his knee up hard to meet the plunging chin with an audible crack. He stepped back and set himself, rammed the wide shoulders with the heels of his hands to fling the boy back and almost upright, and drove his right fist into the bleeding face.

"Jesus, Chief! Jesus," breathed Coats.

It wasn't the words but the horrified tone that reached him. Gutierrez's heart was thudding against his breastbone, blood thundering in his ears. He sucked breath through his nostrils, opened his mouth to expel it in a gust. And again. The fog had misted his forehead, or maybe it was sweat. He did the breathing routine again.

"Chief?"

Gutierrez looked down at Ron Magnuson, who had curled himself into a ball with his arms around his head. He was breathing. Sobbing. "Breathalyze him."

"Uh, Chief, I don't think I can."

"Well. Then get the paramedics and have them take blood for a test," said Gutierrez. "I don't think he'll object."

"Uh, no, probably not."

"He was fleeing the scene of a DUI and probably a burglary charge," said Gutierrez. "He was resisting arrest, with a weapon."

"Yes sir, he sure was."

"Right. I'll stay here with him while you radio for the paramedics."

Coats headed at a trot toward his squad car, looking back only once.

Chapter 22

"YOUR 'RONNIE' came at me with a tire iron," said Gutierrez to the big gray-blond man with the weathered face. "During flight to avoid questioning about a DUI stop that revealed open liquor containers and stolen property."

"He was scared," said Stan Magnuson. "And he told me he wasn't driving, and *he* didn't have no stolen property on him."

"He didn't have his knife, either," said Gutierrez. "The one he slashed my wife's tire with last week. The blade has a print of his right forefinger."

Magnuson sighed and ran a hand over his face. "I don't know about all that. But I still think you was out of line, lighting into him so hard. His nose is all over his face, the doc at the hospital couldn't promise what it would look like when he finished with it."

Any twinges of guilt he might be feeling sprang from the satisfaction he'd taken in flattening Ron Magnuson, not from the act itself. "He didn't look as bad as his girlfriend did after she was beaten and gang-raped Monday night," snapped Gutierrez.

"Jesus Christ, you can't think Ronnie was in on that! Magnuson men don't get rough with women! Besides," he added, "no way Ron would've had to force that Debbie Finn, she was giving it to him whenever he wanted."

"Maybe your Ron isn't exactly a man," Gutierrez said, getting wearily to his feet. Besides being almost surely Meg's ski-masked assailant as well as the slasher of her tire, Ron Magnuson was the only fair-haired male among the housebreaking suspects, the only one who could have left blond hairs on the rape victim.

"You actually charging him with anything?" Magnuson asked as he pulled his watch cap from his jacket pocket.

"Charges will be brought on Monday; until then Ron will remain in custody, at the hospital and then here after they release him."

"Shit, you can't…"

"I can. And the same applies to the two who were picked up with him, both of them also of age for everything except drinking alcohol. No charges, no bail, until Monday." Gutierrez glanced at his watch, saw the time was now two A.M. With a nod of dismissal to Magnuson he moved to his office door and opened it; the other man grunted and trudged out, pulling his cap on as he went.

After a moment Gutierrez followed, and was surprised by the silence he found beyond his office. The squad room was just the usual middle-of-the-night scene: a patrolman at one end of a table taking information from a woman with a cut lip and a swollen eye, another at a nearby desk speaking into the telephone while a glum-faced youth Gutierrez had never seen before hunched in an adjacent chair and tried to pretend he was holding his hands behind his back because he felt like it.

The door to the long room used for conferences and briefings was closed. About to knock, Gutierrez spotted Alma Linhares in the hallway beyond, and gestured to her.

"Hey, boss. You look like a guy who just found out his cat got run over."

"I do? Except for some pulled muscles and bruised knuckles, I feel pretty good," he said, and then rubbed his gritty eyes. Alma's hair was ruffled, he noted belatedly, her shirt pulled loose from the waistband of her pants; a red splotch marked her cheekbone, surely left there by a fist. "Alma, are you okay?"

"Absolutely," she said, eyes glittering.

"Good. What's the score?"

"Lorenzini—the guy driving the Winnebago? The guy just kept flashing his pretty teeth and saying clever stuff like 'Eat shit,' so we went ahead and locked him up for the night. Ray thinks his folks are—confused. Can't believe he'd be involved in something like this, but underneath, they've got their suspicions. They've gone home, back tomorrow."

"What about the girl?"

"Girl, shit!" said Alma. "That one was born full-sized and rat-mean. Isn't that so, Johnny?"

Johnny Hebert's blue shirt gaped at the shoulder seam, and one front pocket dangled loose. As he came from the front area into the inner hall, fluorescent lights on the low ceiling made garish display of the parallel red streaks from his right-side hairline to the edge of his beard.

"Miss Madeline Kebler," he said in tight tones, "is innocent of all charges, found the ring, had only a sip of beer in spite of her point-one-three blood alcohol level, and nobody ever told *her* it was against the law to have open beer in your motor home." He paused for breath. "She's a virgin and the product of a virgin birth, free of original sin as well as any other kind.

"In spite of all that, Miss Kebler—and Kirsten Olson, who responded to Maddy's call with sisterly speed—will be charged with assaulting police officers." Hebert touched his cheek with careful fingers. "And they'll get the bill for my tetanus booster. The two of them are sharing a cell; if we're lucky, they'll eat each other."

About to reply, Gutierrez yawned so widely his jaw cracked and his eyes watered, and the others waited politely until he'd finished.

"One other interesting thing," said Hebert. "Arnie Grebs came in at the start of third watch, to pick up car keys or something from his dad. When he saw the Kebler girl and Olson, he went so white I thought he was going to pass out. He probably had to go home and change his underwear."

"Good," said Gutierrez. "When we've finished shaking down that Winnebago, we should have some interesting prints, and with luck a few more items of missed contraband. Leading, if God is good, to a few more arrests. Ah, I forgot. What about the Hooper kid? Did he come in as requested?"

"Oh yeah," said Alma. "Bobby and his folks spent a good hour in the briefing room with my cousin Dave."

"Figueiredo?"

"Right. Dave was in 4-H with one of the older Hooper boys, knows the parents. He says they're good people and will want to do the right thing when they get hold of it."

"Let's hope they'll also see to it that Bobby does the right thing." Gutierrez opened his office door, reached inside, and lifted his jacket from the coat tree. "One last point. Has anyone turned up any connection between these hoods and the clinic fire?"

Both of them shook their heads.

"Well. We'll get to that tomorrow. I'm going home for a few hours' sleep, and you two should do the same. There's something else I need to follow up tomorrow, but right now I can't remember what it is."

Women—Meg, Alma, Katy, Espy, Graciela—cowered and cried out as mobs of ski-masked naked men danced around them, grabbed and pushed at them. Gutierrez shouted and tried to go to their aid but his feet were buried in mud, tried to draw his sidearm but his hands were chained around a tall, rough-trunked tree.

Later. Lights blazed down on a square, flat-roofed building as a man and woman marched hand in hand up wide stairs to the open double door, where Dr. James Ferrar stood behind an open ice chest. As the couple knelt with bowed heads, Dr. James reached into the chest and then held aloft a slender pipette containing a tiny, perfect baby.

Later still. Dr. Gabe, his face young again and his hair blazing red, spurred his huge white horse and bent from the saddle to scoop up the round-bellied young woman who stood waiting, arms raised. Then the hair was not red but ablaze, the face blackening.

And the blaze was a building, yellow tape bright against the leaping red flames that pulsed in time with the voices screaming from within.

Except for the sweat-drenched patch right under him, the sheets were an icy expanse, a six-by-seven-foot snowfield and no place for a man alone. Should have slept on the couch, Gutierrez told himself in one lucid moment between nightmares. Or, later: should have Meg here with me, warm, sane Meg to keep the ghosts away. Fight the dreams, lock up the bad guys. Bad guys, the reason she wasn't here, and damn them to hell.

When he woke the next time, struggling up from black depths like an ancient sea monster surfacing, daylight was probing the curtains and the bedside clock's blood-red numerals said 8:32. He thrashed free of twisted sheets and dragged himself to his feet, thick-headed and stiff from the miserable night and from...ah, yes, from the earlier exercise of punching the shit out of one of the bad guys. Staggered into the bathroom, where stone-faced, cold-eyed

vengeance stared back at him from the mirror. Remembered Meg's instructions in their telephone conversation. "Blow those fuckers away," he told his mirror-image.

He showered until the water ran cold, and then shaved, trying to see his face while avoiding his own bleak gaze. Put on his uniform, all but the jacket, in unwilling preparation for facing irate citizen–parents who were sure to demand attention from the top cop, highest official threat to their offspring. The cowardly little bastards.

Downstairs the heat was automatically on, and he quickly added to the faint sense of human habitation by making a pot of coffee. There was no real hurry; whatever shit had hit the fan at the shop, his people were handling it or he'd have heard from them.

He poured a cup of coffee and stared out the sink window at weather that was misty gray and could probably go either way. Like him. Maybe breakfast at Armino's... No, too many people full of comments or questions. There were eggs in the fridge, maybe some Canadian bacon left from the other morning.

Then the cop shop, and angry parents. Where he'd have to be a lot more professional than he'd been with Stan Magnuson, or someone might accuse him, not unfairly, of a personal vendetta. Gutierrez took another mouthful of coffee and decided that his call at the station would be brief, for politics and delegation. Then he himself would get on to plugging the annoying gaps in the Graciela Aguilar disappearance.

The telephone's jangle caused him to pour coffee on the counter as well as into the mug. He cursed, set the pot down, reached for the receiver.

"Gutierrez here."

"Hey, Vince. I hear you made some good moves last night."

Gutierrez relaxed as he recognized Hank Svoboda's voice. "We had some good luck. How did you...?" Dumb question. "How are you?" he asked instead.

"Fine, fine. I got to thinking last night, after you'd left. Remembered that Sandra Belinski had this older sister took up with this hippie guy, the pair of them bought a place out on Albion Ridge."

Belinski, thought Gutierrez, and then remembered. "Ah. The Finns."

"Right. Anyway, I talked to a deputy buddy of mine, turns out

Annie Belinski still lives out there. So he did a casual drive-by, and it looks like Sandra Finn is there, too, or at least her car is. What say we go out and have a little talk with Sandra and her Debbie?"

Gutierrez gave one second's thought to Svoboda's health and one to the likely turmoil downtown and said, "You're on. Pick you up in ten minutes."

"I'll be here."

It was twelve-thirty when Gutierrez unlocked the back door of the police station and stepped quietly inside. He still wore the pullover sweater that had been his anxiety-deflecting garb at Albion Ridge, but his uniform jacket was slung over his shoulder, and in its pockets were his small tape recorder and his notebook.

The door to the interrogation room was closed, but a glance through the small glass panel revealed it to be empty. There were voices in the front of the building, not loud or angry enough to require his attention. He could smell food; probably lunch was being delivered to the few prisoners in the ten-cell jail that formed a rear wing of the building.

Maybe there'd be extras, thought Gutierrez. His last meal had been—at Hank's last night. He hurried into his own office, peeled off the sweater, and replaced it with the jacket in case of the need for public appearance. Then, tape recorder in hand, he headed down the hall in search of...

"Aha. Chang," he said to the sergeant coming in from the front area. "Get Linhares, Kuisma, Hebert—whoever's here. In my office."

"Alma's gone to lunch," said Hebert a moment later, as the three male officers shouldered each other through the doorway.

"What I have here, courtesy of Hank Svoboda's efforts and connections, is a statement from Debbie Finn." Gutierrez brandished the tape before laying it on his desk. "Debbie was in on the house-breaking gang because she was Ron Magnuson's girl. She claims she didn't personally do any vandalizing or steal anything. She says she got frightened, wanted out, tried to get Ron to stop, and for that they raped her—Ron and Mike Lorenzini and Arnie Grebs."

"Jesus," said Val Kuisma softly.

"Right. And then Maddy Kebler beat her up."

"Names?" asked Hebert.

"In addition to those I mentioned: Dwayne Hamm and Frankie Beaubien. Neither of them took part in the actual assault, just watched and cheered. And Bobby Hooper, who didn't rape or cheer; Debbie says he got sick and threw up."

"Chief," asked Johnny Hebert, "is she really going to testify to this?"

"I'd say it's ninety, maybe ninety-five percent sure. Debbie's been taken in hand by her aunt, and Annie Belinski is one tough lady. Anyway, we'll get this transcribed and then somebody—maybe you, Val, because I don't think Hank's up to another trip today—can take it out to the Belinski place on Albion Ridge."

"Hey, what's happening?" Alma Linhares burst in without knocking.

"I'll transcribe it, in Captain Svoboda's office," said Val, picking up the tape and its machine. "Where on Albion Ridge?"

Gutierrez gave directions, while Johnny Hebert told Alma what had happened.

"Now," said Gutierrez as Val Kuisma departed, "this leaves us with Hamm, Grebs, Beaubien, and Hooper to pick up for questioning. No arrest, until we have the statement signed; just questioning for cause."

"No need on Hooper," said Alma. "He's coming in at two this afternoon, with his folks and his pastor. To make a statement, I believe."

"Backup is always a good thing," said Gutierrez.

"Uh, Chief. Do you want to say something yourself to Alvin?" asked Hebert. "About his kid?"

"Hell no!" snapped Gutierrez. "This is a very public mess. Let's not be seen making special arrangements for anybody." Untroubled by a little hypocrisy in a good cause, he had a quiet hope that Alvin would find family notoriety a reason for early retirement.

"So send patrol to bring them in," he went on. "And I'll..."

The intercom on the desk crackled, and he reached over to turn it on. "Gutierrez."

"Chief, there's a Dr. Bethany Martinson here to see you," said Alice. "She says you left her a note?"

Martinson. The therapist who worked for the Family Fertility Clinic. "Wait five minutes and send her back," said Gutierrez. Then,

to the others, "Chang, Hebert, you two work out how you want to question these 'kids.' As soon as Kuisma gets back from Albion Ridge, he can work with you.

"But one thing first," he added quickly. "The two we have in custody…"

"Three," said Johnny Hebert. "We picked up Magnuson from the hospital an hour ago. He's walking okay, but he sure isn't pretty—has two of the blackest eyes you ever saw."

Gutierrez, picturing Meg's face the morning after she'd been jumped, permitted himself a brief, satisfied grin. "Okay. Did you ask them about the murder of Esperanza Moreno, committed that same Wednesday night they were having such a good time right in the vicinity?"

"Maddy Kebler just laughed and made an extremely rude suggestion," said Chang, his face tight with distaste.

"Magnuson isn't talking, hardly even moving," said Hebert. "But Lorenzini, now—I'd say our boy Mike is beginning to realize that neither his family nor his smart mouth is going to save his sweet ass this time. He says absolutely no way did he or his friends ever kill anybody. He says maybe they drove past Pelican Point that night, the first time probably about eleven—"

"After they'd jumped Meg," said Alma to Gutierrez. "And the derelict."

"He didn't admit to that," said Hebert. "Anyway, he says there was nobody parked on the point, where sometimes people do park overnight. When they drove by again, maybe an hour and a half later, he thinks there might have been a pickup out on the grass. He says he definitely did not see any people, no Mexican woman dead or alive."

"We'll see what the others have to say," Gutierrez said. "Particularly Hooper. Okay, get with it. Alma, you stay here while I talk to the therapist."

"Yessir," she said cheerfully, and pulled up a chair as Chang and Hebert hurried out. "Besides, I've got news."

"Good news?"

"Useful, anyway. CHP turned up an officer who had contact with what sure sounds like our Rubén Moreno. Moreno's old car died in San Diego County just outside Chula Vista. He'd pulled it onto the

shoulder and was trying to work on it when the cop spotted him. Turned out he was on his way to visit friends in Chula Vista, and since he had two little kids with him, the cop gave him a lift to his friends' house."

"When was this?"

"Thursday night real late, around four A.M. More than a week ago," she added with a shrug. "Probably long gone. But I made an official request for the Highway Patrol to check it out, or to ask the Chula Vista force to do it—to pick up Moreno if he's still there, otherwise find out where he's gone. And get right back to us."

"Thursday night," said Gutierrez, mostly to himself. "Either he made a long, easy trip of, what, seven hundred-plus miles after leaving here Monday. Or he came back or stayed around, killed his wife Wednesday night, and then drove like hell."

They were both thinking this over when a rap sounded on the office door. Gutierrez got quickly to his feet, and Alma flipped her notebook open.

Bethany Martinson was a small, nicely rounded woman who reminded Gutierrez of Charlotte Birdsong. Without seeming self-important, she held firmly to her position regarding the fertility clinic. "I find the place well run, or I wouldn't be associated with it. My relationships with Dr. Ferrar and his staff are professional, not personal; professionally I respect them."

"This young woman has been missing from her home for nearly a week now," said Gutierrez, handing her the photo of Graciela, "and there's a possibility that she might have visited the clinic. Would you tell me, please, whether you've seen her there?"

"What do you mean by 'a possibility'? And why don't you ask the clinic staff about her?"

"We have."

This brought him a sharp look, which she then turned on the photograph. "I…think I might have seen her," she said, her manner less crisp than before. "But not at the clinic. I think I saw her with Dr. Ferrar—old Dr. Ferrar," she added.

"With Dr. Gabe? When was this?" Gutierrez's throat was suddenly dry.

"Quite recently. Last Friday or Saturday evening? Saturday. If she

is the girl I saw getting out of his car, there in the parking lot; I'm sorry, but I can't be completely sure."

"His car."

"That old red Cadillac. I was going into the Dock restaurant for dinner, and it pulled up at the edge of the lot, right under the light. I saw the driver only in profile, and from some distance away, but I certainly thought it was Dr. Gabe. He dropped the girl off, then drove back up toward town. And I went inside for dinner."

Chapter 23

"UH, CHIEF. Chances are she'll just go out there on her own," said Alma.

"We have no right to stop her," Gutierrez said shortly. Finding that James Ferrar had driven to San Francisco early that morning, he had tracked down Jocelyn to ask just where her brother Will's property was located. Jocelyn provided directions, not happily, and asked questions, to all of which Gutierrez replied only that he needed to talk to Will. He had firmly rejected Jocelyn's suggestion that she ride along with him to Will's place.

"But she'll have to promote some wheels first," he added in milder tones. "So get as much speed as you can out of this rig without advertising our status." "This rig" was Alma's Ford Explorer, equipped with a police radio and siren, a long-gun lockbox in the rear, and most important, four-wheel drive as well as a winch. Out where Will Ferrar lived, roads were likely to be gravel at best, and were often blocked by rock slides or fallen trees.

"You got it." The city limits sign loomed, then fell quickly behind them as she goosed the Ford's accelerator. "There's the Comptche Road," said Alma after several minutes of uneasy silence. As she flipped on her turn signal, a big green motorcycle and its leathered and helmeted rider swung in front of them and zoomed left to head down that road. "Hey, you dumb bastard!" Alma yelped, braking.

"Nice bike," said Gutierrez, letting himself be momentarily distracted by the memory of an earlier enthusiasm. "A Harley, I think."

"Yeah. Chief, you don't think Dr. Gabriel…?"

"I don't *think* anything. But there's a lot I need to find out. About Graciela Aguilar, for one; and Will Ferrar is the only clinic person we haven't talked to about her."

"Oh, right." She tossed him a sideways look but said nothing further.

Gutierrez braced his feet and ignored swerves and bumps. The near despair roused by Bethany Martinson's identification of Graciela and Dr. Gabe had given his subsequent questions an aggressive edge that clearly offended her—not that she'd had anything to add, given her determination not to express personal opinions.

But after she'd left, her words—"that old red Cadillac"—raced around his memory like ants or maybe cockroaches, and finally stirred an echo. What he'd remembered, more or less word for word, was a remark of Dr. Gabe's from some time back, in response to Gutierrez's partly facetious suggestion that he might enjoy a smaller, more up-to-date car. "That old Caddy," Gabe had said, "is past its prime, like me, but Will keeps it running so I'll let him borrow it now and again."

"So maybe there is only one twenty-five-year-old red Cadillac in town, that we know of." Alma had kept quiet as long as possible. "So you see the car, you think Dr. Gabe automatically, without looking real hard. And maybe an old biggest-bull-in-the-pasture, excuse it, Chief, old guy like Dr. Gabe wouldn't let anybody near his wheels including his own grown-up son, but wouldn't a *grandfather* maybe share it with his grandkid? Mine would." She paused for breath and thought. "And in profile anyway, Will Ferrar looks quite a bit like the old man."

Gutierrez was momentarily cheered by this line of reasoning from tough-minded Alma Linhares, who had no particular reason to be grasping at straws on Dr. Gabe's behalf. "And his hair is almost blond, probably light enough to look white at night," Gutierrez said. What Will drove regularly was a gray Dodge pickup with a shell. Which just made him one of a multitude around here, and the possibility of his truck being the one parked at Pelican Point the night Espy was murdered was not large. Minimal, in fact. Except, he reminded himself, sometimes a lot of small, jagged, unrelated-looking pieces finally go snap-click and fit together in one big, smooth whole.

"But, boss, I mean, the guy's a *nurse*." Alma blinked and closed her mouth, stunned to brief silence by her own remark. "Okay, dumb. World's probably full of killer-nurses, I guess I've read about some. But even if it was Will Ferrar in the Cadillac that night, he was

probably just being a nice guy and giving a girl, a pregnant girl, a lift. And for all we really know, Graciela is happy and healthy in L.A., postcard to arrive any day now."

A shudder shook him, icy fingers trailing along his bones. The only see-er beyond in Gutierrez's family had been the old one, his pure *Indio* great-grandfather; whatever the gift or skill was, he'd never felt it in himself. But he had a deep, cold sense that Graciela Aguilar was not "happy and healthy" in Los Angeles or anywhere else.

Gutierrez reminded himself that he was a cop who trusted to evidence, not some squat-in-the-dust ancient who believed in devils. Except maybe human ones. "I've thought maybe Will was the one providing late-term abortions," he told Alma reluctantly. It was an idea that made him uneasy because it didn't quite fit. Dr. Gabe, perhaps, but...

"Ol' Marilyn the Wu seemed pretty sure Will wouldn't do any such thing," Alma reminded him.

"I know. I'm still thinking. Just assume that we're making this trip to complete the circuit on the Aguilar investigation." Gutierrez slumped in his seat and stared grimly out the windshield; Alma sat straighter and concentrated on her driving.

"But that would be a good motive," she said some minutes later. "For Rubén. I don't mean good," she added hastily, "but it would be something that might push a—a traditional Latino to kill his wife. Aborting his child."

"And not much of a reason for anybody else to do it," said Gutierrez.

"Right," said Alma with a nod. "So maybe we'll find Gracie out here recovering from surgery or whatever it is."

That didn't make sense, either—medical procedures out in the woods with well or stream water if any, light and heat from burning wood possibly augmented by gas lanterns. "Maybe," he said.

The Comptche Road was tarmac, potholed but navigable, a condition that lasted, he thought, until the tiny town of Comptche. There was light traffic moving close to the limit: a small sedan or two, this or that size pickup, a light motorcycle (the big Harley that had flicked his fond memory was long out of sight).

But beyond the town, the road, as he recalled it, deteriorated into a mixed pavement and gravel surface sure to have suffered from the

winter's rains. And Low Gap Road, which would take them to Will Ferrar's property, was likely to be even worse. "Linhares," said Gutierrez suddenly, "I don't remember any discussion of money and Graciela Aguilar. Did she have savings? Or did she maybe take money from her sister?"

"Luis said she'd been saving baby-sitting money, but he didn't think it could be much. If she'd gone off with family money, his money, I'm sure he'd have been yelling about it. Dolores didn't say anything to me about money."

"Did you ever get responses from the out-of-town banks you queried about Esperanza Moreno's account, if any?"

"Not up to yesterday morning. I haven't checked since. Why?"

Because Dr. Gabe wouldn't have charged for an abortion he felt was justified or necessary. Will, deep in debt and with an income that fluctuated, might not have been so accommodating. And how would either Espy or Graciela have paid him? "Just another of the gaps," he said to Alma, "that I'd like to have filled. You think the radio will work here?" In Mendocino County, where the foggy coastside was separated from the hot inland valley by the hills of the Coast Range, the county-wide communication system depended on hilltop relays.

"Probably not very well. But there'll be a telephone in Comptche. Want me to call in?"

"Yeah, humor me," he said.

While Alma used the pay phone at a combination gas station and general store, Gutierrez went inside to get a couple of Cokes, good dusty-road caffeine jolt. "What?" he asked, as Alma, eyes wide, met him on the steps of the store.

"She had an account in Willits under her maiden name, Esperanza Grijalva. Two, actually—a little savings account, eight hundred and something dollars, and a seven-month certificate of deposit for ten thousand dollars."

"Had?"

"She bought the C.D. last August, which if I remember right is about the time she quit her job and left town. Cashed it in and cleared the savings account the Tuesday before she was killed, literally cash. Which the bank didn't like but couldn't do anything about."

Gutierrez tipped the cold can and let Coke fill his mouth. Let facts and suppositions, needs and circumstances, swirl madly in his mind like the fizzy bubbles bursting against his tongue and teeth: failed and sorrowing would-be mothers; travels to Spanish-speaking countries; damaged records.

"Maybe Dr. James lied," said Alma. "About giving her money. Kuisma said that when he talked about her, it seemed like he really liked her. Maybe he gave her money for an abortion, and more besides."

Ten thousand dollars. Gutierrez had trouble imagining Jimmy Ferrar, uptight and always crying poor, parting with that much money. Unless Esperanza had something on him.

"And maybe she gave it, or part of it, to Graciela, who was like her little sister and in the same kind of trouble."

"Maybe," said Gutierrez, whose mind was playing with the pieces in a new and different way, seeing the possibility of a very different picture. He should call the shop or the sheriff's station for backup, but that would mean a delay and he didn't feel like waiting. "Maybe. Whatever the truth is, we need to talk to Will Ferrar to pin it down. Let's go."

Gutierrez drove. Alma sat tense and alert beside him, watching for Low Gap Road. After a very long twenty minutes, she said, "There," and reached out to reset the trip-mileage indicator to zero as Gutierrez swung the Ford hard right.

The road was lined on both sides with brush and scrub trees, but sun shone through spindly limbs and made the dark vehicle warm. Gutierrez's window was down; Alma lowered hers and tuned her ears and her nose to the outside world while her eyes stayed fixed on the mileage indicator. According to Jocelyn Ferrar, the narrow entrance onto her brother's property was eight and seven-tenths miles from the turnoff.

Five miles. Alma retrieved her now-warm Coke from the drinks-holder on the dash and sucked at it. Six miles.

"Chief? There's dust in the air. I've been smelling it and now I see it. Somebody's been along here fairly recently."

Gutierrez sniffed, peered ahead, frowned. Hit the brakes and said, under his breath, "Goddamn!"

"What?"

"Stupid. The rider on the Harley? Had a long pigtail down the back of that leather jacket. Guess who?"

"Jocelyn?" she said after a moment.

He grunted in assent and moved his foot back to the accelerator. "She has no reason to know you're with me."

"Unless she spotted us at the Comptche Road turnoff."

"Not likely," he said. "Not from under that big helmet. And she wouldn't know this vehicle. No, this is a routine call from the local chief of police and longtime family friend to the last name on our list. Who is a personally respectable, so far as we know, son and grandson of prominent Port Silva citizens, lives out here alone with no telephone, and is known to be grieving for his grandfather."

"Right."

They bumped along in dusty, attentive silence; when the numbers rolled finally to eight and five-tenths miles, Gutierrez pulled over to the shoulder and braked. "Okay, the entrance should be just around that next curve. Linhares, what are you carrying, a nine-millimeter?"

"Nope, just the old wheel gun," Alma told him.

"Colt Python? Belt holster? Okay, give them to me."

She unbuckled her belt, slid holster and revolver free, and handed them to Gutierrez, who threaded the holster onto his own belt and pulled it to one side, under his jacket. "Even if they see it, they have no reason to know I hardly ever carry a sidearm. What have you got in the back?"

"Twelve-gauge; .22 bolt action; .30/06 Remington autoloader."

He nodded in satisfaction. Alma Linhares, raised with three brothers and numerous male cousins, was a duck, deer, and elk hunter and the best rifle shot on the force. "You get out here with a rifle. I'll drive on in, slowly; you follow but try to keep in cover. Jocelyn said the house or whatever isn't far in—maybe a hundred yards. If I yell or you hear shots, come in quick. Otherwise, use your own judgment."

"Yessir!" she said, eyes glittering. She rolled from the passenger door, closed it gently, moved to the back and unlocked the gun box, and lifted out a long gun with a scope. The .22, noted Gutierrez, who would himself have preferred the bigger weapon but left his sharpshooter to her choice.

Alma put two clips in her pockets, one in the rifle, closed box and

door, and stepped back with a wave that was half salute. Gutierrez waved in his turn and put the boxy vehicle in gear.

The driveway, otherwise easy to miss, was at exactly the eight and seven-tenths spot. Gutierrez turned in, ignoring the brush that squeaked along both sides of the Ford. Bad for the paint, good for cover. And ahead was a clearing against a backdrop of pines, oaks, brush, and some big stumps. He drove another twenty feet, stopped, turned off the engine, and climbed out.

Except for dust devils stirred by a whippy wind, the scene was as still as an actorless stage set. A wellhouse, a metal tool shed, a larger wooden shed with a sloping tin roof and a canvas front. A small dented and rust-streaked travel trailer on concrete blocks, its door propped open. In the foreground a Dodge pickup, the big green Harley motorcycle, a dirt-clotted backhoe. Far right, close against the sheltering trees, a concrete slab with the start of framing at one end and a pile of lumber stacked nearby.

The actors waiting far left were only those he'd expected, with no sign of Graciela Aguilar, healthy or otherwise: Will Ferrar, his sister Jocelyn, and between them but inside a split-rail corral, a high-headed, dish-faced bay horse with ears pricked forward. All three stared silently at Gutierrez, the horse with curious interest and the other two with noticeable lack of welcome.

Just the kind of attitude to remind him he was a cop, with a job to do. "Good afternoon," he said.

"I had a right to come here," said Jocelyn, whose black leather-encased body was a sexy, futuristic contrast to her round and troubled face.

"Nobody said you didn't," he replied, circling the vehicles with an appreciative glance at the Harley. "Nice bike. Where'd you get it?"

"My ex-boyfriend, not that it's any of your business."

"Everything's my business," he said, stopping at the wooden shed to push the canvas cover aside: bales of hay and horse tack. "Nice place you've got here, Will."

"Hey!" yelped Will, as Gutierrez stepped up onto a concrete block and stuck his head into the trailer: cramped, messy, empty of humanity for the moment. "That's my home, you stay out of there!"

Jocelyn put a restraining hand on Will's arm. "Chief Gutierrez, I talked to my brother about the missing girl. He doesn't know her."

The tool shed was padlocked; Gutierrez decided to skip that for the moment. He ambled on across the rocky ground until he was some ten feet from the Ferrars—far enough away to be able to watch them both and close enough to intercept either if necessary.

"That's right, Chief," said Will, in an almost affable tone at odds with his red-rimmed pale eyes that blinked rapidly, from nervousness or maybe just blowing dust. "Oh, this is Mandy," he said, giving the horse's satiny neck one more pat before pulling his hand down to aim at a pocket it turned out he didn't have. Will wore a long, loose garment that Gutierrez thought was called a caftan, its blue-striped fabric flapping in the wind over bulky white socks and sandals. It occurred to Gutierrez that he'd never seen the boy in anything but boots—pointy-toed, slope-heeled western horseman's boots.

"As long as I'm here, I'll ask you to have a look anyway," he said, taking the photo from his pocket and stepping nearer to hand it to Will. "This is Graciela Aguilar, the young woman we're looking for."

Will took it, swept his glance over it, and handed it quickly back. "Don't know her. Never seen her. Sorry." The smell of him, carried close on a puff of wind, was rank. If grief had a odor, Gutierrez didn't think this was it. Fear, more likely.

Gutierrez slid the photo back into his jacket pocket without looking at it again, keeping his gaze instead on the sweat-streaked face that was a flawed copy of one he'd known most of his life. He himself was not sweating at all, was cold as iron. "We have a witness who saw you drop this girl off down by the Dock restaurant last Saturday night."

"Witness? There can't be! Who?" Will pushed his body straighter against the rails of the corral, and the horse snorted and danced away.

"A local person with normal eyesight and no apparent axe to grind," said Gutierrez.

"It wasn't me, absolutely not. It must have been Granddad," he added quickly.

Jocelyn started at this, turning her frown on her brother.

"I understood you had Gabe's Cadillac that night," said Gutierrez.

"Look, Granddad never let anybody drive that old heap of his. Probably he—just saw a pretty girl and took her for a ride. He liked pretty girls."

"Pretty pregnant girls?" asked Gutierrez.

This brought Jocelyn's mismatched eyes back to him in a hurry. "I told you," she snapped, "my grandfather was not doing abortions, not late or any other kind."

"What about your brother?" he asked her, watching Will.

"Will? Of course not. He always says—"

Will broke in, reddening face thrust forward. "Absolutely not! I don't believe in abortion, I argued with Granddad about that. Look, I've answered your questions. Now I want you off my property. You're just a Port Silva cop, anyway, and I'm in the county."

Gutierrez waved this petty problem aside. "It occurs to me," he said in thoughtful tones, "that we've been distracted by a national obsession. I don't think abortion is what we're into here."

"Good. I'm glad. Now go away and leave me alone."

Jocelyn was interested. "So what *are* we into? I mean, I thought this was about a pregnant kid disappearing."

Gutierrez was moving a little now, a step or two one way, a step or two back, eyes always on the Ferrars—to keep his muscles loose, to distract attention from any odd noise. Linhares was good, but after all human.

Jocelyn faded into a featureless blur as he focused all his attention on Will. "Let's look at what we have here. Two Hispanic Catholic women, one of whom had already refused an abortion. Close friendship. Unwanted pregnancy. Relative poverty."

"Women change their minds all the time. And Granddad wouldn't have charged them," said Will.

"You stop that!" Jocelyn, taking several steps away from her brother's side. Good. "He wouldn't have risked those women, and he did too let you drive his car sometimes!"

"Shut up," said Will.

"But take the individuals out of it," said Gutierrez, as if the exchange had not happened, "and get rid of the distractions, and what we have is people without babies who want them. And people who have babies, and don't want them." The obviousness of this, the missing piece, stirred the pain lurking in his gut.

Jocelyn's face had the look of enlightenment striking; Will's was stony.

"You see, it turns out that Esperanza Moreno suddenly had ten

thousand dollars, in August, just before she left town. An impossible amount for her to have saved.

"But imagine another woman who'd tried for years to have her own baby, possibly with the help of a respected fertility doctor, and failed. Maybe been told by the doctor that more attempts were a waste of his time and hers," said Gutierrez, the story evolving as he found words for it. "Imagine someone putting this woman in touch with Espy, a proven producer of healthy children, now unhappily pregnant again. Wouldn't she, this hypothetical woman, see ten thousand—more likely double or triple ten thousand—as a small price to pay to realize her dream?"

"I wouldn't know. Ask my father," said Will with a large shrug.

"Will! You prick!" cried his sister.

"Of course, Espy ran into trouble with her husband," said Gutierrez, and saw a tightening of Ferrar's already clenched jaw. "But Graciela? Espy's friend, little sister. Confidante. Younger and more Americanized than Espy," he added, deepening his voice against a tremor there, "with no husband she had to worry about. Made a mistake that'll turn her into another version of her own sister but realizes she knows of a way out. Do you suppose she's being coddled right now in some maternity clinic in, oh, Santa Barbara? Phoenix? Denver?"

"This is all a bunch of crap," said Will. "I told you, I never saw her."

Gutierrez drew a quick, deep breath and focused for a moment on Jocelyn, wide-eyed with what looked to him like honest confusion. "Or maybe Graciela somehow found out what really happened to Espy, and so didn't get to Denver after all. How much property do you have here, Ferrar?"

"Eighty acres."

"Lots of space to hide. Or to hide something." Gutierrez was standing within a few paces of the backhoe. Without any particular intention in mind, he stepped closer to the machine, reached out, and brushed a hand over the toothed edge of its bucket. Friable dirt crumbled away from his fingers.

"Will Ferrar, I'm going to ask you to—"

Before he could finish his sentence, or get his hand on the Colt in the shoved-back holster, Will had lunged for his sister, pinioning her

arms and lifting her off the ground as he swung her in front of his own body.

Jocelyn shrieked and tried to break free, twisting her body and kicking back with booted feet. One kick caught Will's shin; he gave a high scream of anguish and stumbled off balance for a moment but caught himself.

"Drop the gun!" he howled, before Gutierrez had the weapon clear. "Or I'll break her neck!" Left arm clamping her body to him, he slammed his right hand against the side of her narrow neck, thumb over the windpipe and fingers wrapped around behind. Her screams faded to a gurgle.

Gutierrez stood frozen, by the menace of that enormous hand and by what he'd seen as Will's stumble and a gust of wind whipped the caftan knee-high: bright pink, hairless flesh wrapped with thick white bandages, one of them—from Jocelyn's kick?—now oozing redly. He had an instant's sharp memory of the smell of singed flesh.

Will's thin-edged voice pentrated. "I can do it. I will do it. Drop that gun."

Gutierrez pulled the revolver free of his jacket and lifted it high, his hand wrapped around the frame. "Will, let her go. One more killing can't win you anything."

"How about two?" Will's right hand stayed where it was, and Jocelyn was no longer struggling. "Never mind. Throw the gun down."

"It's a revolver. It will go off. Let her go."

"Lay it down then, and kick it away. Now!" he yelled, and Jocelyn made a gagging sound.

"All right. Fine." Gutierrez bent to lay the gun in the dirt, then gave it a nudge with his foot.

"Not far enough! Kick it again!" When Gutierrez had obeyed, Will said, in conversational tones, "Good," and began to inch crab-wise toward the weapon. "I'm no killer. I just want to go away. I'll put you both in…the toolshed."

"Will…"

"Shut up!" Will stood straighter, and Jocelyn made that sound again. "You lie down on the ground. Flat, on your belly. Now!"

Gutierrez bit back a groan of his own and prepared to do as instructed. The revolver was out of his reach, and Will Ferrar stood

foursquare facing the driveway, Jocelyn a shield for his entire body and part of his head as well. An impossible shot and he hoped, he thought he hoped, Linhares wouldn't try it.

The scream of the horse was swallowed by the boom of the rifle. Will screamed in turn, tossing Jocelyn aside as he swung around toward the corral; she hit the ground and rolled. With a roar he didn't recognize as his own, Gutierrez flung himself not at the revolver on the ground but at Will Ferrar, wrapping hard arms around those bandaged legs and felling him.

"Bastard!" Gutierrez snarled as Ferrar pushed himself to his knees, dragging his assailant with him.

"Filthy. Burning. Son of a bitch. Agh!" Ferrar had wrenched his body around and was swinging long arms, one big fist catching Gutierrez a glancing blow on the temple, another landing harder on his breastbone, putting knives in his breathing.

Ferrar was up now, or nearly; Gutierrez grabbed handfuls of the man's clothes and flesh and pulled himself upright, too. Ferrar, taller by several inches, pounded at him with both fists but Gutierrez absorbed the blows without feeling them, burrowing in close and head-down to pump his own piston-blows into the other's gut and ribs.

Ferrar, keening through clenched teeth, got his forearms between their bodies and shoved Gutierrez away, threw a head-ringing punch and another that Gutierrez slid under to lunge in close again, wrestler not boxer he always was, and he wrapped his heavier arms around the long ribcage and squeezed.

Ferrar rained blows on his shoulders, punched the sides of his head. Gutierrez held on tighter, squeezed harder, and heard or felt a rib go; he kick-scraped with a booted foot at Ferrar's shin and they both fell, rolling.

Gutierrez, on top but winded and tiring and *old*, the struggling body under him young and strong, lifted his weary head and gulped air and brought his forehead smashing down against the other's nose and felt it give. Got his aching arms up and seized double fistfuls of ears and long hair to lift his enemy's now-bloody head and slam it against the rocky ground, and again. And again.

He stopped. Rolled off the no-longer-moving Ferrar, flopped onto his back in the dirt, and blinked to clear a red haze from his eyes. Heard the rasp of his own breathing, saw a sky that was streaky

blue. Heard, yes, Ferrar's breathing. Thought, Too bad. Lifted his head with great effort and saw Alma Linhares standing ten feet away, her eyes on him but her lowered rifle aimed generally in the direction of the huddled and sobbing Jocelyn Ferrar.

Gutierrez rolled over, away from Will Ferrar, and got first to his hands and knees, then to his feet. He stood wide-legged, locked his knees, waited for the tilting landscape to level itself. "Linhares," he said. "You didn't stop me."

"No sir. I figured you'd stop if you wanted."

He pulled a filthy hand down his face and sighed. "I didn't think I would."

"Me neither."

"I don't have cuffs. Give me yours," he said, and she pulled them from her belt. He flipped Will Ferrar over with his boot, planted that boot on Ferrar's right wrist while he bent to grasp the left and pull it up, cuffed both.

"Hey," he said as he straightened. "Alma, you shot a horse!"

"I like horses," she said with a shrug, "but I like some people better, and I couldn't get a safe shot at El Creepo there. Anyway, I only creased her ear. She'll be okay."

A sound from Jocelyn brought him back to the immediate world. He moved to stand beside her, but was not sure he'd survive bending down again. Probably fall on his face. "Jocelyn, I'm sorry."

She lifted a dirt- and tear-streaked face and opened her mouth, but only a faint croak came out.

"Oh Jesus, don't try to talk. Jocelyn, do you understand that in addition to whatever else he was involved in, your brother has some bad burns? Those just about had to come from the clinic fire. Which, however it started, he clearly got out of but Dr. Gabe didn't." Leaving the implications to her.

She nodded and buried her face against her up-folded knees.

"I'm sorry," he said again. "Linhares, try the radio, see if you can get the sheriff. First thing, we'll want the paras. I don't know what Jocelyn needs in the way of first aid, and as for him—" he looked at the still-unconscious Will Ferrar and felt sourness rise in the back of his throat "—I don't trust myself to touch him again."

He turned away, swallowed. "And we'll need a search crew. I figure he buried Graciela somewhere out here."

Chapter 24

"YES, I'M SORE, obviously I'm ugly, and no, I wouldn't be better off in the hospital." Vince Gutierrez tightened the belt of his wool robe and turned to walk slowly, carefully, back to his pillowed corner of the couch. "And for Christ's sake, shut the door; it's cold out there."

Johnny Hebert obeyed before following his boss into the living room. "Meg not home yet?"

"Not for a few more hours, she figured sometime midafternoon," said Gutierrez, settling back against the cushions. "Okay, Hebert, let's have it."

"They found Graciela Aguilar's body," said Johnny. His usually cheerful face was somber, the bright blue eyes clouded. "I was on my way home anyway, so I thought I'd come to tell you instead of calling."

"You're always on your way somewhere." Gutierrez leaned his head back and closed his bruised and aching and suddenly tear-blurred eyes. No surprise, but painful, like the punch you see coming but can't dodge. "Johnny, there's a pot of coffee in the kitchen. Would you fill my cup for me? And get one for yourself."

Hebert brought coffee, then pulled one of the two wing chairs closer to the couch and its low table.

"How?" Gutierrez asked.

He read this correctly. "The doctor thinks some kind of shot, maybe morphine."

Gutierrez took a deep breath, expelled it slowly. "When?"

"Probably soon after she disappeared. Not within the last two or three days, anyway."

Maybe, eventually, that would make him feel better—the fact that quicker work on his part wouldn't have saved her.

"There was a big leather handbag in the—the grave—with her," said Hebert, "that had Esperanza Moreno's wallet and things in it. I figure he couldn't burn that, the way it appears he did Graciela's stuff, the clothes and things she'd taken with her. And I thought, maybe Graciela found the bag out there and that's how she realized who'd really killed her friend."

And probably confronted him and… Gutierrez closed his mind to the scenes this suggested. Took a big mouthful of bitter black coffee. "What is Will Ferrar saying?"

"Last night, police brutality," said Hebert.

"Yeah?" Gutierrez rubbed a hand across his bruised forehead and remembered the feeling, the crunch, of Will Ferrar's nose against it. "Maybe he has a case."

"When the guy had twenty years and five inches on you? And you were defending your own life and Jocelyn Ferrar's? You'd have been justified in killing the bastard."

"I didn't want to kill him. I just wanted to beat him to a bloody pulp."

Hebert opened his mouth and then closed it, incomprehension written on his face. Clearly he had never lived with, been inhabited by, blood lust, anger too hot to be cooled merely by pulling a trigger. Hang on to that virginity, Johnny—if you can. "Never mind, we won't worry about that. Probably he'll have the SPCA on us for shooting his horse, too. Is he still at the hospital?"

"Yep, with an officer on the door. This morning, he was the maligned and mistreated citizen, silently waiting for his lawyer. Then we got word of the body, and Chang had a talk with Esperanza Moreno's husband, and Willie started to sweat and shiver. Captain Svoboda is with him now."

"Ah," said Gutierrez. Hank Svoboda had been known to reduce drunken, axe-brandishing loggers to tearful confessions. If anyone could untangle Will Ferrar, it would be Hank. "What did Moreno have to say?"

Hebert recounted the salient points of Ray Chang's telephone conversation with Rubén Moreno, mostly confirmation of what Gutierrez had suspected. "And he can prove he was in Salinas the night his wife was killed. He's coming to claim her body."

"And raise hell," suggested Gutierrez.

"That, too. Oh, one other thing." Hebert's face was brighter now, and he paused for a mouthful of coffee. "That Wednesday night, when Meg got punched out and Esperanza Moreno's body was dumped? Turns out Debbie Finn was riding with Mike Lorenzini and her boyfriend, Ron Magnuson, when they drove past Pelican Point on their way home from their cute housebreaking games. She says she saw the pickup truck that Lorenzini mentioned, and Will Ferrar was standing beside it. At least, she's pretty sure it was him; she'd seen him around town a few times and thought he was 'awesome.'"

Brick by brick, the wall was going up around Will Ferrar. Gutierrez closed his eyes and wondered if it was time for another handful of aspirin.

"Chief?"

He opened his eyes, pushed himself upright, brushed aside Hebert's reaching hand, and got to his feet. "Thanks for coming by, Johnny. I'm going to stretch out for a while, but I probably won't sleep. I want a call if there are any new developments."

"Yessir," said Hebert. "And if there's anything you need before Meg gets home, call me. Okay?"

What he needed was…aspirin for the spirit. A confessor. His wife. "Just leave the door unlocked when you go out."

"So you think it's a good case? I understand some of the young…" probably remembering it was Sunday, Mayor Lindblad swallowed whatever word he'd had in mind and chose another "…vandals have agreed to cooperate fully." Late in the afternoon, he was dressed as if he'd just come from church, his gray suit set off nicely by the dark red fabric of the wing chair.

"According to Sergeant Chang, the district attorney's office thinks it's a good case." Gutierrrez was propped in his corner of the long couch, pillows cradling him and a soft hassock supporting his legs.

"Fine, fine. And 'three strikes' should put those Olsons, and the sister, away for good."

What we built all those nice new prisons for, after all. And we should insist they take their little kids with them, that'd be neat and Dickensian, besides easing the burden on the social welfare system. But Meg, who had been biting her tongue against platitudes and

unwise remarks since arriving home less than an hour ago, put experience into practice and kept her opinions to herself.

"The sister, Maddy Kebler, just turned eighteen," Gutierrez pointed out wearily. "Same age as some of the local kids involved."

Lindblad, father of two preadolescent boys as well as a fourteen-year-old daughter, winced and rubbed an ear. "Yes, I see. Well, if we can get the Olsons out of circulation—they were the instigators, after all, the receivers—then we can try to be creative and compassionate in handling the youngsters."

Gutierrez spread his hands, to show them free and empty. "That will be up to Rob Agnelli." The district attorney, Gutierrez knew, shared his own sheep-and-goats view of the the younger offenders in this case, and would no doubt proceed, or prosecute, accordingly. Housebreaking was one thing, gang rape something else.

Meg, who'd been thinking of dutifully offering more coffee to their visitor, saw Gutierrez wince as he shifted position. Okay, enough, she thought, and had her mouth all ready to announce departure time for guests when her husband caught her eye.

Tongue-biting routine again. She subsided against the cushions of the couch's matching love seat as Lindblad leaned forward in confidential fashion and said, "And what about young Ferrar? I hear the sheriff's people found a body this morning, out there at his place."

Two bodies, actually. Or a body and a half? Two murders, or one? "That's what I heard, too," was all he said.

"Has he, um, been in condition to talk? I mean, I understand you and he..." Lindblad chose not to specify what he understood, settling instead for a slight shrug and a meaningful glance at Gutierrez's recumbent form.

"He's a lot younger than me. I believe he's mobile, and being questioned," Gutierrez said, in a tone that contained its own shrug. "Sorry, Lyle, but you'll have to talk to Detective Hebert about that case. I'm having nothing more to do with it. I'm on sick leave. Or vacation. Or whatever it takes."

Lindblad nodded and got to his feet. "Fair enough. You did good work, Vince."

"Mostly my people, but thanks."

"My wife reminded me this morning that the old man, Doctor

Gabe, was a close personal friend of yours. We're both real sorry about the whole business."

Meg was on her feet to usher Lindblad to the door when the telephone rang. She nodded to him instead, and heard low-voiced goodbyes and then the snick of the door latch as she hurried to the kitchen.

Meg put the receiver back on its base with exaggerated care—bad idea to break up useful equipment in fits of temper—and headed back to the living room to tend to the fire and her husband. Her feet in soft slippers were quieter than she'd realized or intended, with the result that moments later she found herself standing in the dining area in silent observation.

Vince's face bore ample evidence of the pounding he'd taken: cheekbones and jawlines puffy and discolored, a blue fist-shaped bruise on his left temple, one eyebrow broken. Knuckles were split on both hands. She knew that ribs on his right side were taped, and he moved as though his knees hurt.

"Not as bad as it looks," he'd said when she arrived, with an attempt at a grin. So he looked dreadful, but skin and flesh and bone would heal. What came near to breaking her heart was that he looked so...weary. Limp, as if the vital spirit had been sucked out of him.

She must have made some involuntary sound. He opened his eyes and asked, "Who was that on the phone?"

"Just Mary Louise." His mouth was oddly undamaged in that battered face; she bent to brush her lips against it.

"What did she want?"

Meg moved to the fireplace, to feed a fresh log to the small, steady blaze. "She wanted me to know that Cass's fear and flight were my fault. For forcing her into that work-study program in the first place."

"Shit, Meg..."

"Hush. I told her..." Meg ran her memory over the several responses she'd made, to choose one safe to repeat to Mary Louise's brother. "I told her she should be pleased that Cass was headed for a nice lucrative profession, else there'd be nobody to support Mary Louise in her lonely old age."

"I see. I guess I forgot to ask you how Cass is."

"She's okay. Her pose is that it was her very own idea to come forward with the truth, and she'll be sorry if she doesn't get to be a witness." Meg grinned at his expression.

"Don't twist your poor sore face like that, love. Cass's self-deceptions are much less worrisome than her mother's. They're closer to reality, and she doesn't truly believe them anyway."

He grunted. She nudged the fire again, set the poker carefully in its holder, and turned to face him. "So what can I get you to make you feel better? If you're hungry, Charlotte sent over some of her black bean soup, which is wonderful."

"Gin. Bombay gin."

"Are you sure?" Finally one of the dumb remarks got past her.

"Absolutely," said Gutierrez. "Chewing hurts some, but drinking doesn't. And I'm not taking any drugs except aspirin."

She filled two small glasses with ice, added gin from the square bottle in the freezer, handed one to him, and settled into the wing chair with her own. "Can you tell me what it was all about—the Ferrar business?"

He took a sip of gin, then blew out a long breath. "Yesterday Will Ferrar was a poor battered victim of police invasion and brutality. Who roughed up his own sister only because he'd been terrified into it."

"And today?"

Gutierrez had received several telephone calls between Hebert's departure and Meg's arrival. "Today Will Ferrar is a man who was moved by nursely compassion to help childless women. And help other women avoid the evils of abortion or the burden of an unwant-ed baby." Gutierrez took a gulp of gin this time, and choked for a moment but waved off any assistance.

"A baby seller!" said Meg.

"More of a baby broker. Same as a real estate broker, looks like to me; bring together a willing seller and a willing buyer and make a nice commission. So far he's admitted to doing this successfully five times."

"Five! And what will happen now to... Never mind," she added hastily. Quite possibly misery lay in wait for five sets of people, what-ever their original culpability. If any. "Vince, it sounds—indecent." She sipped at her drink. "But is it illegal?"

"Depends. But his use of confidential records and patient contacts, at the fertility clinic and at Planned Parenthood and the Women's Wellness clinic, for instance, would probably have cost him his nurse's credential. Not to mention his jobs and any hope of inheritance from his father or his grandfather."

Meg got up from her chair and stretched, then reached back to pull the clip from the nape of her neck and shake her hair loose. "I feel as if I've been sitting for about a week. And I need a shower. Next question: What upset his game?"

"Esperanza. We found Rubén Moreno."

"Oh." Meg stared at him, then picked up her drink. "Who didn't kill her, I bet."

"Like a loving husband, he stopped just short of that."

Meg held her silence and sipped the frigid liquid, eyes on his face.

"Anyway. Ray Chang had a long telephone talk with Rubén Moreno. Moreno said Esperanza actually gave birth to a healthy, full-term baby, his son, instead of 'losing' him as she'd told everyone—well, except Graciela Aguilar, obviously." He blinked hard and fixed his gaze on the icy glass cradled in his hands.

"When he came to town a couple of weeks ago, Rubén found out about the baby from his five-year-old son. Then he pounded on Espy till she told him the rest of the story—that she'd sold it, him, to a childless couple."

"Oh," said Meg again, softly.

"So what ol' Rubén did then, he loaded the two older kids and all their belongings into his car and told her he was taking them home to Mexico. If she ever wanted to see them again, she'd better get that baby back."

"Did he know who had the baby?"

"Nope. But he knew it was this rich gringo doctor's son who made the arrangements." Lifting his glass, Gutierrez paused for a moment to gaze at his own split knuckles, and Meg had a glimpse of the expression he must have worn yesterday, doing battle.

"So Esperanza Moreno either asked Will Ferrar for help in retrieving her baby," said Meg slowly, "or maybe just told him she was going to do that. And he wasn't willing to have his nice little scheme blow up publicly in his face."

"That's what we think—nor willing or maybe even able to return

the fee he'd been paid by the adoptive parents. And there was Espy's ten thousand, too, which Rubén says she meant to return in exchange for the baby; that hasn't turned up yet. But it will. And with Graciela's body buried on his property…"

The front door flew open and Katy bounded in, Grendel right behind her. "It's really cold out! Is there anything really good to…? Oh, Vince, I forgot how awful you look! I'm sorry!"

"Me, too," he said.

"I hate it! You were the sexiest-looking father in my class, all the girls said that."

"And he will be again," said Meg. "Katy, did you leave me any hot water?"

"Oops," said Katy. "That shower felt so good I just kept standing there. But it heats fast. I am clean!" she sang, spinning around with her arms out, "and I have clean hair, and I talked to Kimmie and everybody. Could somebody drive me to Kimmie's maybe? After I have something to eat?"

"'Somebody' probably could," said Meg. "But you can't stay late; tomorrow is a school day."

"Eeeuuuw uck," said Katy.

"But for food, there's a big container of Charlotte Birdsong's black bean soup in the fridge. Heat some up in the microwave. And feed Grendel," she called after her daughter. "Vince, are you ready for some soup?"

He shook his head carefully. "I don't think so. I'm not very hungry."

"Hey!" called Katy from the kitchen. She came in waving a small sheet of paper. "Here's a note from Charlotte. It says amnio—what's that?—anyway, it confirms that her baby is a girl. And Val says he told her so."

Meg, who was watching Vince, was startled to see tears flood his eyes. She set her glass down on the low table, picked up his empty one, and went to the kitchen, to the freezer.

Katy glanced at her mother's face and her own bright expression dimmed. She added another cupful of dog kibble to the metal dish on the counter, picked it up, and said quietly to the big dog watching, "Come on, Grendel. Let's feed you outside." Tail whipping and ears up, Grendel followed her out the back door.

Meg carried the icy glass back to the living room to set it down beside Gutierrez.

"Thanks. Aren't you having one?"

"We're running low on gin, and you need it more than I do. Maybe when I take Katy to Kimmie's…"

Her words were cut off by the sound of the front door hitting the wall. Framed there against a gray sky was not Katy, but Dr. James Ferrar. His tan trenchcoat was mud-streaked and buttoned askew, its belt dangling; his tangled hair was plastered to his forehead.

"Shut up!" he said to the silent pair as he flung the door closed behind him. With his left hand, Meg noticed. His right hand was deep in the pocket of his coat, and he had to tug for a moment to get it out, his hand and the long-barreled pistol it held.

"Jimmy," said Gutierrez, swinging his legs off the hassock.

"I said shut up. And stay where you are." He pointed the gun not at Gutierrez but at Meg. The barrel shook and wavered, but not enough, at this distance, to ensure that he'd miss what he fired at.

"You ruined…" He gulped breath, eyes so wide they looked flat. "You have ruined my life!" he shouted, spraying a fine mist of saliva.

"I'm sorry," said Gutierrez. He was sitting erect now, hands on his knees and feet flat on the floor. Meg stood still right where she was, halfway between the fireplace and Gutierrez's couch.

"You're destroying me, you always wanted to do that."

"I never wanted…"

"Shut up! Why couldn't you just leave it alone?"

"Because one woman was dead and I wanted to keep the missing one alive."

"But you didn't, did you? You as much as killed her yourself. If you hadn't pushed and hounded and been such a goddamned *cop*, she'd probably be fine!"

Meg took an involuntary step toward him and he snarled, "Stop! I'll shoot you right here, right now, with pleasure!"

Gutierrez sat very still, and Meg took a deep breath and squared her shoulders, trying to look as if she were rooted to the spot. Where was Katy? Could she possibly have missed hearing the slammed door, the shouts? Katy, Katy, Katy, stay out of here.

"James, your son murdered people."

"Shut up! It wasn't *murder*, he was frightened and just—just struck

out, didn't know what he was doing. *If* he did anything." Ferrar fumbled a handkerchief from a pocket, left-handed, and wiped his sweaty forehead, taking awkward care to keep his lines of vision clear. "From the time he was little, Will always exploded when he felt cornered."

"He killed two women, one of them pregnant. He threatened to kill his own sister."

Ferrar shook his head. "Now that's silly, he wouldn't really have hurt her. He was probably trying to trick you."

"Have you asked Jocelyn about that? Oh, I forgot; after the way he throttled her, she probably can't talk yet."

Meg was concentrating on keeping her feet still and her ears alert; maybe Katy had gone into her own room, to her telephone, to call for help. More probably, she'd gotten there before Ferrar arrived, and was now deep in conversation with Kimmie and unaware of the nasty drama being played out over her head.

"Keep your filthy mouth shut, I said!" Ferrar swept Meg's nearly empty glass up from the table and flung it at Gutierrez, who didn't move but let it strike his shoulder and dribble liquid down his robe.

"He killed your father."

"No, he didn't mean to, it was an accident." As Ferrar mopped his face again, Meg slid a half step sideways, toward the fireplace.

"He just wanted to get rid of the records. The police, you, were threatening to subpoena my records and he was afraid someone would find out. What he'd been doing. And my father came in and Will tried, he tried to explain to him how it was. But my father, my father, he never could see anybody's way but his own." Ferrar's voice rose to a near-wail and tears ran down his face.

"So Will hit him and set a fire around him."

"Shut up! You don't know—"

The throbbing howl of a siren engulfed the room. Ferrar spun toward the door and fired a shot. Meg lunged for the fireplace, snatched up the poker and smashed it across his pistol arm. The gun hit the floor, Ferrar screamed and clutched his arm, and Gutierrez's flying shoulder-block brought him down hard.

"Get him, Grendel!" shrieked Katy as she and the dog raced in through the back door.

Gutierrez, gun in his hand now, got carefully to his feet. Meg

moved out of the line of fire but kept the poker ready. Grendel stood over the fallen Ferrar, bared fangs six inches from the man's face.

Katy said something inaudible, shook her head, and ran out the front door. Seconds later the siren died.

Ferrar lay on his back, rigid. Meg spoke to her dog, put a hand on his collar and pulled him back. "Good boy. Watch."

"You can get up, Jimmy," said Gutierrez. "Slowly."

"What for?" asked Ferrar, but he managed to get to his knees and then, shakily, to his feet. "Go ahead and shoot," he said, and collapsed into the nearest wing chair.

Katy reappeared, wide-eyed, but stayed near the door and kept her mouth shut. Ferrar, sniffling, cradled his right arm against his chest. "Oh Jesus. Why didn't you just…why didn't you go ahead and finish him off, yesterday? Put him out of his misery. Me out of mine. Jesus."

"Did you know about Will's baby business?" Gutierrez lowered himself to the broad arm of the couch and let the pistol rest on his leg.

"Oh for Christ's sake. Of course not, what do you think I am?"

Clueless, thought Meg.

"It will ruin me," said Ferrar, choking back a sob. "No one will ever trust me again."

"Probably be a while," agreed Gutierrez. He'd given little thought to Jimmy Ferrar in the past day or two, and wasn't much interested in the man's plight now. "How is Jocelyn?"

"Fine. Oh, her neck is bruised and sore, but she's going to be fine, she's…" He looked up suddenly, eyes wide. "She didn't know anything at all about Will's actions! Nothing!"

"I never thought she did."

Ferrar sniffed again, squared his shoulders. "So. What are you going to do to me?"

"I don't know. I could shoot you, it'd be self-defense. Family defense."

"Go ahead, I don't care. But I have something to tell you first."

Gutierrez and Meg, Katy and Grendel, all looked at him. He lifted his chin and found his handkerchief again, to wipe his forehead and then brush back his sweat-dampened hair.

"Will didn't kill Gabe. I did."

Gutierrez, suddenly light-headed and aware of all his pains, tried to follow this. "You set the fire?"

"No, no, of course not. Will—or somebody else, who knows who?—did that."

Meg, watching her husband's face, saw the truth strike him. "Ah."

"Right," said Farrar, baring his teeth in a grin. "What he wanted, needed, and you couldn't do it, didn't have the nerve to come in there with, what, your gun? Your bare hands? Useless little Jimmy was the best person, the only person who could help him; how do you feel about that? How do you think he feels about it, wherever he is?"

Gutierrez lifted the pistol, lining its sight up with Dr. James Ferrar's chest. Meg, unable to breathe, couldn't speak either. Or move or lift the poker. Vince, don't.

"Bang," he said, and put the gun down on the couch beside him. "You're right. I couldn't help him. But I'm grateful that you could. Now go home."

Ferrar simply stared at him, and Gutierrez snapped, "Get out of here. Now. Or I'll call downtown and have somebody haul you off and lock you up."

There was silence as Ferrar stood up and gathered his coat around him, broken by the shuffle of his footsteps as he headed for the door. And then by Grendel's faint whine.

"It's okay, boy," said Katy, as the door closed. "You did good."

Meg unclenched her aching hand and put the poker in its holder before turning her attention to Gutierrez. He looked…better, oddly enough. Eyes dry, shoulders relaxed. Mouth easy, in fact turning up just a bit.

"Vince?"

His smile in her direction widened to light his entire face as he turned it on Katy. "Katy. You restore my soul."

She blinked, and her unnaturally pale face took on color. "I saw him through the side window, and his gun, when I was coming down the steps there, he looked really scary and…wild. And then I came around to the front where the chief's car was parked, and I just thought of the siren. Like somebody was already here to help. Aren't you going to have him arrested?" she asked, indignation pinking her cheeks still more.

"I think it would be a waste."

Meg, who two minutes earlier would cheerfully have beaten the man to death with her poker, took a deep breath and nodded. "He's no danger now to anybody, except maybe himself."

Gutierrez leaned forward to pick up his glass. "Must have been hot in here. The ice is all melted."

"The gin is gone," said Meg firmly. "But bean soup requires very little chewing."

Jerry Bauer

About the Author

Janet LaPierre came to northern California from the Midwest via Arizona, and knew that she was home. After raising two daughters in Berkeley, LaPierre and her husband began to explore the quiet places north of the Bay Area: the Mendocino area, the Lost Coast, Trinity County. Often working on a laptop computer in a twenty-five-foot travel trailer in the company of a yellow Labrador named Emmitt Smith, LaPierre has tried to give her award-nominated mystery novels a strong sense of these far-from-the-city places. Her web site can be seen at www.janetlapierre.com. She can be reached by e-mail at janet@janetlapierre.com.